# PORTRAIT REVOLUTION

INSPIRATION FROM AROUND
THE WORLD FOR CREATING
ART IN MULTIPLE MEDIUMS
AND STYLES

Edited by JULIA L. KAY

WATSON-GUPTILL PUBLICATIONS
California | New York

POST CARD

FOR CORRESPONDENCE    FOR ADDRESS ONLY

Dear Ann,
This book is for
you. Your humor
and intelligence
brighten my life
every day. Love,
Juli

Ann
Kirschner
Asteroid B-612

BURMA POSTAGE

Copyright © 2017 by Pimpernel Press Limited
Text copyright © 2017 by Julia L. Kay

All rights reserved.

Published in the United States by Watson-Guptill Publications,
an imprint of the Crown Publishing Group, a division of
Penguin Random House LLC, New York.
www.crownpublishing.com
www.watsonguptill.com

WATSON-GUPTILL and the WG and Horse designs are registered
trademarks of Penguin Random House LLC

Published in the United Kingdom by Pimpernel Press Ltd., London.

Additional text and images are copyright individuals credited.

Library of Congress Cataloging-in-Publication Data
Names: Kay, Julia, editor.
Title: Portrait revolution
Description: California : Watson-Guptill, 2017. | Includes bibliographical
references and index.
Identifiers: LCCN 2016051436 (print) | LCCN 2016052203 (ebook)
Subjects: LCSH: Portraits. | Art—Technique. | BISAC: ART / Subjects &
Themes / Portraits. | ART / Mixed Media. | ART / Techniques / General.
Classification: LCC N7575 .P585 2017 (print) | LCC N7575 (ebook) |
DDC 757—dc23
LC record available at https://lccn.loc.gov/2016051436

Trade Paperback ISBN: 978-1-60774-996-7
eBook ISBN: 978-1-60774-997-4

Printed in China

Interior design by Pimpernel Press
Cover design by Chloe Rawlins

10 9 8 7 6 5 4 3 2 1

First Edition

FRONT COVER: (left to right)

Top row: Daniel Novotny, Slovakia (see page 185), Marie Aschehoug-
Clauteaux, France (see page 126), Joan Ramon Farré Burzuri, Spain
(see page 172), Cecca Whetnall, UK (see page 110).

Bottom row: Janice Wahnich, UK (see page 192), Theresa Martin, USA
(see page 180).

BACK COVER: Kline Howell, USA (see page 79), Jennifer Lawson, USA
(see page 45), Sally Sheen, UK (see page 43).

PAGE 1: Yip Suen-Fat, Hong Kong (see page 130).

PAGE 2: JKPP group, London, by Sue Hodnett, UK. Watercolor,
ink and pen on paper, 60 × 48 inches (1524 × 1219 mm).

THIS PAGE, ABOVE: Julia L. K., USA by Mitt Cheevey, USA. Ink and
watercolor on paper, 10 × 8 inches (254 × 203 mm).

BELOW AND OPPOSITE: (left to right) Lynne Lamb, UK (see
page 64); Diane Marie Kramer, USA (see page 39); John Thornton, UK
(see page 76); Barbara Luel Pecheur, Belgium (see page 46); Francesca
Andrews, USA (see page 72); Rodney van den Beemd, Netherlands
(see page 35); John Holliday, UK (see page 41); Jill Harding, UK (see
page 61); Lucy Childs, UK (see page 19); Kim Drake Schuster, USA
(see page 30); Oksana Shiell, USA (see page 51); Jutta Richter, Germany
(see page 55).

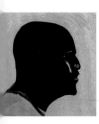
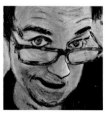
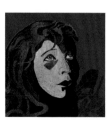
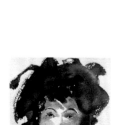
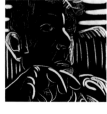
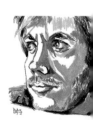

# CONTENTS

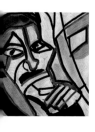
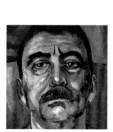
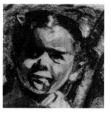
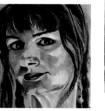
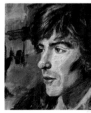

# ABOUT JULIA KAY'S PORTRAIT PARTY

Julia Kay's Portrait Party (JKPP) is an international collaborative project in which artists all over the world make portraits of each other. After seven years of exchanging portraits, tips, and techniques with each other, we're now sharing our art, our words and our inspiration with everyone who is interested in or would like to get started with portraiture.

JKPP began in 2010 as a way to celebrate the successful completion of my three-year project to make a self-portrait every day. During that project I experimented with multiple media and conceptions of "self-portrait." I drew while looking in the mirror, from photographs, from memory and from imagination. I painted in my studio and drew with my finger on my iPod

Touch. In all this experimentation, the thing that emerged as the most important to me was my commitment to a daily art-making practice. I had never had that in my life before, and it was terrific. After three years, I was ready to stop putting myself in every picture, but I wasn't ready to stop drawing every day.

As a transition between staring at my own face for three years and opening up to other genres entirely, I thought it would be fun to throw a portrait party and look at some other faces. I'd first heard of portrait parties from Rama Hughes's blog, where he described a portrait party as a get-together where artists draw each other. Originally I thought I would have a traditional live portrait party.

*David A. F., USA* by Ann Kirschner, USA
pen on paper, 3½ × 3 inches (86 × 76 mm).

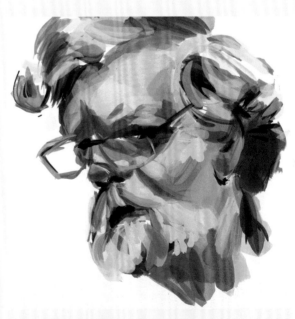

*Norman, USA* by Mia Robinson Mullen, USA
ArtRage app on a Modbook, no fixed dimensions.

6

# From doodles to digital, from oils to inks, variety abounds at Julia Kay's Portrait Party.

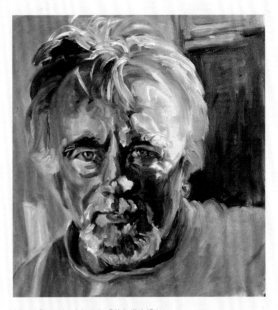

*Magi, Spain* by Mariah O'Neill, USA
water-mixable oil paint on canvas, 16 × 15 inches
(406 × 381 mm).

Unfortunately, as the three years of my self-portraits were winding up, I found myself in the middle of a family emergency and in no position to throw a live party. I'd begun posting my work and following other artists on flickr.com so I decided to try starting a group there. I sent invites to some of the other self-portrait and figurative artists I'd been interacting with, crossed my fingers, and hoped a couple of people would post photos by the time I was ready to start, a week later.

Apparently I wasn't the only self-portrait artist in the world hungry for another face to stare at. In that first week, before I even began drawing anyone myself, 60 artists jumped on board and drew more than 200 portraits of each other. After six weeks, we had 150 members from around the world who had posted more than 1,300 portraits of each other. By the time of this book's publication, we had more than 1,000 members from more than 55 countries, and the group had produced more than 50,000 portraits of each other.

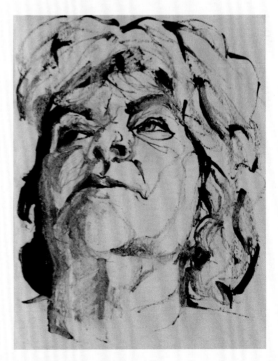

*Amy, USA* by Maureen Nathan, UK
ink (drawn using a chopstick) and white chalk on paper,
11 × 8 inches (279 × 203 mm).

As the portrait count was growing, the group was also growing closer as a community. Group members were using the Flickr interface to comment extensively on each other's work, have conversations about different art processes, tell jokes. There was an inadvertently funny moment early on, when one of the digital artists asked a watercolorist "What app did you use for that?" Usually the digital artists posted to digital groups and the watercolorists posted to watercolor groups, so they weren't used to seeing each other's work. But here artists in all media were mixing it up and being inspired by each other. A wide range of styles also emerged—from realistic likenesses to wild semi-abstracts that are perhaps only conceptually portraits. Of course you'll see this range of styles and media throughout the book, but to whet your appetite, here you can see two portraits in very different styles from the same photo of Lena, Norway.

In addition to a growing body of work and a growing community, the group has had growing recognition. Many individual artists exhibit, publish and sell their JKPP portraits. We've been invited to participate in portrait-themed exhibits and portrait events. Several JKPP group exhibits have been held, in locations from the USA to the UK, including a month-long exhibit in San Francisco culminating in a three-day international meetup to celebrate our 5th Anniversary.

The digital revolution was instrumental in bringing the artists of JKPP together. The advent of the internet enabled us to connect visually with each other over great distances. It has allowed artists from places as disparate as the USA and Iraq, the UK and South Korea, to exchange photos of ourselves for portraiture and to share our work, our ideas, and our advice.

Another part of the digital revolution also impacted JKPP. Art made on phones and tablets, known as mobile digital art, was gaining momentum as the party was starting. I was very interested in this medium from its inception, and was involved with the online community of artists exploring it. Within a month of JKPP starting, the first Apple iPad was released and mobile digital artists were freed from the tiny screens of their phones. The artists who came together at the inception of JKPP used media ranging from painting with brushes to painting with the Brushes app. Everyone was interested in all the different processes, and many artists were influenced by each other. Traditional artists

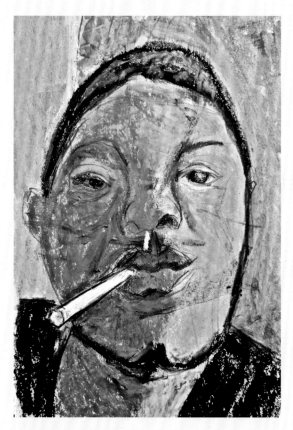

*Lena, Norway* by Charlotte Tanner, USA
water-soluble crayons, pencil, and oil crayons on
construction paper, 14 x 10 inches (356 x 254 mm).

started playing with iPads, and digital artists pulled dusty watercolor sets out of their closets.

I've wondered if it's revolutionary to make a portrait—thousands of portraits—without having to worry about flattering or bestowing prestige on the subject, as artists commissioned to make portraits generally have to do. At JKPP, the members offer up their photos of themselves to be used by other artists to explore their own artistic interests. Although there are guidelines for being respectful, there's no requirement for a resemblance, or a flattering depiction.

On the other side of the equation, historically, you had to be the queen, the pope, the prime minister, or at least a sports star to have so many portraits made of you. But at JKPP, hundreds of people without exceptional fame have had the experience of not just one, two, or three portraits of themselves, but dozens, even hundreds.

In this book, you will find hundreds of portraits by and of artists from all over the world. Our portraits are in a wide range of media, including digital and traditional—and some that fall in neither category. Styles range from colorful to monochrome, realistic to abstract. Themes such as artists at work and play show that a portrait can be more than head and shoulders. The range of interpretations is illustrated with different artists' portraits of the same subject, often from the same photo. Conversely, the development of distinct styles is seen in the Featured Artist pages. I hope you enjoy what you see here, and get inspired to make some portraits yourself. And I hope it leaves you wanting to see more, at http://studiojuliakay.com/jkpp.

JULIA L. KAY

**In just six years, this dedicated group of artists from more than 55 countries has made more than 50,000 portraits of each other.**

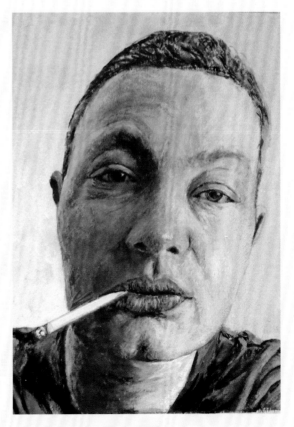

*Lena, Norway* by Gary Tausch, Canada
acrylic paint on cold press watercolor paper, 9 x 6¾ inches
(229 x 171 mm).

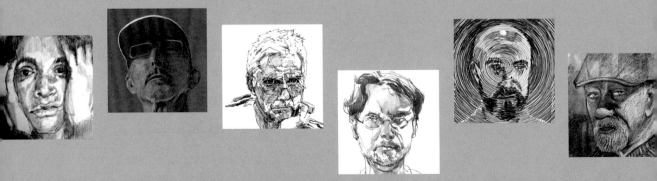

# PORTRAITS BY MEDIA

" Everything I do is out of curiosity, enquiry, and study. I find that juggling different media helps me take a break from one medium, while finding new horizons in others. "

ANAT RONEN, USA

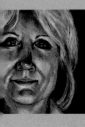
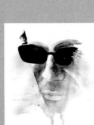
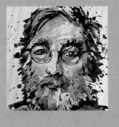
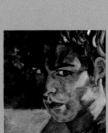

# PENCIL

Pencil is the most basic and widely available of mediums. With just one pencil, you can make an incredible variety of marks by using more or less pressure or by using a sharp or a dull point.

You can further vary the mark by how you hold the pencil: at the top or bottom, loosely or tightly, upright or at different angles.

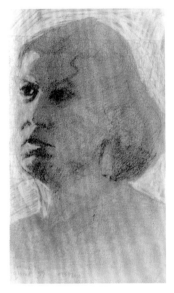

*Bénédicte, Canada*
by Barry Wayne Farmer, USA
pencil in a Moleskine sketchbook,
12¼ × 5 inches (310 × 125 mm).

Drawn in a Moleskine sketchbook with the drawing showing through from the reverse side of the page. I liked the edge of the face in light with shadows over the rest.

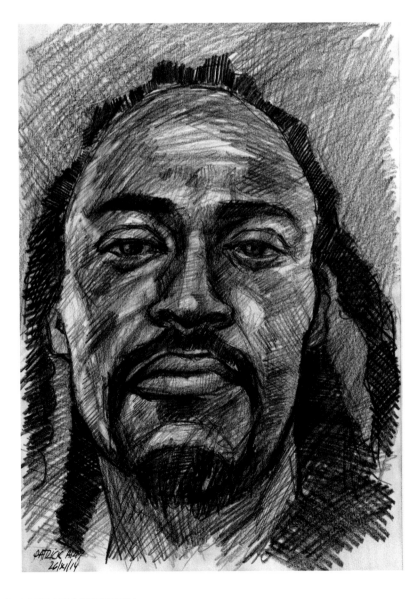

*Patrick C., USA*
by Arturo Espinosa Rosique, Spain
4B pencil on Fabriano paper,
11¾ × 8¼ inches (297 × 210 mm).

*Jutta R., Germany* by André van der Kaaij, Netherlands
Faber-Castell 4B Graphite Aquarelle pencil on Stone
paper, 8¼ × 5¾ inches (210 × 148 mm).

I use Stone paper or traditional paper, whichever is
around. Sometimes I draw on envelopes, in magazines,
or on tickets. Mostly I draw with an Aquarelle pencil
because I don't decide until the end of the process
whether or not I will add water.

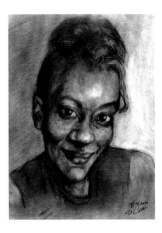

*Leona, Liberia* by Mellanie Collins, USA
graphite on paper, 10 × 8 inches (254 × 203 mm).

I love working with graphite. It's so forgiving. I started
by rubbing my paper with some graphite powder,
laying down a few shapes with a large 2B pencil for
a guide, and then used other soft graphite pencils
(4B and 6B) and a white plastic eraser to make the
actual drawing. I erase and restate a lot, while I work
out all the different tones and highlights I see.

*Olivia A., Switzerland*
by Jutta Richter, Germany
pencil on Hahnemühle Nostalgie
paper, 23½ × 16½ inches
(594 × 420 mm).

A portrait from my series called
*Mind: Full.* It represents psychic
stress, too many thoughts, and
burnout.

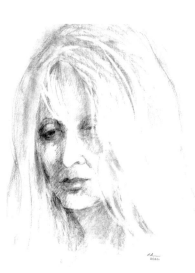

> **❝I find it useful to use a range of pencils—6B/8B for darker areas and HB/2B for lighter areas. This helps to give depth and contrast. Generally, I make sure I'm reasonably satisfied with the proportions and likeness before fully rendering the modeling.❞**

SEAN CRONIN, IRELAND

*Anita, UK* by Ray Gross, USA
pencil and eraser, 6 x 4 inches (152 × 102 mm).

Open and incomplete spaces counterbalance more intense and detailed areas. The light-colored hair offered a great opportunity to erase out part of the drawing and establish the effect of the light on the hair. It also offered a nice counterbalance to the darker and more intense areas—like the eyes.

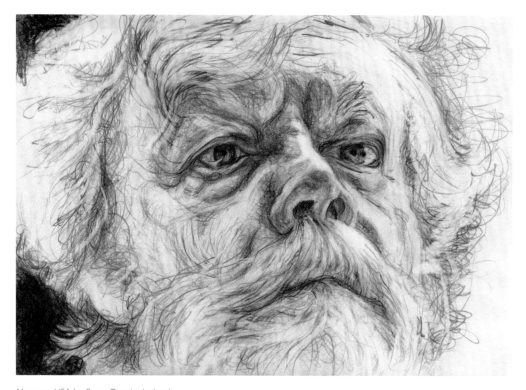

*Norman, USA* by Sean Cronin, Ireland
pencil on paper, 5½ × 7¾ inches (140 × 200 mm).

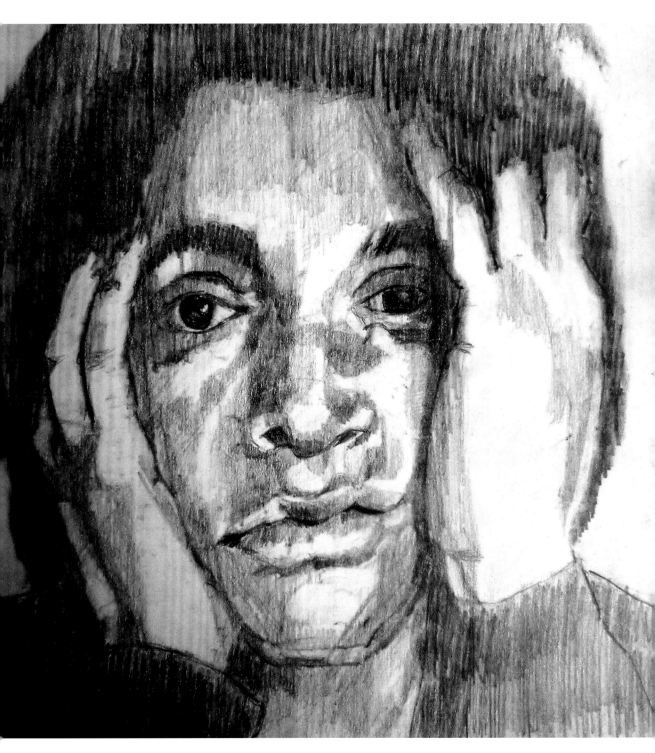

*Marga, UK* by Stella Tooth, UK
pencil on paper, 9¾ x 9¾ inches (250 x 250 mm).

I saw a yearning to connect in my subject's expression and gesture, and I responded
with a portrait executed in a medium where there is no room to hide . . . pencil.

# COLORED PENCIL

Colored pencils are a great medium for building up color in layers and rendering very precise details. Most brands are hard to completely erase, but an electric eraser can help.

**"** I recommend sharpening your pencil frequently during the drawing process. **"**

JAN JAAP BERKHOUT, NETHERLANDS

**OPPOSITE** *Cooper, USA* by Jan Jaap Berkhout, Netherlands colored pencil on colored paper, 11½ × 8¼ inches (295 × 210 mm).
I used Caran d'Ache Pablo pencils and Canson Mi-Teintes paper.

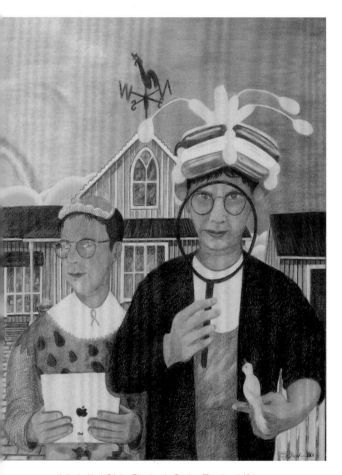

*Julia L. K., USA* by Elizabeth Gruhn-Zearley, USA
Prismacolor colored pencils on Bristol board,
20 × 16 inches (508 × 406 mm).

My take (titled *Julia Kay, American Gothic*) on the classic painting by Grant Wood is a story of the contemporary American landscape.

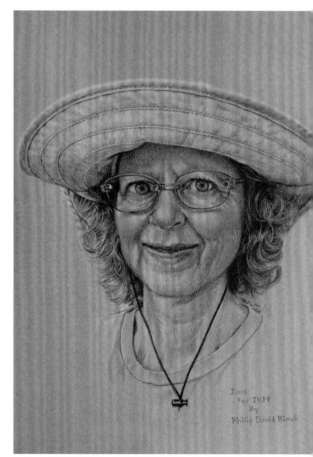

*Jana, USA* by Philip D. Kinzli, USA
colored pencil on tan paper, 12 × 9 inches (305 × 229 mm).

I like using medium-value tan paper to quickly obtain a full range of values and its resulting feel of three dimensions.

# CHARCOAL

Charcoal is a great medium for exploring light and dark shapes in a subject. You can create a large area of tone by using the charcoal on its side, easily bring out highlights with erasers, and create gradations of tones by rubbing the charcoal with tortillons. Although it may be tempting to use your fingers, it is not recommended since oils will transfer from your fingers to the paper and then the charcoal won't adhere to the surface.

*Zaid, Iraq* by Julia Sattout, Australia
Willow and compressed charcoal, white charcoal, and black and white pastel, 14¼ × 11 inches (360 × 280 mm).

I chose the reference photo used for this portrait because of the intensity of Zaid's gaze and because of the multiple light sources.

*Becky, Canada* by Simone Geerligs, Netherlands
charcoal, charcoal pencil, and a bit of white Conté de Paris on paper, 11¾ × 8¼ inches (297 × 210 mm).

I squinted to see the major light and dark planes more clearly.

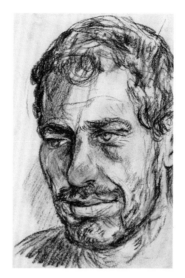

*Lucy, UK* by Steve Huison, UK
compressed charcoal
on paper, 33 × 23½ inches
(841 × 594 mm).

Lucy's eyes first caught my
attention. I felt they deserved
recapturing on a large scale.

*Sven, France*
by Amy Erickson, USA
charcoal, 8 × 5¼ inches
(203 × 133 mm).

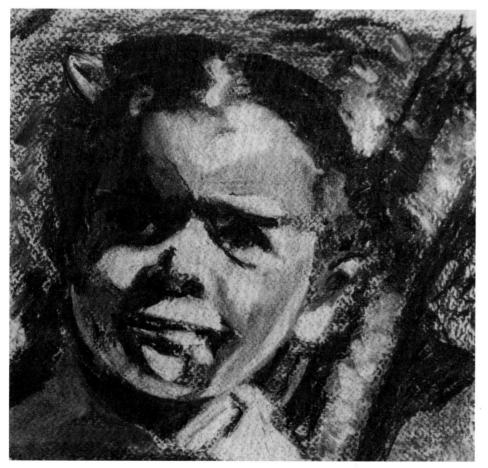

*Gisele, Brazil*
by Lucy Childs, UK
charcoal, 8¾ × 8¾ inches
(220 × 220 mm).

I tend to use charcoal
in preparatory studies for
paintings. It helps model
the form. Therefore
it is helpful to have a
photo that has depth of
shadow and light clearly
contrasted.

# PORTRAITS OF OMAR JARAMILLO

## Germany

"It was a fascinating experience to be drawn by different artists. It was interesting to watch the different approaches to portraiture. It also pushed me to not take myself too seriously about likeness. In many cases I appreciated more the line or the color. Not having the pressure to make a flattering portrait allowed everyone to be free in exploring different techniques and styles."

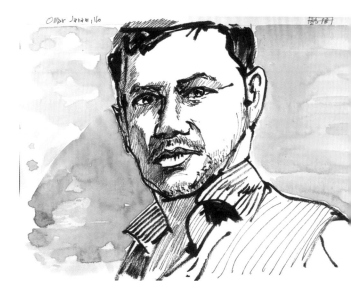

**Tom Pellett,** USA
watercolor and ink, 7½ x 10 inches (190 x 255 mm).
This portrait was quickly drawn with bold marks from an ink brush and some watercolor washes.

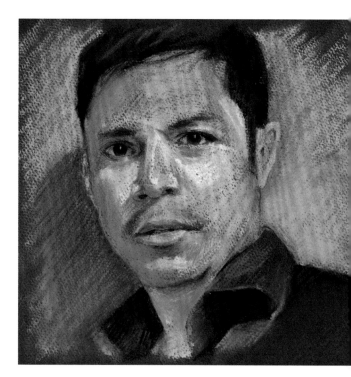

**Linda Vanysacker-Van den Mooter,** Belgium
Derwent pastel pencils on dark green Canson Mi-Teintes paper, 8¼ x 8¾ inches (210 x 220 mm).

**Dan Powell,** USA
Derwent Inktense
water-soluble pencils,
8 × 5½ inches
(203 × 140 mm).

**Nini Teves Lapuz,**
USA
Brushes app on an
iPhone, no fixed
dimensions.

This was made before
iPads and tablets were
available, on the small
screen of an iPhone,
using one of the first
art apps available.

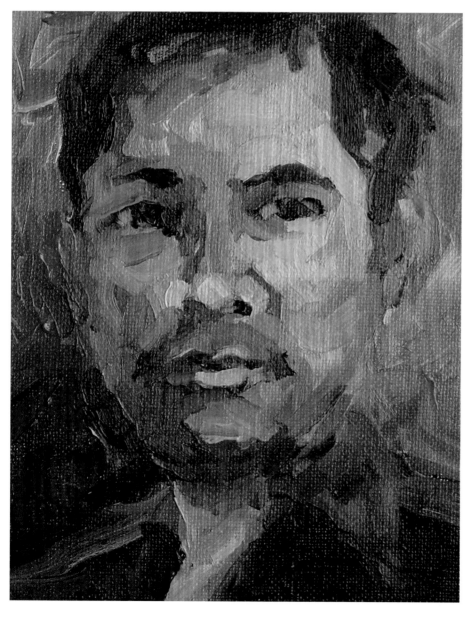

**Jennifer Lawson,** USA
oil paint on panel,
8 × 6 inches
(203 × 152 mm).

I was experimenting
with different media,
perfecting technique
and pushing my creative
process. In oil, the
colors, especially in the
flesh tones, became
the most important
part of the process.

# BALLPOINT PEN

Ballpoint pens use a viscous, oil-based ink and have a small metal ball in the tip of the pen to control the flow. They are widely available, inexpensive, and generally will allow you to draw for longer than with other kinds of pens. You can't erase ballpoint pen, but you can draw darker lines over lighter and create textures and volumes with stippling, cross-hatching, and other kinds of marks.

*Kevin E. L.* by Pieter Verbaarschott, Netherlands
Gel ballpoint pen, 165 × 254mm (6½ × 10in)

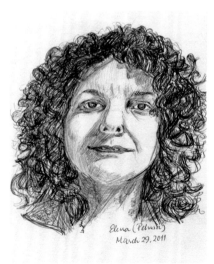

*Elena B., Cuba* by Shalini Raman Parakkat, India
ballpoint pen on paper, 6 × 5 inches
(152 × 127 mm).

A ballpoint pen offers you drama. This simple tool is found nearly everywhere. While drawing hair, the shine, the length—short or long, and the curls, you can just lose track of time. It is meditative.

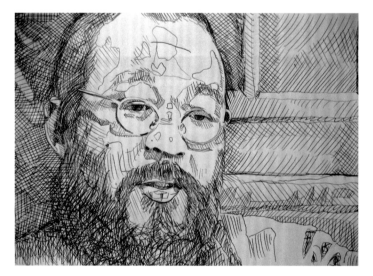

*Kim, South Korea* by Bill Rogers, USA
ballpoint pen on paper, 9 × 12 inches (229 × 305 mm).

Truly look at the subject and background as you work on a portrait. Don't be fooled by reducing it down to what you think you know. Sometimes the presence of light or of some feature will tug at you to be more or less emphasized. The result will be something a little more true than mere realism. It might be something closer to what an actual encounter might feel like. Don't be scared to mess things up. Go for honesty.

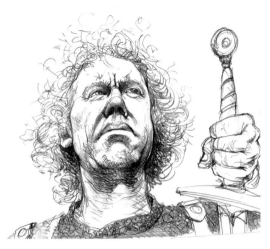

*Steve, UK* by Giorgio Bordin, Italy
ballpoint pen and pencil, 4¾ × 6 inches (120 × 150 mm).

There are times when I see something and I am compelled to draw it in that very moment. Here, I was drawn to the dramatic power of the reference photo, which reminded me of a Pre-Raphaelite rendition of a scene from the Middle Ages.

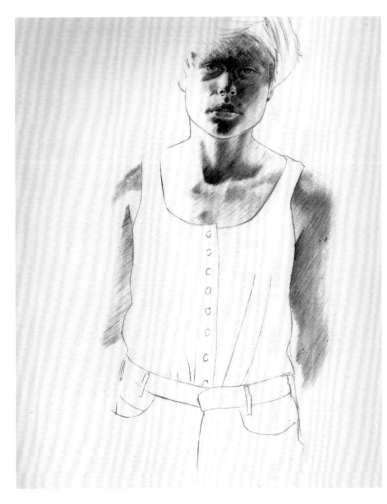

**"Ballpoint is unforgiving. You can't erase, so you have to give close attention to each mark. You can create lights and darks by varying pressure. However, ink builds up on the pen tip and it makes the lines dark when you intended them to be light. Use a tissue to wipe the tip off, and have some spare pens for when the ink runs low. "**

ERIC FRANCIS, USA

*Marta, Netherlands* by Eric Francis, USA
ballpoint pen on paper, 10 × 8 inches
(254 × 203 mm).

The challenge here was to create the illusion of depth.

# INK

Ink comes in fountain, brush, disposable and refillable pens, and in bottles. It can be used to draw with lines or paint with washes. If you use bottled ink, you can get a variety of effects depending on how much you thin the ink with water and what you dip in the ink to draw with.

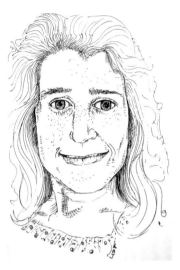

*Jen, USA* by Rajesh V. U., India
Sakura Pigma Micron .01 pen on paper,
9 × 7 inches (229 × 178 mm).

For me, the lines should be free-flowing. I'm not very interested in the approach of first making a rough pencil sketch and then inking over it in pen.

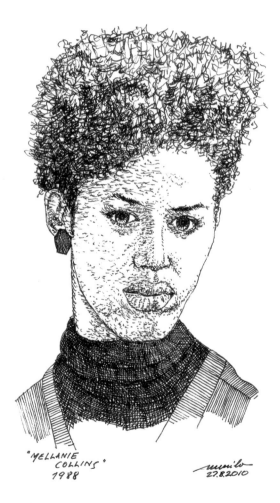

*Mellanie, USA* by Murilo Sergio Romeiro, Brazil
Staedtler 0.8 mm pen on bond paper,
11¾ × 8¼ inches (297 × 210 mm).

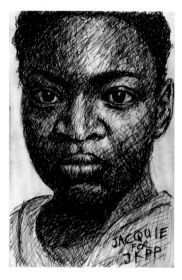

*Jacquie, USA* by Gary Tausch, Canada
sepia and black ink in a Moleskine
sketchbook, 7¾ × 5 inches (197 × 127 mm).

I enjoy layering two ink colors together with a loose cross-hatching technique. It results in some interesting color effects.

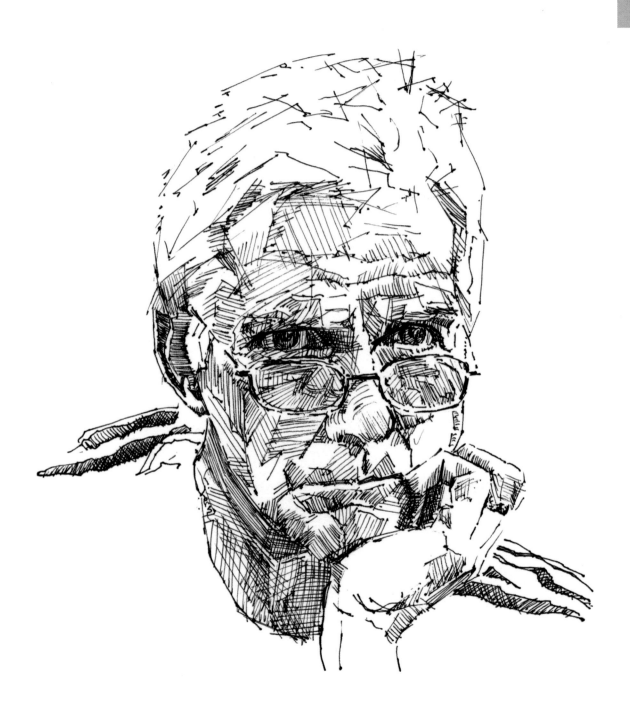

*Sean, Ireland* by Steve Huison, UK
pen and ink on paper, 8 x 8 inches (203 x 203 mm).

I was attracted to Sean's face as it seemed to contain a map of sorts, with elements
of a rock-face; hence, the solid structure I've hopefully encapsulated in this piece.

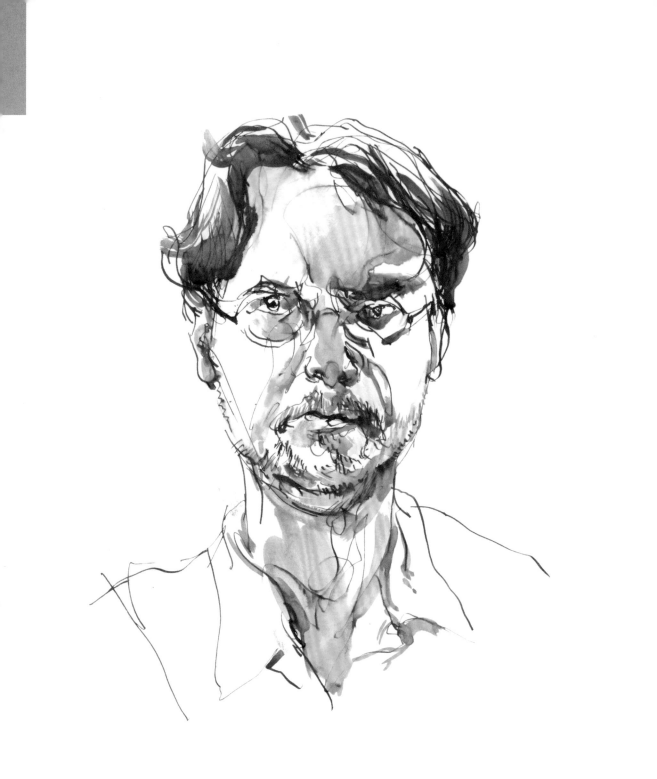

*Jarrett, USA* by Marc Taro Holmes, Canada
water-soluble ink and watercolor on plate finish bristol, 9 x 7 inches (229 x 178 mm).

When combined with watercolor (or just clear water) "washable," non-waterproof inks
will often bleed in wonderful ways, particularly when you use a smooth paper stock.

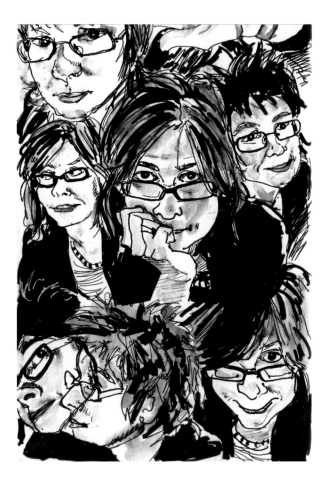

*Sue, UK* by Nicolas Brossais, France
ink pen and watercolor, 8¼ × 5¾ inches (210 × 145 mm).

I chose the accumulation and superimposition of portraits to express the energy I perceived in Sue. I like to balance the precision and detail of ink pen with the loose spontaneity of watercolor.

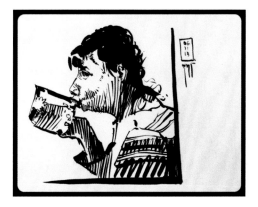

*Oksana, USA* by Uma Kelkar, USA
permanent ink in a brush pen, 4 × 6 inches
(102 × 152 mm).

Oksana's photograph of "stealing a sippa from a cuppa" resonated because I too was stealing a break for sketching while my son was sleeping. These unplanned opportunities are gifts.

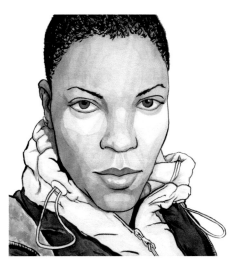

*Kimberly* by Tim Clary, USA
ink and wash on illustration board,
6 × 6 inches (152 × 152 mm).

I had a lot of fun with the details in the clothing in this one. Also I think I began to get a better hold of laying down multiple washes to get some subtle variations in tone. With ink washes, patience is key.

**LEFT** *Hannah, USA* by Timothy Schorre, USA
brush and ink on paper, 5 × 8¼ inches (127 × 210 mm).

Made with a Chinese brush on one leaf of a watercolor Moleskine sketchbook, emphasizing black and white contrast and handling the brush to produce an economical presentation of gesture and light.

# MARKERS

Markers come in a great variety of colors and tip types, so they are a great medium for drawing with color. By layering transparent markers on top of each other you can also experiment with color mixing. However, most markers will fade when exposed to daylight, so this is not the best media for works that will be on display.

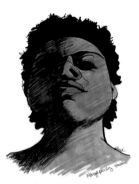

*Marga, UK*
by Tammy Valley, USA
markers, (primarily Sharpie),
11½ × 8¼ inches
(292 × 210 mm).

I used several different brands and sizes of markers in this portrait to add dimension and to capture the intensity of the subject.

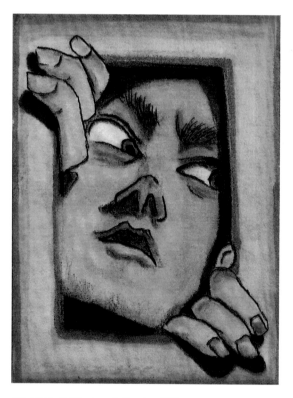

*"Mr. Flibble,"* UK by Jacquie Ramirez, USA
Prismacolor markers, Prismacolor pencils, and ink,
3½ × 2½ inches (89 × 64 mm).

This portrait is an Artist's Trading Card (ATC). I thought it would be funny to create an ATC with the subject trying to break free of a collector's book of ATCs.

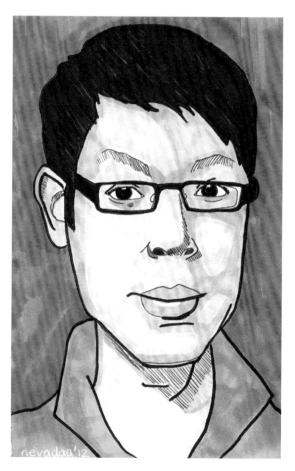

*Darren, Taiwan* by Nevada Gutierrez, USA
Copic markers in a Strathmore Visual Journal,
8 × 5½ inches (203 × 140 mm).

Here I experimented with using markers and line to create shadows. Although using the pink around the eyes seemed counterintuitive, I trusted my eyes and ignored my inner critic.

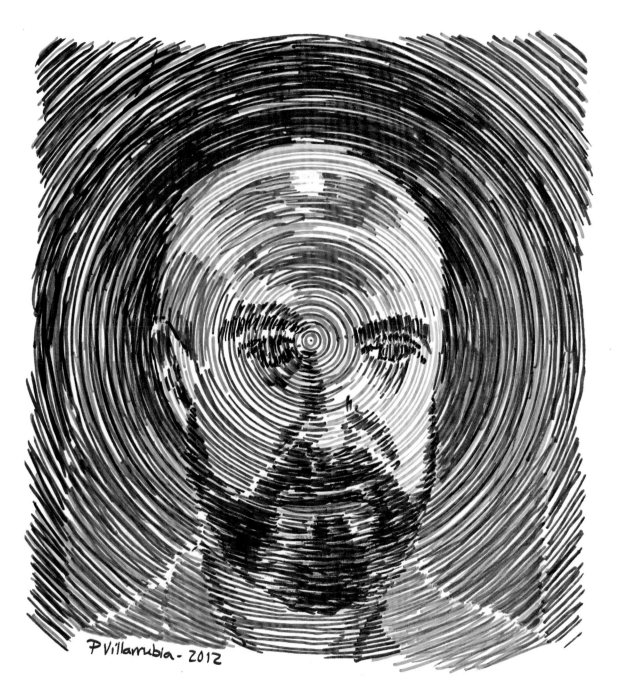

*Luis R. V. G. T., Spain* by Pedro Villarrubia, Spain
colored markers on paper, 14½ × 12¾ inches (366 × 326 mm).

I took the circle as a motif. Using a point between the eyes as the center, I created this portrait with a compass and colored markers.

# PORTRAITS OF JACQUIE RAMIREZ

## USA

"I have enjoyed seeing all of the pictures depicting me. You can see the many aspects of yourself through other people's eyes and thoughts. I wasn't expecting that."

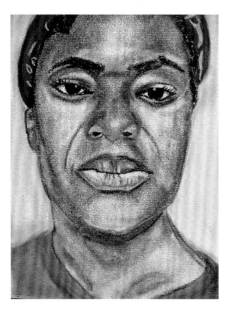

Kim Drake Schuster, USA
charcoal and soft pastels on paper,
10 × 8 inches (254 × 203 mm).

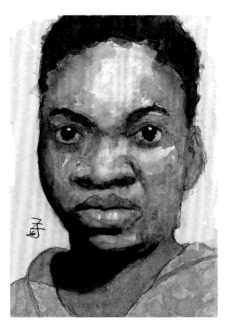

José Zalabardo, UK
watercolor, 9½ × 6¾ inches (240 × 170 mm).

Watercolor is a one-chance thing, like life. Sooner or later you reach a point where any changes will make it worse. At that point, you need to stop and live with any imperfections.

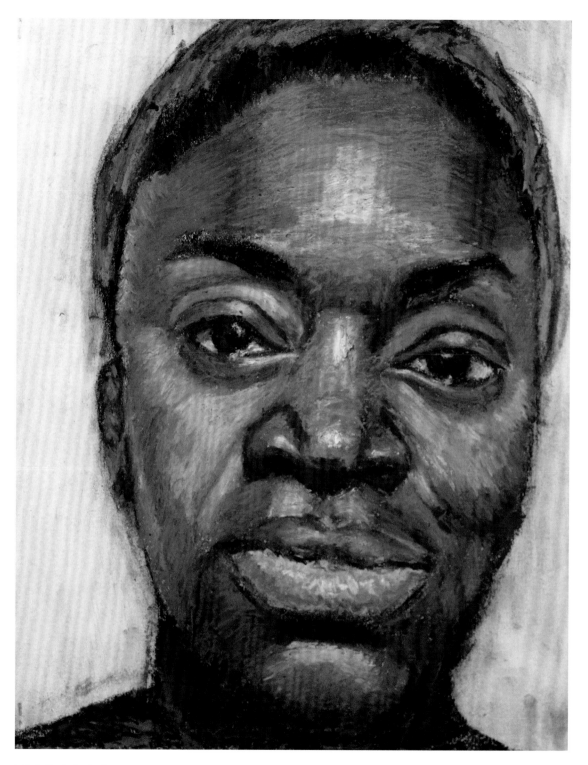

**Julia Sattout,** Australia
charcoal (under-drawing), acrylic wash, and oil pastels,
14¼ × 11 inches (360 × 280 mm).

# DIGITAL DRAWING

Digital drawing tools are now widely available as most smartphones, tablets, and computers have at least one drawing app or program. They are ideal for drawing in museums where traditional materials are often prohibited. When working with touch-sensitive devices such as phones and tablets, you can use your finger, or a variety of styluses, some of which are pressure-sensitive.

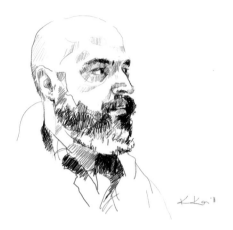

*Luis R. V. G. T., Spain* by Kate Kos, Ireland
Corel Painter Sketch Pad on a PC using a Wacom tablet, no fixed dimensions.

Using a graphics tablet, I can imitate traditional drawing as closely as possible. I love working digitally because I don't have to scan the work afterward in order to share it online.

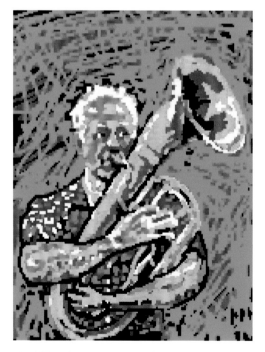

*Mitt, USA* by Søren Raagaard, Denmark
Freedraw app on a 2004 Motorola A925 phone, no fixed dimensions.

Our future will always be built with older technologies. To me the quality of this app lies in its antique limitations: ten colors only, 154 x 204 pixels.

*Patricio, Chile* by Helene Goldberg, USA
Brushes and NPtR apps on an iPhone, no fixed dimensions.

I begin paintings with a vague idea of my subject, but I am happy to follow the lead of the painting itself. Here I was more concerned with capturing an idea I had of Patricio than trying to create a realistic image.

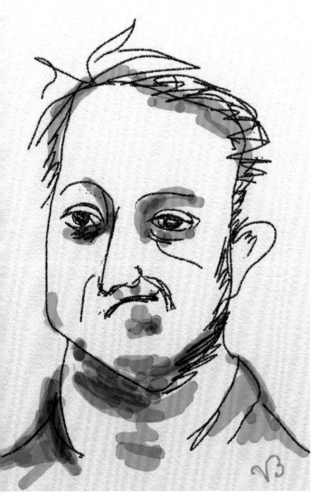

*"Mr. Flibble," UK* by Valerie Beeby, UK
ArtRage app on an iPad, no fixed dimensions.

I had arrived late for a JKPP meetup, and only had moments
to capture the essence of the current sitter. Quick sketches
are often the most interesting. You must quickly identify and
emphasize the features of this face that differ from the average.
There's no time to dilute the impact with inessential details.

*Cooper, USA* by Tom Lambie, Australia
Brushes app on an iPhone, no fixed dimensions.

This was one of the first things I drew on a
smartphone. I was really surprised at the soft
features you can create from harsh textures.

# CRAYON

Crayons can take us back to the pleasure we had in creating as children. Some children's crayons are hard to work with because they are pale and waxy. However, new brands have been developed for artists that don't have these problems and are very responsive to different mark-making techniques.

**" Neocolor II wax crayons offer a wide range of colors and can be used wet or dry. You cannot erase without leaving a trace of the correction. "**

RODNEY VAN DEN BEEMD, NETHERLANDS

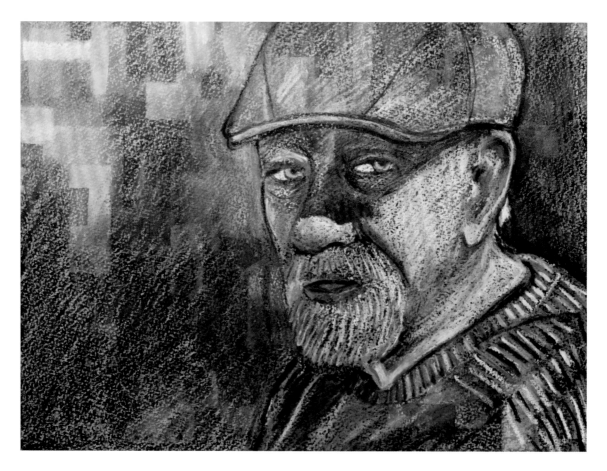

*Kline, USA* by Cecca Whetnall, UK
Neocolor crayons over watercolor on paper, 18 × 24 inches (457 × 610 mm).
I was experimenting with Neocolor crayons which I worked over an existing abstract watercolor painting.

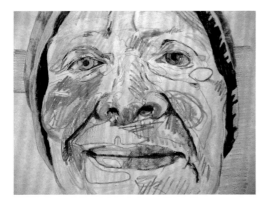

*Charlotte, USA* by Bill Rogers, USA
crayon on paper, 9 × 12 inches (229 × 305 mm).

Really look at the subject. Do not fear beauty. Be bold—rules of color be damned! Honesty above all.

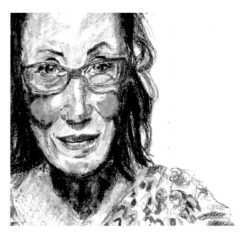

*Frannie, USA* by Anna Morales Puigcerver, Spain
Neocolor crayons on paper, 7¾ × 8¼ inches
(200 × 212 mm).

I was drawn to her smile and her sparkly blue eyes. I cropped the photo to focus on these elements and changed the color of the frames of her glasses to make the painting more lively and colorful.

*Stuart, UK* by Rodney van den Beemd, Netherlands
Neocolor II crayons on grained paper, 8¼ × 8¼ inches
(210 × 210 mm).

I often use Neocolor II crayons for dry application only, as here. I usually start with drawing the eyes as that is often what draws one in to a portrait. From then on, the use and application becomes more expressive. I choose colors according to my mood as well as to fit the temperament of the portrayed.

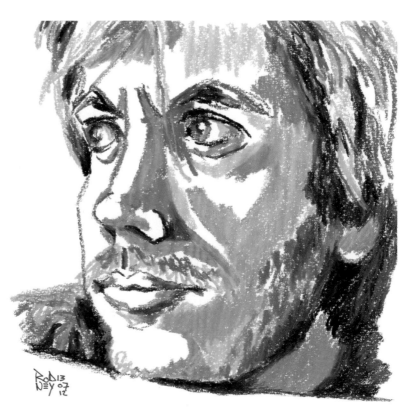

# CHALK PASTEL

Chalk pastel is a traditional medium that has been used since the Renaissance. You can layer colors on top of each other or blend them together. Care must be taken to preserve pastel drawings once complete: you can use fixative spray, separator sheets between pages of a sketch pad, or frame the portrait with a thick mat that will hold the glass away from the artwork.

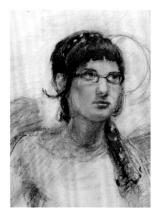

*Acey, USA* by Amy Erickson, USA
pastel, 12 × 10 inches
(305 × 254 mm).

This portrait was important to me because I was coming out of a slump of not having drawn for quite some time. Finding the Portrait Party and making this drawing inspired me and made me feel like an artist again.

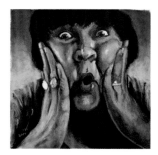

*Elizabeth L., USA* by Irit Levy, Monaco
pastel on paper, 15¾ × 15¾ inches
(400 × 400 mm).

This reference photo was so dramatic and funny that I just had to draw it. My challenge here was to get the details right.

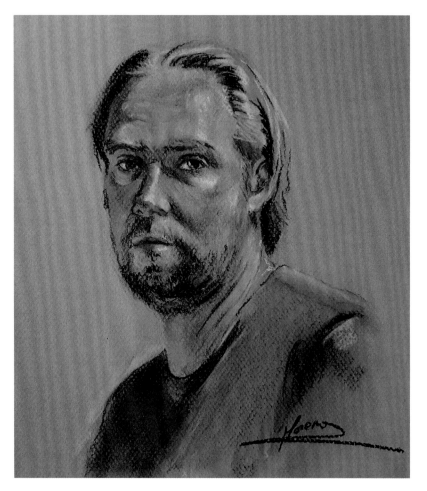

*Søren, Denmark* by Carmen G. Moreno, Spain
dry pastel on the rough side of Canson Mi-Teintes paper,
11¾ × 10¼ inches (300 × 260 mm).

**OPPOSITE** *Sven, France*
by Valérie Mafrica, France
soft pastel on sandpaper,
11¾ × 9½ inches (300 × 240 mm).

The skin tone and the deep blue gaze were the double challenge of this portrait.

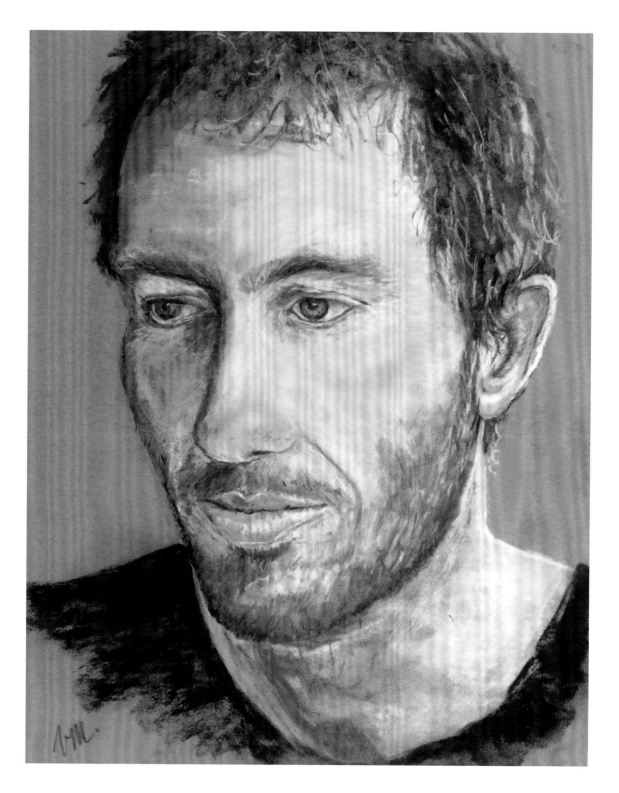

# OIL PASTEL

Oil pastels are great for laying down large areas of rich color. You can blend them in a variety of ways, including using your fingers, a tortillon, cloth, or solvents. If you use solvents, you need to choose a surface for your work that they won't bleed through.

*Susanne, UK*
by Elizabeth Wilson, USA
oil pastel on paper,
25 × 19 inches (635 × 483 mm).

I try to capture the vitality and personality of the subject through a hyperbolic color palette combined with a loosely realistic form. Here, I started with quick sketching on a mid-toned background and then built up layers of color to achieve a saturated, expressionistic effect.

*Jörg, Germany* by Diane Marie Kramer, USA
oil pastel on paper, 20 × 16 inches (508 × 406 mm).

My favorite of all the pastels are the French ones. They are buttery and remind me of painting and drawing with my mom's and grandma's lipsticks when I was a child. Ah, the joy on their faces when they walked into the room . . . and saw me painting on the walls . . . lipstick in hand.

*Barbara L. P., Belgium*
by Elena Vataga, UK
oil pastel, 13 × 9½ inches
(330 × 241 mm).

Instead of using the colors in the skin tone color sets, I decided to try a "wild palette" combined with using cold colors for darker areas and warm tones for lighter ones. I found this liberating, and it allowed me to express an emotional connection with the subject's personality using color.

*Dan D., USA* by Martin Beek, UK
oil pastel on Canson pastel paper,
28 × 20 inches (711 × 508 mm).

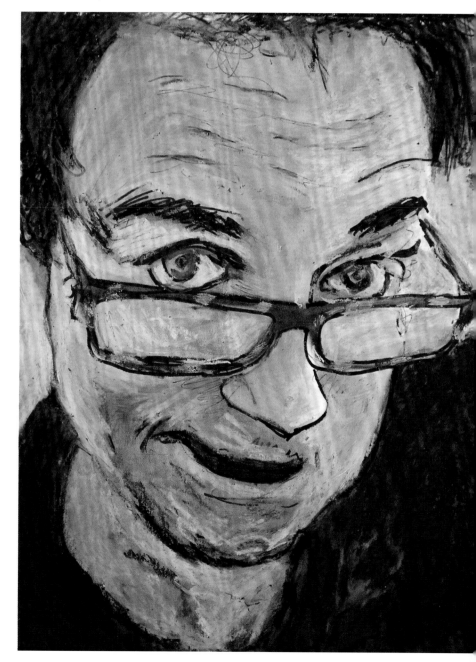

# PORTRAITS OF RAJESH KUMAR JOHN

## India

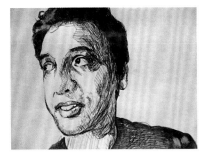

Bill Rogers, USA
ballpoint pen and marker on paper,
9 × 12 inches (229 × 305 mm).

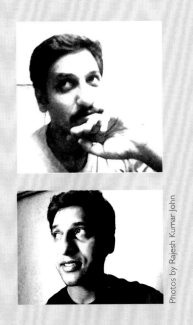

Photos by Rajesh Kumar John

"The variety of the portraits always surprises me. What I thought was the main feature of the reference photo was not necessarily what the artists saw, and that's interesting. In one case, I chose to post photos because they had good light and contrast. However, the others saw what I did not see: that my hair was blue in these photos. I only noticed it after several artists had colored it that way in their portraits. It is amazing how we choose to observe certain things and ignore the rest, even when they are prominent!"

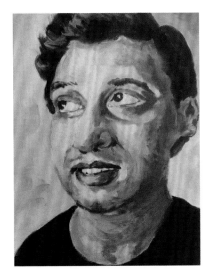

Jane Sherwood, UK
acrylic paint on canvas,
15¾ × 11¾ inches
(400 × 300 mm).

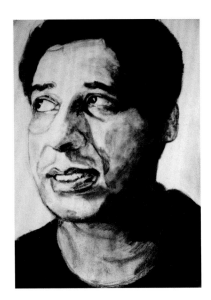

Kim Drake Schuster,
USA
graphite, 10 × 8 inches
(254 × 203 mm).

**Linda Jackman,** USA
markers on paper,
7 x 5½ inches (178 x 140 mm).

I drew the head in faint pencil
to get the positioning right,
then finished using markers.
I often use "almost dried-up"
markers for skin tones and
other shading because the
colors come out lighter,
and you can use additional
strokes to gradually build
up the intensity.

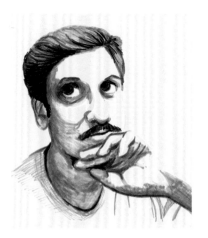

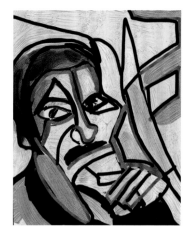

**ABOVE John Holliday,** UK
ArtRage app on an iPad,
no fixed dimensions.

I work very spontaneously. I
can be sitting and watching
TV, and in the middle of
the program I decide to
draw or paint or play guitar.
I sometimes get carried
away . . . not sure where I go,
but it does result in some
wild portraits, which I don't
always share.

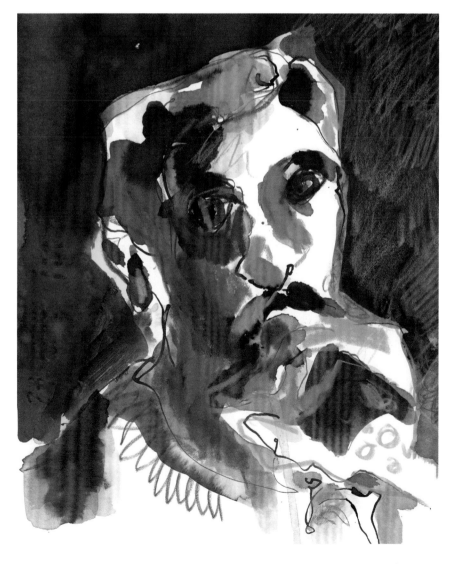

**Ira Prussat,** Germany
ink and Neocolor II on
paper, 10¾ x 8¼ inches
(270 x 210 mm).

# WATER-SOLUBLE PENCILS AND CRAYONS

Water-soluble pencils and crayons can bridge the gap between drawing and painting. The color and effect change enormously between wet and dry marks. There are a variety of ways to use them, such as drawing and then applying water with a brush, wetting the tips before drawing, and applying water to the page either carefully or in spatters before drawing.

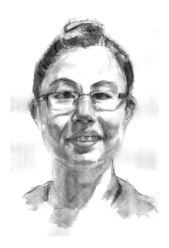

*Becky, Canada* by Dan Powell, USA
water-soluble graphite pencil,
12 × 9 inches (305 × 229 mm).

Water-soluble graphite can be less forgiving than watercolor. Heavily-sized paper seems to give the best results.

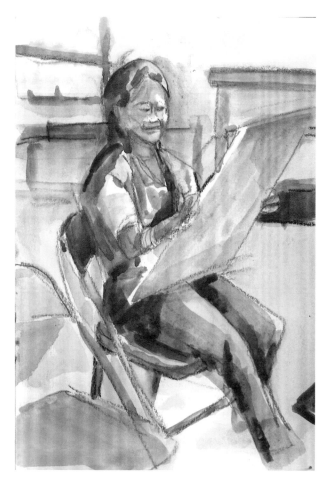

*Nini, USA* by Tom Pellett, USA
Derwent Inktense blocks, 8 × 6 inches (203 × 152 mm).

I drew with the edges of the Derwent blocks and added water to make washes.

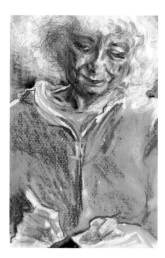

*Barbara J. W., USA*
by Sean Cronin, Ireland
Neocolor II on watercolor paper,
8¼ × 5½ inches (210 × 140 mm).

Neocolor II, to my mind, is more forgiving than traditional watercolor. I tried to convey the light from behind Barbara's hair with lightly colored areas without distinct edges. I included her hands to balance the composition and provide a secondary focal point.

**RIGHT** *Jerry, Canada*
by Omar Jaramillo, Germany
water-soluble crayons on paper,
11½ × 16½ inches (290 × 420 mm).

For this portrait, I drew the face
with water-soluble crayons and
sprayed with water . . . and that
created the dreamy effect. I added
some shadows with the brush
and painted the glasses.

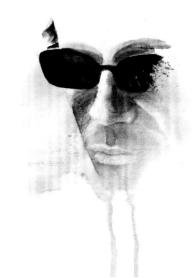

**BELOW** *Jill, UK* by Sally Sheen, UK
Neocolor II and ink on
watercolor paper,
9 × 12 inches (229 × 305 mm).

I was curious about the thoughts
behind her gaze. I couldn't resist
this opportunity to explore both
color and texture.

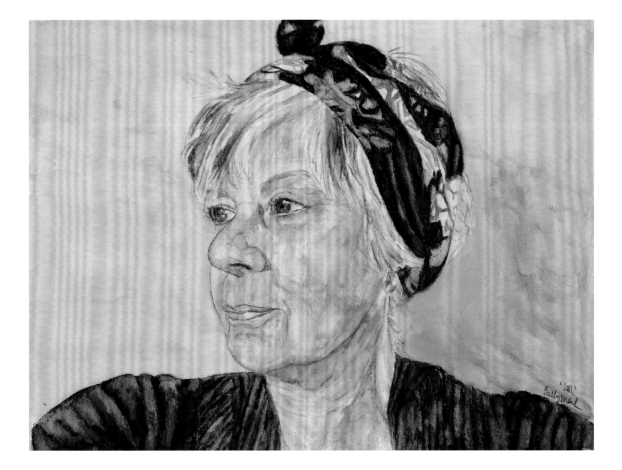

# WATERCOLOR

Watercolor is the easiest kind of paint to travel with, as the paint itself takes very little space and clean-up is easy. It can be fun to work with the unpredictable way that wet paint moves on wet paper. Alternatively, you can have more control with dry-brush techniques. Watercolor encourages you to commit to your brushstrokes, since they cannot be covered over as the paint is transparent.

> **" Watercolor offers a great opportunity to draw and paint quickly. You have the freedom to be loose with your paint strokes and color choices. "**
>
> JENNIFER LAWSON, USA

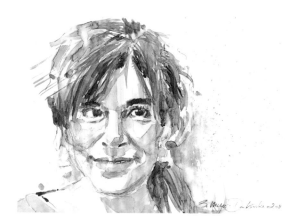

*Jena, USA* by Beata Wielgos-Dunikowska, Poland pencil and watercolor, 4 × 5¾ inches (101 × 144 mm).

Visible pencil marks and bold spots of watercolor in juicy colors, started my artistic language on a new path.

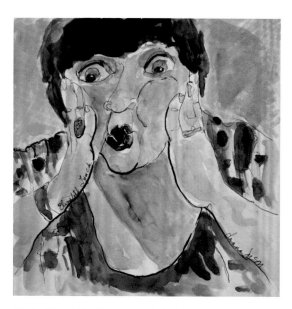

*Elizabeth L., USA* by Donna Campbell McMenamin, USA ink and watercolor, 8 × 8 inches (203 × 203 mm).

The reference photo inspired me to pick up my pen— drawing quickly, just looking to capture her essence. Watercolor was then applied spontaneously.

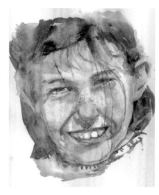

**LEFT** *Zoraida, Spain* by Isabelle Gaillardon, France Watercolor on Montval paper, 9¾ × 8¼ inches (250 × 210 mm).

I made a quick sketch and then played with the colors.

**OPPOSITE** *Tim W., USA* by Jennifer Lawson, USA watercolor, 10 × 7 inches (254 × 178 mm).

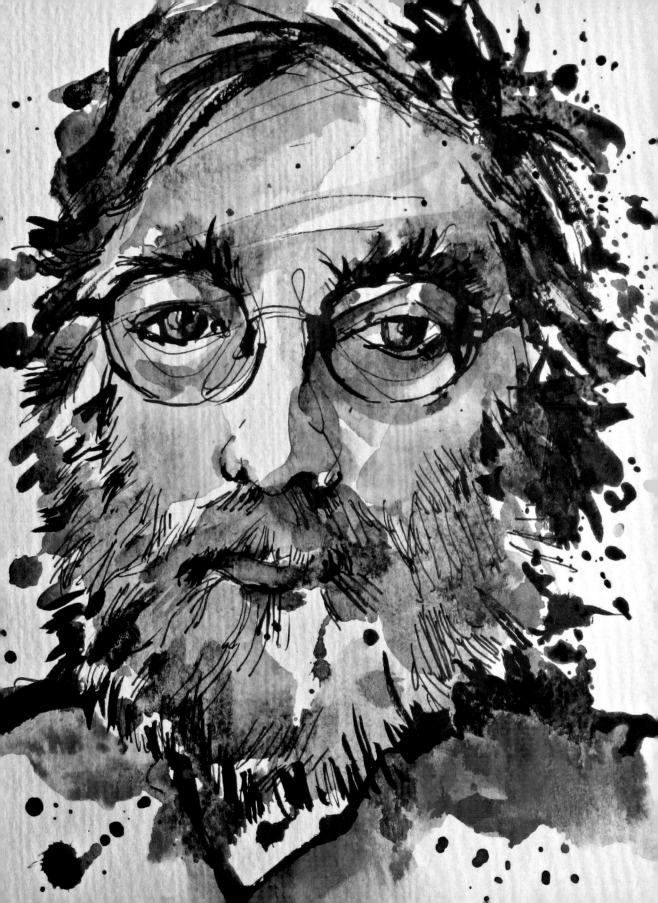

> **"To make a 'good' watercolor and experiment with this medium, it's important to have a good brush which can carry a lot of paint and to use good watercolor paper."**
>
> BARBARA LUEL PECHEUR, BELGIUM

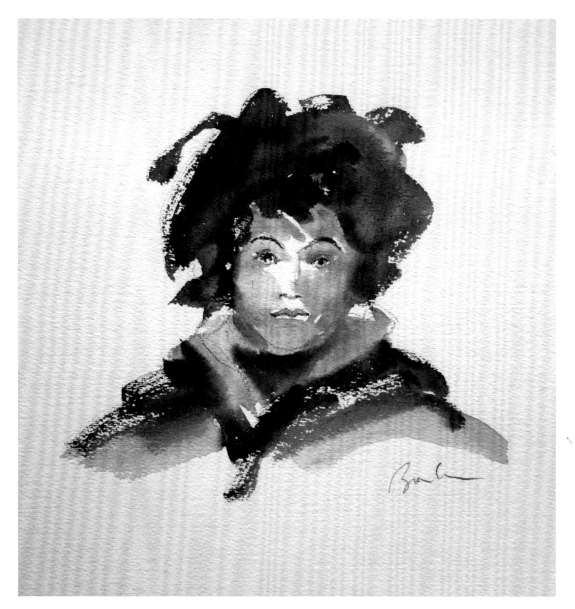

*Mia, USA* by Barbara Luel Pecheur, Belgium
watercolor and pencil on paper, 11¼ × 8¼ inches (283 × 210 mm).

After a quick pencil sketch, I made rapid brushstrokes on dry paper. It was important to have dry brushstrokes with sharp edges and the paper showing through to give energy to the portrait.

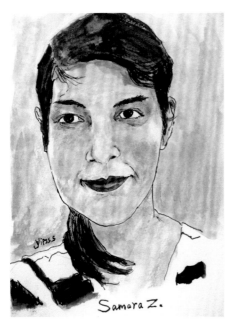

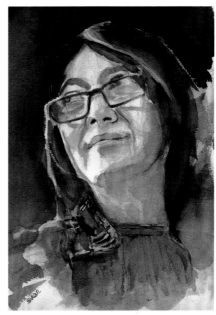

**LEFT** *Samar, Iraq*
by Yip Suen-Fat, Hong Kong
ink and watercolor,
7 × 5 inches (175 × 125 mm).

I used layering techniques
to paint the skin tones in
this portrait.

**RIGHT** *Hwasook, South Korea*
by Sven Jordy, France
watercolor on paper,
11¾ × 8¼ inches
(297 × 210 mm).

Never be afraid to use
very dark colors to create
a dramatic portrait. But go
slowly or you might lose all
the brightness of watercolor.

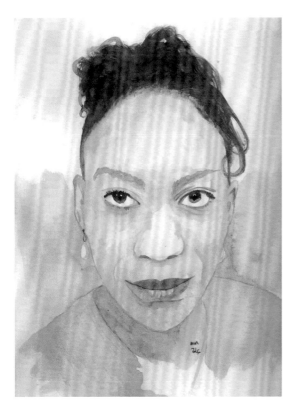

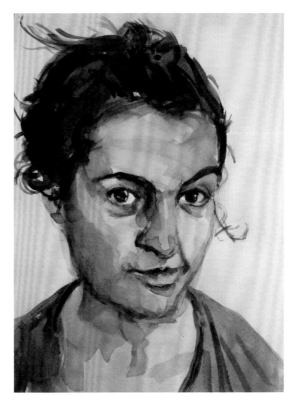

*Leona, Liberia* by Mick Mulviel, UK
Winsor & Newton Cotman watercolor paint on
watercolor paper, 12 × 9 inches (305 × 229 mm).

*Olivia M., France* by Pedro Martin, Spain
watercolor on paper, 11½ × 7¾ inches (290 × 200 mm).

# PORTRAITS OF ANGEL ZHANG

## China

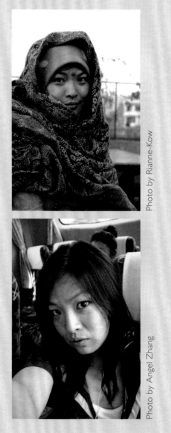

Photo by Rianne-Kow

Photo by Angel Zhang

"I normally enjoy painting others more than being painted. There are always some styles that are very interesting to see. However, I do feel most people paint all Asian faces in a similar way. Sometimes, I thought portraits uploaded to the group were for me, but they were actually of a different Asian woman."

**Jane Angell,** UK
colored pencil on cartridge paper,
11½ x 8½ inches (292 x 216 mm).

I drew this portrait as part of a year-long commitment to drawing every day. I was experimenting with colored pencils in a very simple way. Since I am particularly drawn to eyes, the light and apparent serenity in the original photograph were especially appealing.

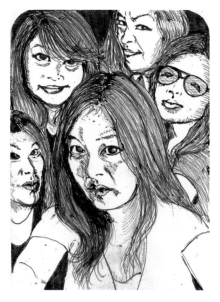

**Rajesh Kumar John,** India
ballpoint pen on cardboard,
6½ x 4½ inches (168 x 112 mm).

I wanted to make a "groupie" out of her selfies—because it is impossible to take a selfie of a group of yourself!

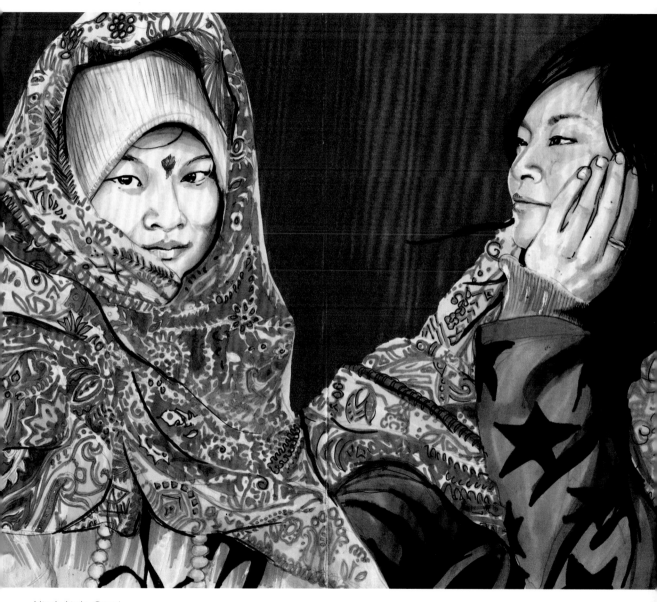

**Nicole Little,** Canada
marker and ink on paper, 5½ x 7 inches (140 x 178 mm).

Direction of brushstroke is important with markers. Here, I used vertical lines to color in the background and an additional border line around the figures to enhance sharp edges, especially against light colors. I brought poses from two of Angel's reference photos together to create a contemplative relationship dynamic.

# GOUACHE

Gouache is similar to watercolor but opaque, which means you can cover areas you want to adjust. Gouache changes value when it dries so it can be hard to match colors.

*Joan, USA* by Klaas Van der Auwera, Belgium gouache, 7¾ x 6¾ inches (200 x 170 mm).

I used a limited palette: yellow ocher, cadmium red, white and ivory black, aka the Zorn Palette (after painter Anders Zorn).

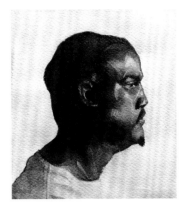

*Devon, USA* by Rafael Comino Matas, Spain
gouache, watercolor, and black and white Conté pencils
on gray Canson paper, 5½ × 5 inches (140 × 125 mm).

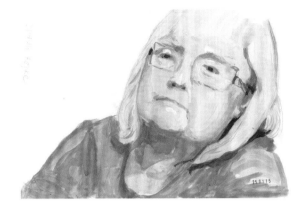

*Judith, USA* by Nadya Fartushnaya, Russia
gouache, 8¼ × 11¾ inches (210 × 300 mm).

Every portrait is an experiment. I like gouache because it dries
fast, doesn't smell, and it offers many rich colors.

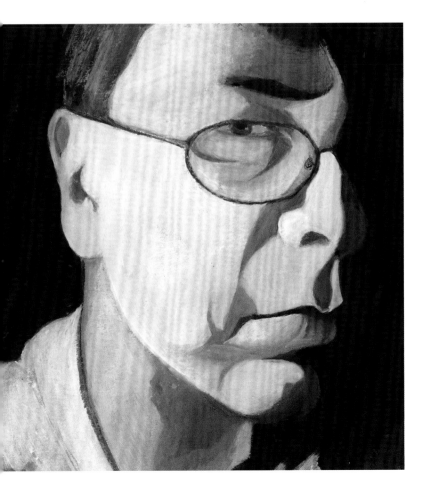

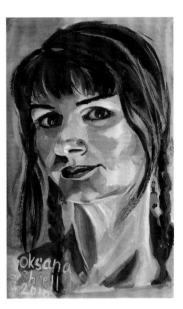

**ABOVE** *Serena, Australia*
by Oksana Shiell, USA
gouache in a sketchbook,
7 × 5 inches (178 × 127 mm).

**LEFT** *Manuel, Spain* by Jill Harding, UK
gouache, 4¾ × 4¼ inches (120 × 110 mm).

I think gouache is a difficult medium. I
use it thickly and work fast. I then let
it dry, paint over it, and continue to
refine the detail.

# ACRYLIC PAINT

Acrylic paint is a flexible medium. You can thin it down for a watercolor-like effect or build it up more thickly for effects almost like oils. It dries quickly and is easy to paint over. There are many different mediums and products available to enhance or change its properties.

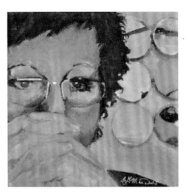

*Janice, UK* by Elizabeth Gaye MacDonald, Canada acrylic paint on stretched canvas, 6 × 6¾ inches (152 × 171 mm).

In portraiture I look for intriguing light, mood, and mystery. Janice's photo gave me all that and more.

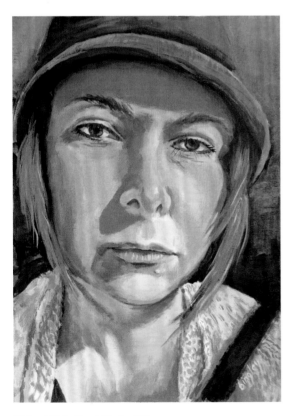

*Melisa, USA* by Frank Bingley, UK acrylic paint, 11¾ × 8¼ inches (300 × 210 mm).

This was quite a complicated portrait to do, as there was a strong diagonal light across Melisa's face causing deep shadows across her face and neck. This was coupled with an up-light under her chin from exactly the opposite direction.

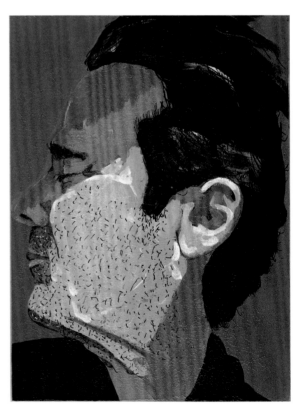

*Jerry, Canada* by Herman Schouwenburg, Netherlands ink and acrylic paint on wood, 7¾ × 6 inches (200 × 150 mm).

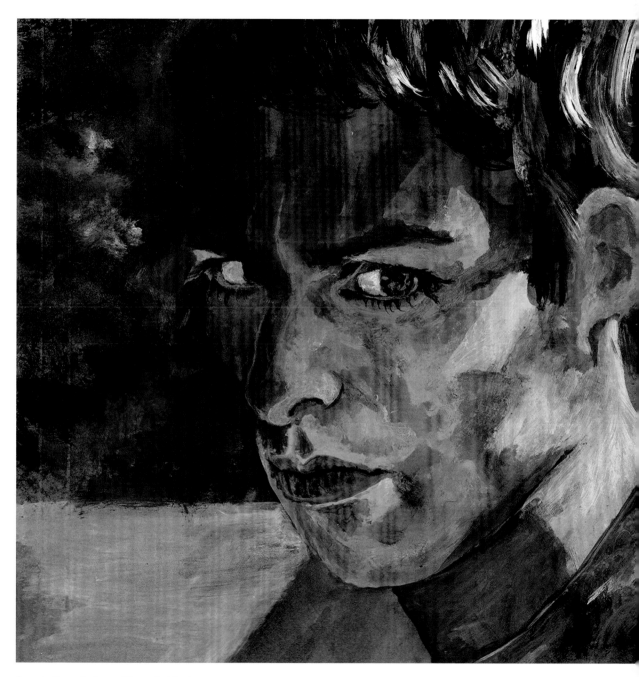

*François, France* by Leona Ellsworth, Liberia
acrylic paint, 8 × 8 inches (203 × 203 mm).

Acrylic is a great medium to use if you want vibrant colors and don't
have the patience to build through layers. Acrylic's best feature is
its ability to dry fast.

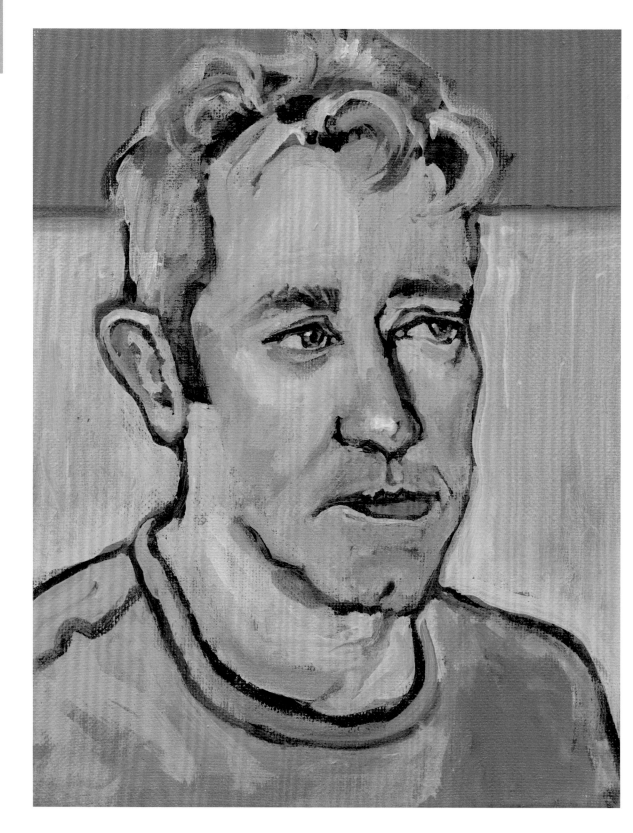

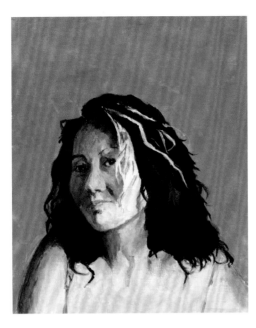

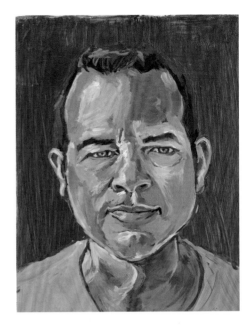

*Kim L. T. D., France* by Richard Long, UK
acrylic paint on paper, 9 × 7 inches (229 × 178 mm).

I had painted Kim before, but I wanted to try something looser and less pre-planned.

*Quentin, USA* by Janet Burns, USA
acrylic paint on Yupo, 11 × 8½ inches (279 × 216 mm).

I decided to experiment with Yupo after seeing other artists work on it. It has a nonporous finish, almost like painting on glass or plastic. You need to get used to this but the advantage is there is time to rework or even wipe mistakes off completely.

> **Acrylic is a very forgiving and versatile medium. If you make a mistake, just leave it for a short while to dry, then paint over it. This makes it easy to let a painting evolve.**
>
> RICHARD LONG, UK

**OPPOSITE** *Pedro, Spain* by Amy Lehr Miller, USA
acrylic paint on canvas, 10 × 8 inches (254 × 203 mm).

I wasn't trying so much to get a likeness as to have fun with the colors, shapes, and planes of the subject.

**RIGHT** *Martin, UK* by Jutta Richter, Germany
acrylic paint on canvas panel, 5½ × 6 inches
(140 × 150 mm).

I primed the panel with gesso before underpainting in blue tones. I worked from dark to bright tones. It is important to get the eyes the right size: not too big but still with room for light and shadows in them.

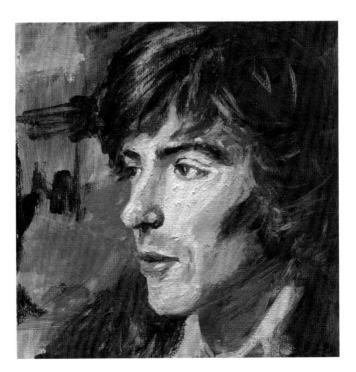

# PORTRAITS OF PATRICIO VILLARROEL BÓRQUEZ

## Chile

"I very much like to see how other artists who I respect see me. Each one of these portraits has been a source of joy to me."

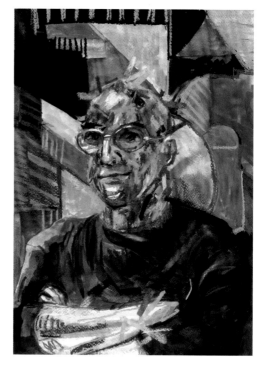

Samar Alzaidy, Iraq
poster paint and pastel on watercolor paper,
15 × 11 inches (381 × 279 mm).

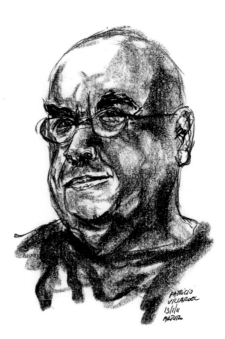

Arturo Espinosa Rosique, Spain
charcoal on paper, 11¾ × 8¼ inches
(297 × 210 mm).

**Julia L. Kay**, USA
water-soluble pencils, water-soluble crayons, and water on smooth Bristol paper, 24 × 18 inches (610 × 457 mm).

This was drawn with the left and right hands simultaneously.

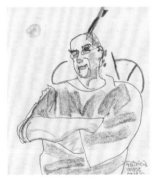

**Jerry Waese**, Canada
pen and ink on paper with Neocolor, 7 × 6 inches (178 × 152 mm).

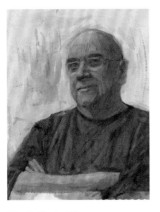

**Martin Beek**, UK
watercolor on rough paper, 12 × 8 inches (305 × 203 mm).

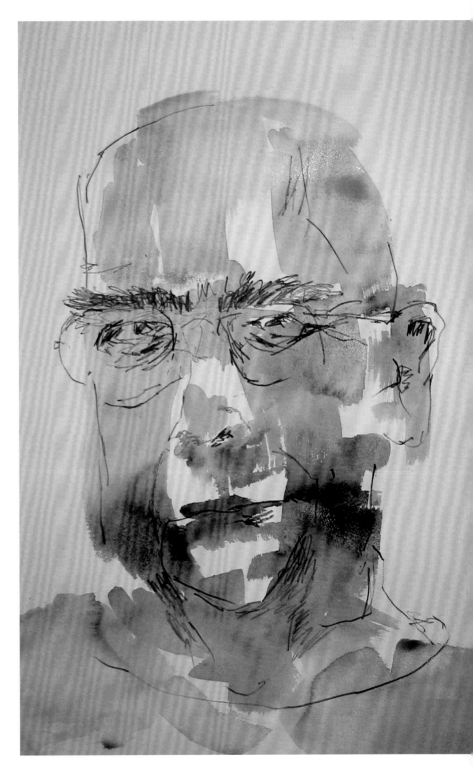

**Sue Hodnett**, UK
watercolor and pencil on watercolor paper, 30 × 22 inches (762 × 559 mm).

# OIL PAINT

Oil paint is famous for its buttery consistency and slow drying time. This means you can continue to work into the existing paint the next day. To make sure the paint does not crack as it dries, there are three main rules: more oil medium in each successive layer, thick paint strokes over thin, and slow-drying over fast-drying colors.

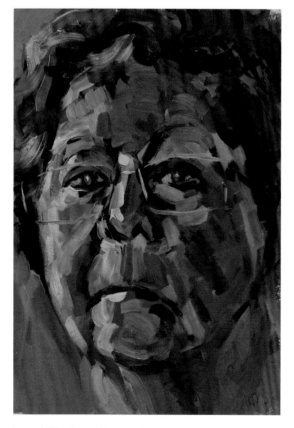

*Janice, UK* by Arturo Espinosa Rosique, Spain
oil paint on paper primed with acrylic paint,
13 × 9 inches (330 × 230 mm).

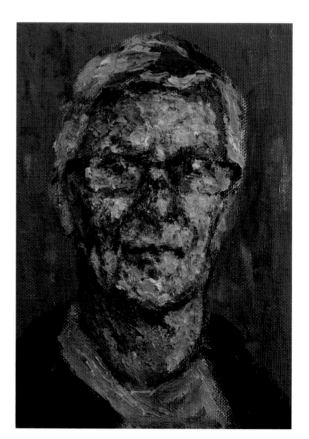

*Arturo, Spain* by Juan Domínguez, Spain
oil paint on canvas, 8¾ × 6¼ inches (220 × 160 mm).

I used a thick linen canvas frame and added some impasto or texture over several sessions on already dry layers.

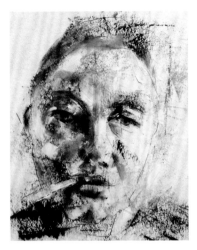

**LEFT** *Lena, Norway*
by Fay Stephens, UK
oil paint on Arches paper
applied with a credit card,
11¾ × 9½ inches
(300 × 240 mm).

A very minimal fifteen-minute
study made in low light.
Sometimes less is more!

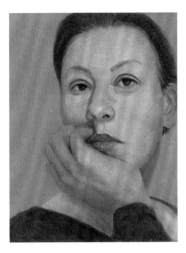

**RIGHT** *Nadya, Russia*
by Michael F. King, USA
oil paint on canvas,
10 × 8 inches (254 × 203 mm).

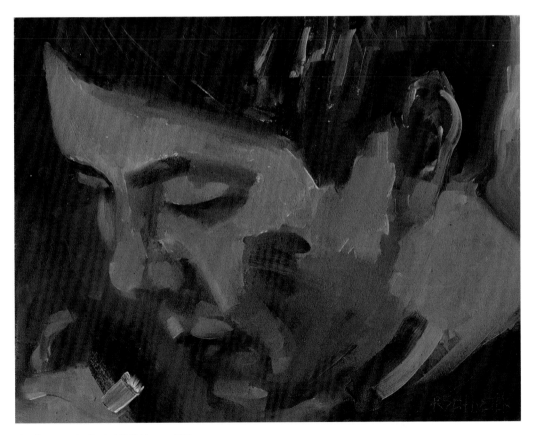

*Ken, Singapore* by Rachel K. Schlueter, USA
oil paint on panel, 7¾ × 10 inches (197 × 254 mm).

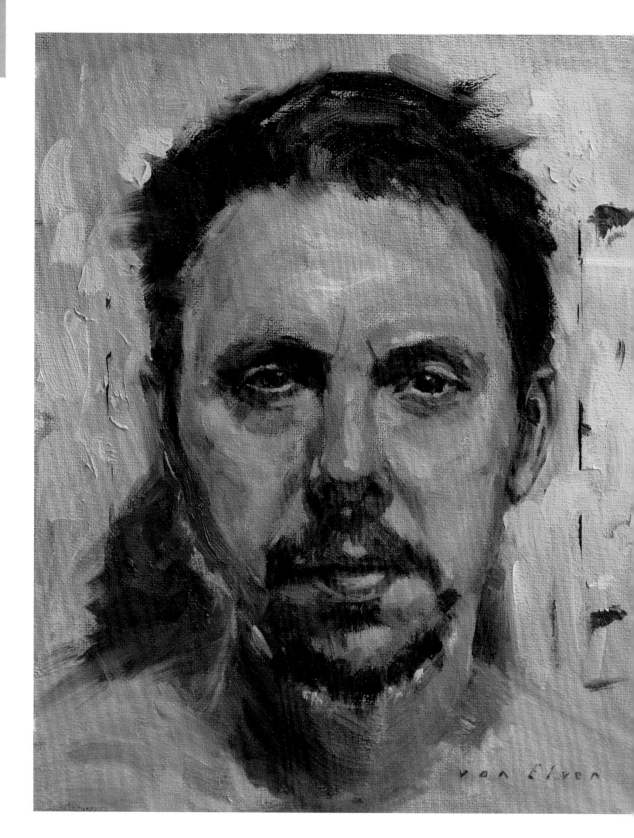

> **" Oil is a wonderful medium to use because it blends seamlessly. It enables one to work and rework problem areas. "**
>
> LEONA ELLSWORTH, LIBERIA

*Grietje, Netherlands* by Leona Ellsworth, Liberia
oil paint, 6 × 5 inches (152 × 127 mm).

*Marion L., Netherlands* by Pablo Sarabia Herrero, Spain
oil paint on paperboard, 11¾ × 11¾ inches (300 × 300 mm).

*Roberto P. A. D., Spain* by Jill Harding, UK
oil paint on paper, 7¾ × 6 inches (195 × 155 mm).

To depict this very masculine image, I used oil paint straight on black paper. I used thick paint to draw and build up the image; this can result in a more painterly effect.

**OPPOSITE** *John B., USA* by Erik Van Elven, Netherlands
oil paint on canvas panel, 30 × 24 inches (762 × 610 mm).

I wanted to focus on brushwork. I liked the harsh light and the textures of the beard and the rough concrete wall in the photo. Stiff hog bristle brushes combined with paint straight from the tube gave me the juicy paint texture I was looking for. I let some of the green/blue color from the background appear in the beard and hair to better integrate the subject in the painting.

# DIGITAL PAINTING

Digital painting emulates the ability to thin, thicken, blend, mix, layer, and otherwise build up paint on paper or canvas. Different apps specialize in effects that are more like watercolor, oils, or acrylics. With mobile devices, you have the advantage of an entire art studio in your pocket. There is lots of storage, no fumes, and you never run out of "paint."

> " I usually try to work with only a few brushes, and three layers: one for the initial sketch, one for the background, and one for the painting. I love to mold the contours and surfaces out of the color by lightening and darkening parts of the head, until it starts looking three-dimensional. The highlights on the skin, lips, and in the eyes make the painting vivid. "

CARSTEN SCHIEFELBEIN, GERMANY

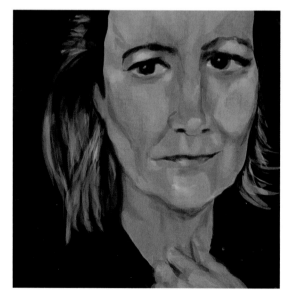

*Liz, USA* by Nini Teves Lapuz, USA
Sketch Club app on an iPad, no fixed dimensions.

I like portraits with a certain drama in them. I start drawing lines, building shapes, and continue to refine the drawing or painting until my work has achieved the expression or quality that the reference photo conveyed to me.

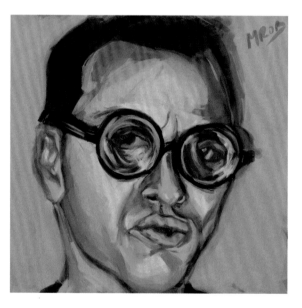

*Luis P., Spain* by Mia Robinson Mullen, USA
ArtRage app on an Axiotron Modbook/tablet, no fixed dimensions.

I am spontaneous in my development of portraits, following the colors and textures as they unfold. I prefer to use programs which emulate the realistic texture and mixing of wet-on-wet paint so that a natural blending and "muddying" of color can occur.

**OPPOSITE** *Leona, Liberia* by Carsten Schiefelbein, Germany
Procreate app on an iPad with an Apple Pencil stylus, no fixed dimensions.

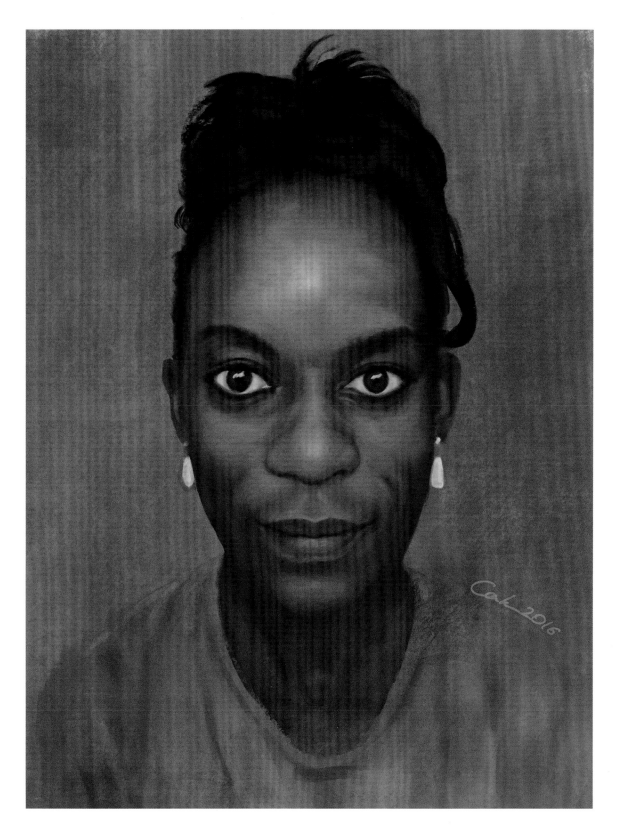

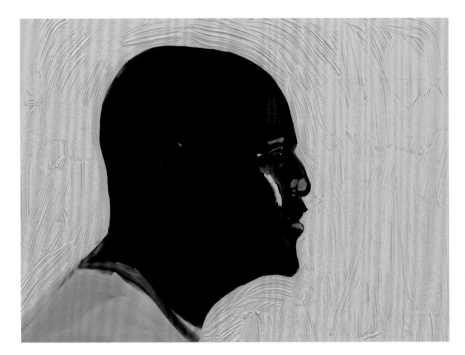

*Devon, USA* by Lynne Lamb, UK
ArtRage app on an iPad,
no fixed dimensions.

I chose to make the colors
overly dramatic to emphasize
the drama of the pose.

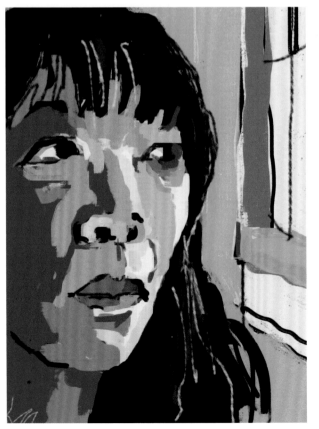

"When working digitally, you don't experience the sound of the drawing tool nor the smell of the color medium nor get your hands dirty, but the process of discovering a subject and the way to create a representation of it are the same. No app will create a unique art work for you just on its own."

JÖRG KRÜHNE, GERMANY

*Carol, USA* by Kate Barber, USA
Procreate app on an iPad, no fixed dimensions.

I love the subject's haunted look out the window. I used the inherent value of the colors to provide the tonal quality of her face. Doing this digitally gave me room to experiment with color combinations to convey her moody expression.

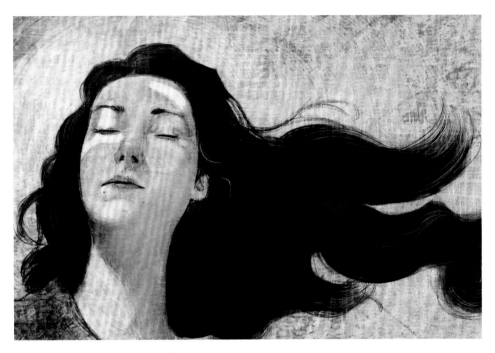

*Emily, Canada* by Lixandro Cordero, Canada
Easy Paint Tool SAI and Photoshop on a PC, no fixed dimensions.

My background is in fine arts, so I like to experiment with getting the feeling of a traditional painting in my digital work. SAI is very intuitive to work with, and Photoshop allows you to make light and shadow adjustments if necessary.

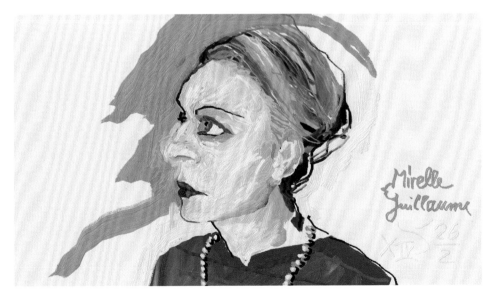

*Mireille, France* by Jörg Krühne, Germany
Fresh Paint app on a Surface RT using a Sensu Brush stylus, no fixed dimensions.

I like fast sketches. They don't have to be "right," but just have to feel right for the moment I create them—abstract realism if you will.

# PORTRAITS OF GARY TAUSCH

## Canada

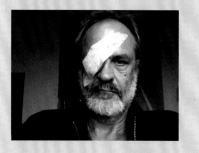

"It has been enjoyable to see the many varied portraits. This photo in particular led to some expressive and dramatic works. The styles and the quality vary, but I have liked them all and am very appreciative that so many have been made. Ironically the eyepatch was due to cataract surgery and at the time I posted my photo I was very pleased with the surgery results. However, there were complications later and I now view the eye patch portraits with some mixed feelings."

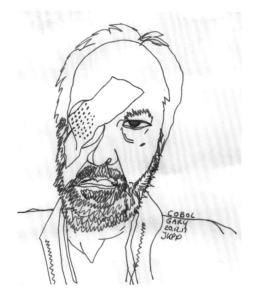

**Grietje Keller,** Netherlands
Lamy Safari fountain pen on paper,
8¼ × 5½ inches (210 × 140 mm).
I really enjoy drawing bandages and other medical things.

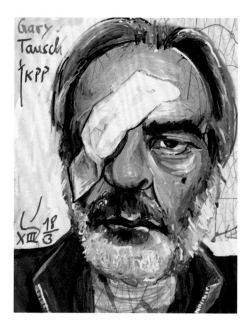

**Jörg Krühne,** Germany
Grungetastic and ArtStudio apps on an iPad and Fresh Paint app on a Surface RT, no fixed dimensions.

This piece was built up with different apps on different devices over the course of three years. It was part of a series in which I drew over older drawings. I was interested in the contrast of one eye being covered while the other gazed directly at the viewer.

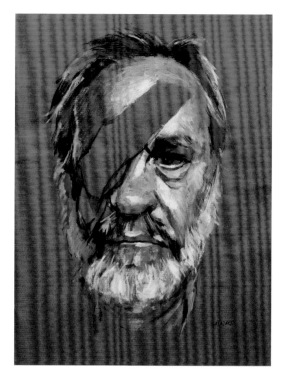

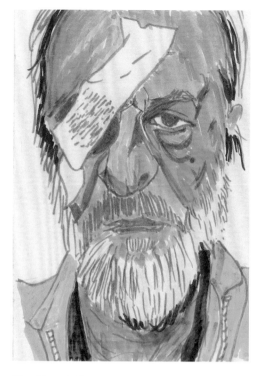

**Miguel Angel Lopez Salazar,** Spain
acrylic paint on paper, 15 × 10¼ inches (380 × 260 mm).

To capture the drama I saw in the reference photo, I painted the portrait directly on red paper, leaving the eye bandage unpainted.

**Kline Howell,** USA
graphite and marker in a Daler-Rowney sketchbook, 14 × 10 inches (356 × 254 mm).

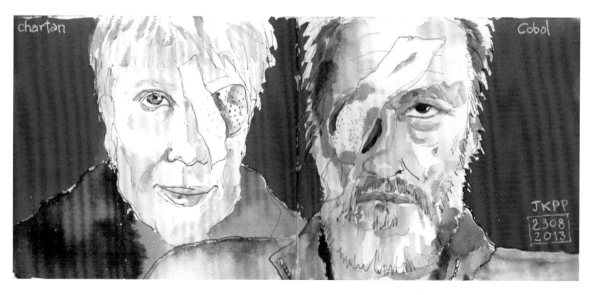

**María Luisa Aguado,** Spain
fountain pen with Noodler's bulletproof ink and watercolor on Guarro watercolor paper, 5¼ × 11¾ inches (135 × 300 mm).

This piece (with Charlotte, USA) was done as part of a series of portraits of people with something in common.

# TRADITIONAL PRINTMAKING

In printing processes, ink or paint is applied to a nonporous surface and then transferred to the paper using a printing press or rubbing with a baren. In all cases the final image is reversed. In block printing, the rolled ink adheres to the surfaces you have not cut. In intaglio processes such as etching, you rub the ink into the very fine cuts and wipe the surface of the plate clean, so the reverse is true. In both of these techniques, you can re-ink the plate to create multiple prints. There are no multiples for monotypes: you paint on a plate of glass or other surface, then transfer the whole painting to the paper.

> **When carving a relief print you can see your progress without pulling a print, by placing tracing paper over the block and rubbing across the surface with a crayon to take an impression. Areas that have been cut will show up white. While crude it is a great way to see how things are unfolding.**
>
> ANNA BLACK, UK

*Hettie, USA* by Anna Black, UK collagraph on cardboard plate, 11¾ x 8¼ inches (297 x 210 mm).

I cut away the negative space of the profile on the cardboard plate, leaving the head and shoulders. The entire plate was inked and then areas wiped away to create the light. The eye was drawn in glue and then carborundum sprinkled over the top. Using tissue paper, cloth scraps, and netting I built up the hair and body.

*Angela, Australia* by Janice Wahnich, UK
monotype and acrylic paint on
Japanese Hosho paper, 7 × 9½ inches
(178 × 241 mm).

This was the second version of three,
using the same reference photo. I found
this reference photo very appealing
and wanted to capture the drama and
romance.

*Maureen, UK* by Marina Mozhayeva, USA
monotype made using acrylic paint on paper,
14 × 11 inches (356 × 279 mm).

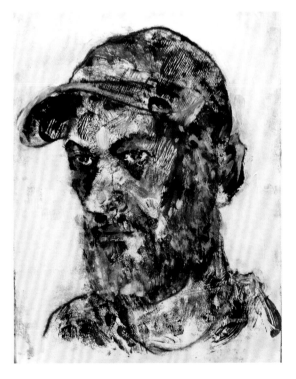

*Gary, Canada* by Fay Stephens, UK
monoprint with white acrylic paint corrections,
11½ × 8¾ inches (290 × 220 mm).

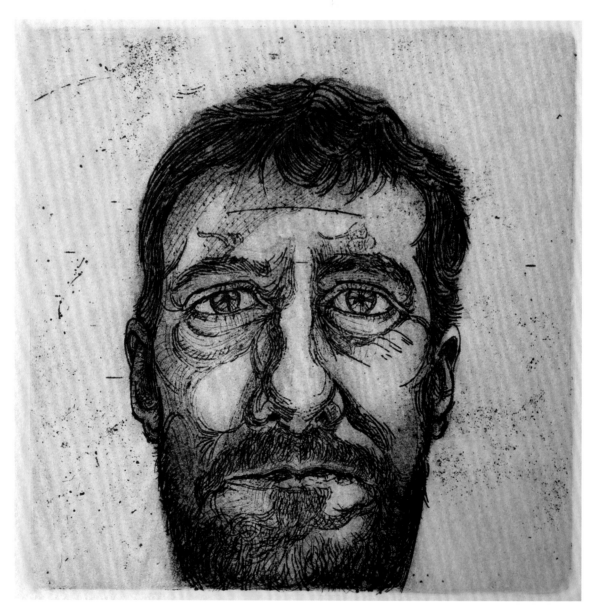

*Mike, USA* by Leland Struebig, USA
etching and aquatint, 4½ x 4½ inches (114 x 114 mm).

As a printmaker I am always looking for ways to improve the health and safety aspects of the studio environment. This portrait is a result of my early efforts learning to use a new low-toxic etching solution for zinc printing plates.

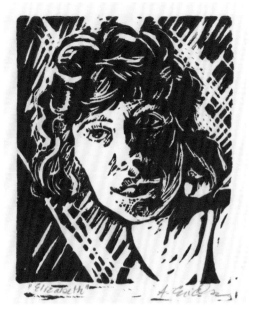

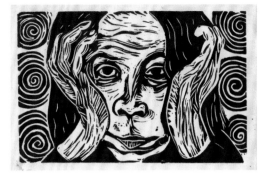

**LEFT** *Elizabeth G. Z., USA* by Amy Erickson, USA
linocut print, 4¾ × 4 inches (121 × 102 mm).

I was drawn to the original reference photo as it had a classic film noir movie star look about it. The heavy contrasts between dark and light seemed to lend themselves well to making a print rather than a drawing.

**ABOVE** *Mariah, USA* by Gila Rayberg, USA
linocut print, 7 × 10 inches (178 × 254 mm).

I later used this print as the reference for a mosaic.

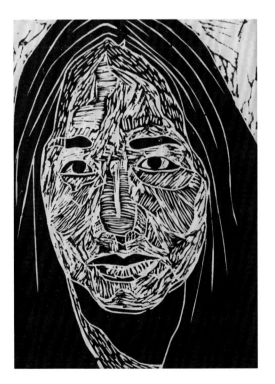

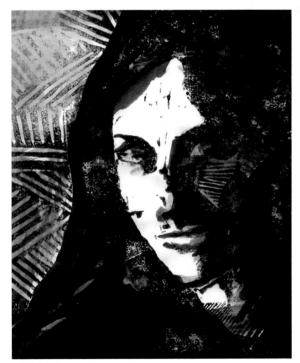

*Irene* by Maureen Nathan, UK
linocut print using water-based printing ink on Japanese Hosho paper, 12 × 10 inches (305 × 254 mm).

I don't draw on the linoleum, but prefer to cut freehand while looking at the subject. I use the blade to "draw." I think it gives my prints an immediacy and sense of freshness.

*Marion J., Australia* by Barry Wayne Farmer, USA
relief print from a plaster block with added watercolor wash, 7 × 6¾ inches (180 × 170 mm).

This was an experimental printmaking project, as I had not printed from a plaster of paris block before.

# DIGITAL PRINTMAKING

Digital printmaking emulates traditional printmaking using apps that are designed for this specific purpose, or by finding ways to work in general-purpose art apps to get the feeling of the process or the result of printmaking.

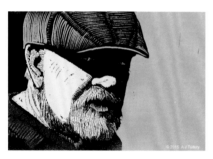

*Kline, USA* by A. J. Tudury, USA
Ukiyoe app on an iPad, no fixed dimensions.

Kline's high contrast reference photo seemed to ask for a woodcut treatment. I had to let go of my desire to produce a black and white "print" and include gray to balance the sunlight on his face.

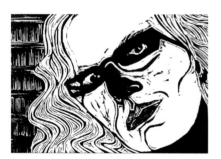

*Tammy, USA* by Julia L. Kay, USA
Ukiyoe app on an iPad, no fixed dimensions.

Block printing, whether traditional or digital, forces me to think about tonal values nd how to represent them (in this case using only black and white).

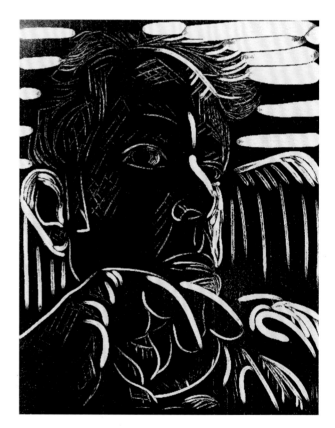

*Pedro, Spain* by Francesca Andrews, USA
Ukiyoe app on an iPad, no fixed dimensions.

Ukiyoe is a woodcut simulation app which is no longer available. I don't know how to do woodcuts in real life, so I used the photo of Pedro to cut the lines.

*Devon, USA* by Margarita Pérez García, UK
Brushes app on an iPad, no fixed dimensions.

This piece is part of a series of digital portraits trying to reproduce linocut techniques. In a linocut, one cuts away from the block; similarly I have drawn Devon using the eraser tool to "cut" away from a black layer.

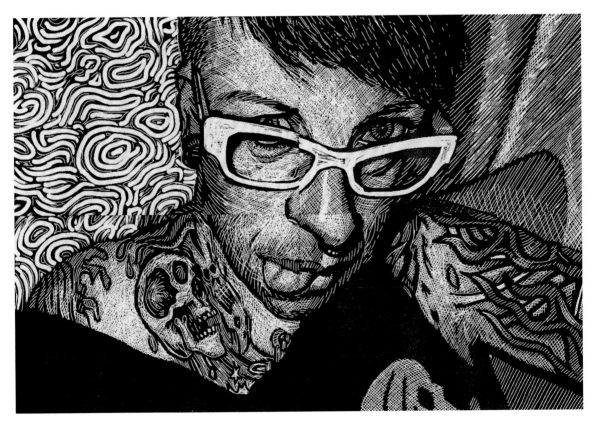

*Rebecca S., UK* by Paul Wright, UK
Ukiyoe app on an iPad and Photoshop, no fixed dimensions.

To combat the limited resolution of a single image, each of the four "woodcut" quarters was drawn independently of the others from a photo that had been enlarged and cut up into the same proportions. The results were joined together in Photoshop and I was happy to leave any areas that didn't quite match up.

# PORTRAITS OF VALÉRIE MAFRICA

France

"The essence of good portraits is portraying people naturally and as themselves, so it is best to be as natural as possible in photos to be used for this purpose. Being the model for portraits is great fun, however, as a model one has to be open to all kinds of artwork and see it as an experience to enjoy."

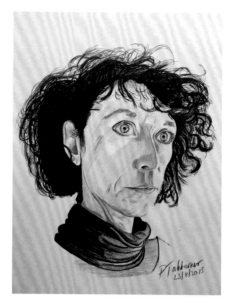

**Paul Tabbernor**, UK
Polychromos colored pencils and fine-tipped pen on smooth Bristol board, 11½ × 10 inches (292 × 254 mm).

Smooth paper is perfect for pencil work. To get depth in a pencil drawing use a black ink pen for the darkest lines and cavities on the face, deep shadows anywhere, and black hair. If you then go over the ink with pencil it should blend in seamlessly.

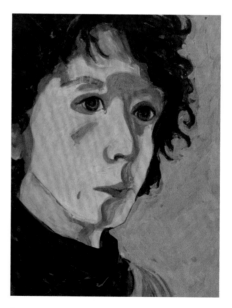

**Sherry Thurner**, USA
acrylic paint, 10 × 8 inches (254 × 203 mm).

For this portrait I made an effort to simplify shapes and use bold colors.

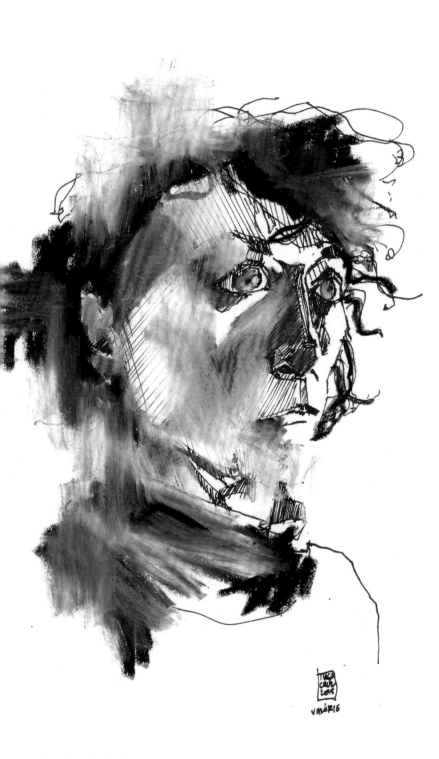

**Geoff R. Bryan**, Australia
watercolor pencil, Neocolor
II water-soluble crayon, and
SketchBook Pro on a Mac,
no fixed dimensions.

The subject has striking eyes
and hair with a mind of its own.
I found changing the color scheme
to dusk emphasized her resolute
expression.

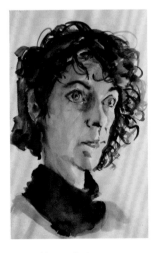

**Tiago Cruz**, Portugal
ink and wax crayon on paper, 11¾ × 8¼ inches (297 × 210 mm).

This portrait was an experiment. I like using portraits to try out
new materials or a different combination of materials.

**Pedro Martin**, Spain
sepia watercolor on paper,
11½ × 7¾ inches (290 × 200 mm).

# COLLAGE

Collage is the process of making something new from premade materials such as ripped or cut magazines, solid or patterned papers, your own old artwork, photos, or fabrics. In traditional collage, the materials are glued to a backing. In a modern variation, image files are manipulated and arranged digitally.

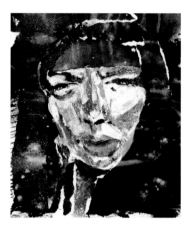

*Elizabeth T., USA* by Fay Stephens, UK
collage: from papers created using inks, bleach, texture paste, and acrylic paint, 11½ x 9¾ inches (290 x 250 mm).

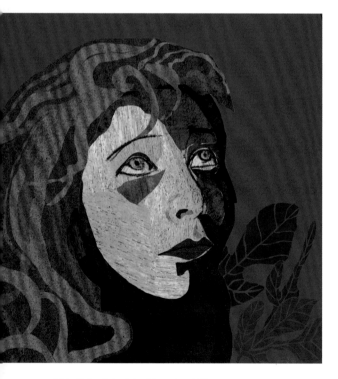

*Silvia, Bulgaria* by John Thornton, UK
digital collage using Procreate app on an iPad, no fixed dimensions.

I photographed a wooden bench, a sawn tree trunk, and some cardboard, and collaged these textures to emulate a woodcut.

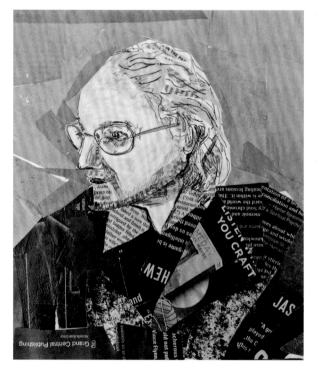

*Kevin H., USA* by Elizabeth Titus, USA
collage: from magazines and newspaper; pencil and ballpoint pen, 9 x 8 inches (229 x 203 mm).

I like to incorporate bits of text for different values and to add interest. There's this sense that some clue will be revealed in the text.

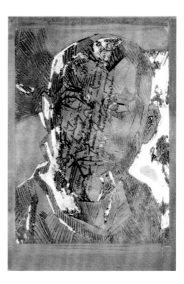

*Dave* by Cecca Whetnall, UK
etched solar plate monoprint
with Chine-collé,
9 × 6¼ inches
(230 × 160 mm).

By inking up the grooves of
the plate with black intaglio
ink and then rolling over the
whole plate with teal relief
ink, I've combined intaglio
and relief printing methods.
I've also used collage, with
some patterned tissue paper
over half of the face.

**" You can make a papercut portrait
without liquid adhesives. First,
pre-coat the paper with acrylic
medium, then cut and assemble
the pieces into the collage.
Last, lay a piece of teflon paper
over the collage and use a hot
iron to adhere the pieces to the
backing. This process allows
more freedom while handling
the materials, and there are no
glue stains on joins or over the
paper. During the pre-coating
process, one must ensure that
the paper dries flat without curls
or wrinkles by using weights. "**

MARGARITA PÉREZ GARCÍA, UK

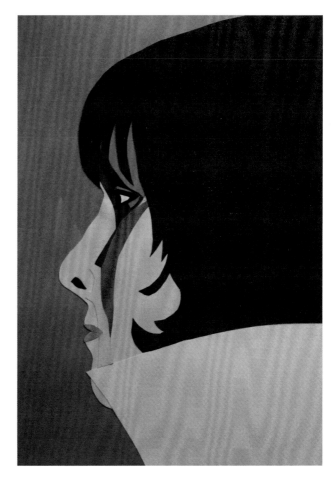

*Marina, USA* by Margarita Pérez García, UK
collage: from cut Canson Mi-Teintes acid-free
paper, 11¾ × 8¼ inches (297 × 210 mm).

# MIXING TRADITIONAL AND DIGITAL MEDIA

There are many options for working back and forth between digital and traditional media. Some common processes are to draw on paper and then scan it in to be colored, to draw or paint traditionally and then scan it in to manipulate the color or form, and to draw digitally and then print it out and paint on top of it. You can also scan in a sketch and adjust the proportions, then use that as a guide when you go back to the traditional piece. The possibilities are endless.

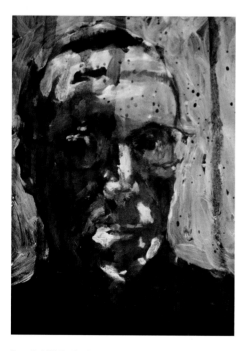

*Dan P., USA* by Jim Vance, Canada
water-mixable oil paint with digital enhancement using Photoshop on a PC, no fixed dimensions.

The oil paint is applied to an acrylic surface, and photographed while wet. Once photographed, the oil painting is washed away and the photo becomes the only record of the painting. The photo is then digitally manipulated in many ways for varying results.

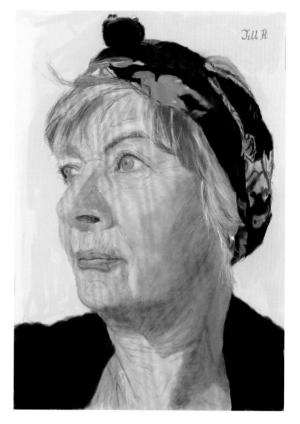

*Jill, UK* by Geoff R. Bryan, Australia
charcoal pencil on Canson drawing paper, scanned and digitally overpainted using Autodesk SketchBook Pro on a Mac, no fixed dimensions.

I wanted the face to "pop" out so I chose a yellow-green for the background to contrast with the skin tones. I found that Autodesk Sketchbook Pro has an easier interface to master than Corel Painter.

*Roberto A., Spain*
by Toni Rodríguez, Spain
water-mixable oil paint on
gray paper; ArtRage, Art Set
Pro apps on an iPad, no
fixed dimensions.

After scanning my quick oil
sketch, I used ArtRage to
add a background and change
part of the color in the face.
I added the final strokes on
the face and background with
Art Set Pro. The portrait
still preserves some of the
initial analog painting.

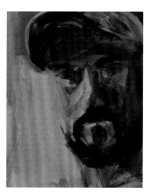

*Mike, USA*
by Cecca Whetnall, UK
mixed media including
watercolor on paper and
Photoshop on a PC, no
fixed dimensions.

I had created an earlier
portrait of Mike in a brightly
colored expressionist style
using watercolors. For this
digital version I started with
my watercolor and tried
out multiple filters and
effects in Photoshop.

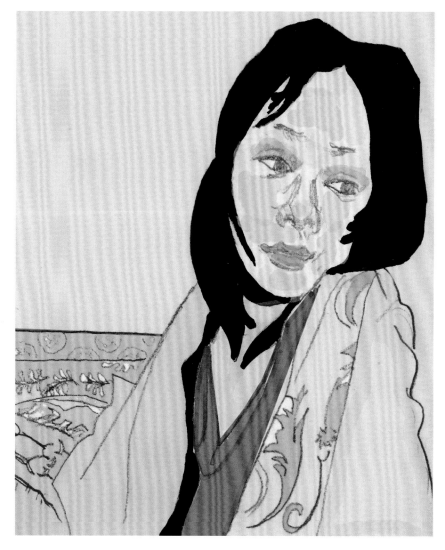

*Janet, Taiwan*
by Kline Howell, USA
graphite and Sharpie in a Daler
Rowney sketchbook with color
enhanced in Photoshop, no
fixed dimensions.

# PORTRAITS OF ARTURO ESPINOSA ROSIQUE

## Spain

"It is very interesting to learn about people by the way they express themselves in their art. Being friends has allowed a surprising freedom in the use of materials and creativity when portraying each other. I can see many facets of my personality in the portraits, and the portraits are a great story of who I am in the eyes of others."

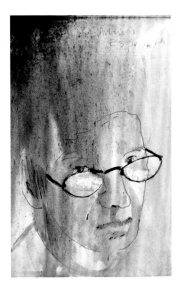

**Fay Stephens,** UK
water, raw pigment, bamboo pen and ink, white acrylic paint highlights, 8 × 5 inches (203 × 127 mm).

This portrait was an experiment using raw pigments tapped on to damp paper and allowed to flow. There was only very minimal drawing.

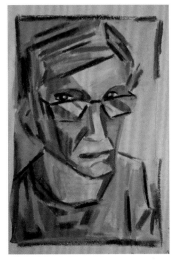

**Marie Aschehoug-Clauteaux,** France
wax pastel on paper, 8¼ × 5¾ inches (210 × 148 mm).

I chose this reference photo because he has an interesting expression, and I love to paint portraits with glasses.

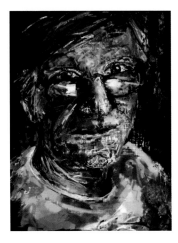

**Mike Ryon,** USA
Wasabi, ArtRage and ArtStudio apps on an iPhone, no fixed dimensions.

Brushstrokes and heavy textures applied digitally helped me to emulate the rich oil paint seen in Arturo's own works.

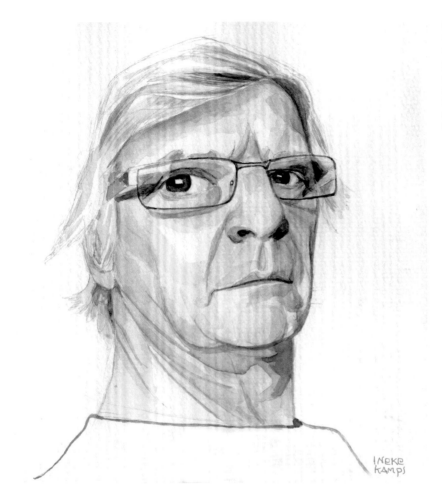

**Ineke Kamps,** Netherlands
watercolor on paper,
6¼ × 5½ inches (160 × 140 mm).

I chose to paint this with more angular shapes, to give it an edgier feel than if I had painted it rounder. I used as few layers as possible, so that the image would keep its transparency.

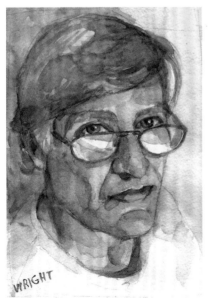

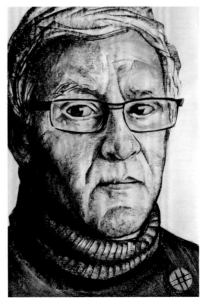

**FAR LEFT Barb Wright,** USA
DaVinci watercolors on Strathmore cold press paper,
7¾ × 5½ inches (197 × 140 mm).

I paint in a loose manner, dropping color into other colors while the paint is still wet. There is some build up of layers, but not too much. I like watercolor to look like watercolor, to see the transparency and the grains of paint on the paper.

**LEFT Pepe Fárres,** Spain
charcoal, pastel, and watercolor on paper, 16½ × 11¾ inches (420 × 300 mm).

I like to fuse charcoal and pastel together—working as if it is just one material. Sometimes I apply brushstrokes of watercolor to create changes in texture as I did here with the glasses and eyes.

# NEEDLE ARTS

Needle arts include drawing with needle
and thread, painting with crochet needles, and
collaging with appliqué.

*Julia L. K., USA* by Jarrett Kupcinski, USA
pieced and appliquéd fabric, stitched thread,
8 x 8 inches (203 x 203 mm).

This piece began as a vector illustration which I then
adapted to fabric. A large part of quilting is creating
patterns and images using pieced shapes of fabric.
Digital vector art is similar, as the basic elements
are shapes. Therefore the crossover from digital
to fabric art isn't as huge of a leap as it seems.

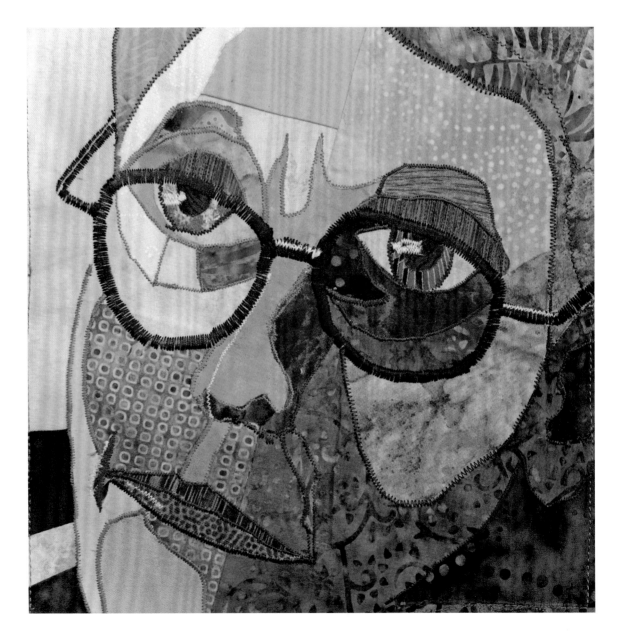

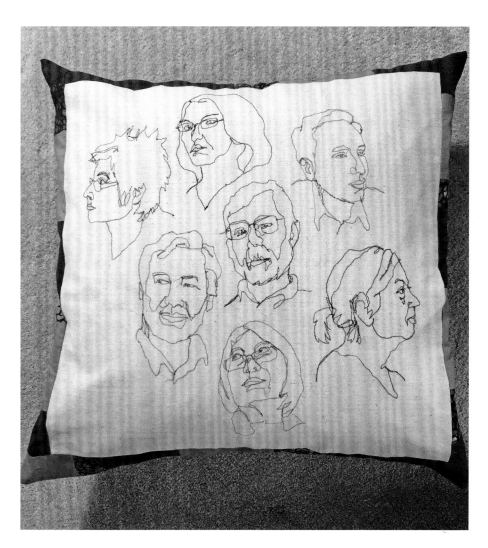

*JKPP group*
by Janet Burns, USA
machine-thread
sketching on cotton
muslin, 18 × 18 inches
(457 × 457 mm).

Thread sketching by
machine is done when
the feed dog is lowered.
This frees the fabric to
be manipulated under
the needle.

**BELOW** *JKPP group* by
Elizabeth Waltermire-
Wilcox, USA
crochet, 15 × 45 inches
(381 × 1143 mm).

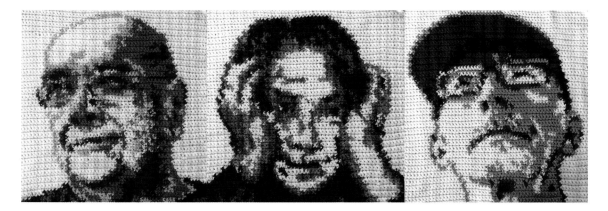

# UNUSUAL MEDIA

When it comes to making portraits,
your imagination is the only limit.

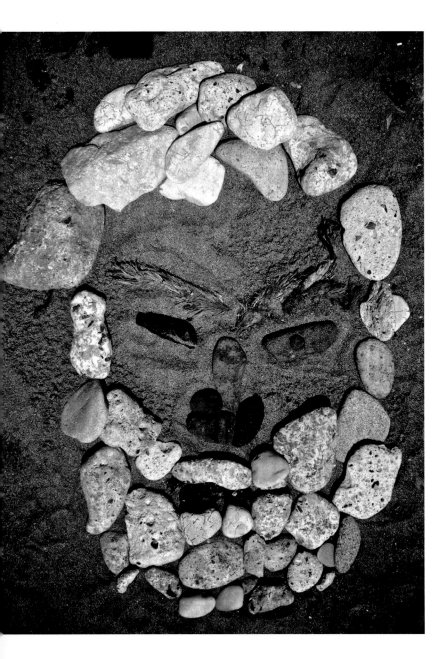

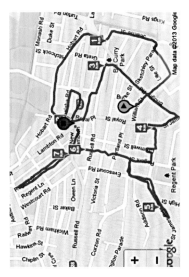

*Julia L. K., USA* by Tom Lambie, Australia
Walkmeter app on an iPhone, no fixed
dimensions.

It takes a long time to plan a road-
running portrait. Hours with a
highlighter and printed maps to plan
the route. Also, remember to hydrate
frequently. This one was on a 5 mile
(7.5 km) run. I got chased by a dog.

**LEFT** *Tim W., USA* by John Thornton, UK
Stones, seaweed, etc., 60 × 40 inches
(152 × 102cm)

No idea why I had the idea to make
a bas relief on the beach. It must have
been 104°F (40°C). Tim's gaze was in
my mind's eye after drawing him and
I just had this urge to try and sculpt
with stones and seaweed while trying
not to get sunburned.

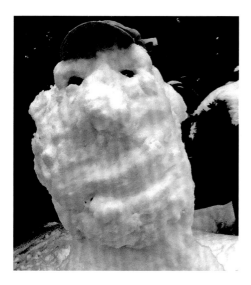

*Timothy, USA* by Charlotte Tanner, USA
snow, found objects, 36 x 24 inches
(914 x 610 mm).

It was snowing and I got inspired to make
a snow face, and Timothy popped into my
mind as a likely subject.

*JKPP group* by Ramón Carlos Válor López, Spain
ink on beach stones, 3¼ x 1½ inches each (80 x 40 mm each).

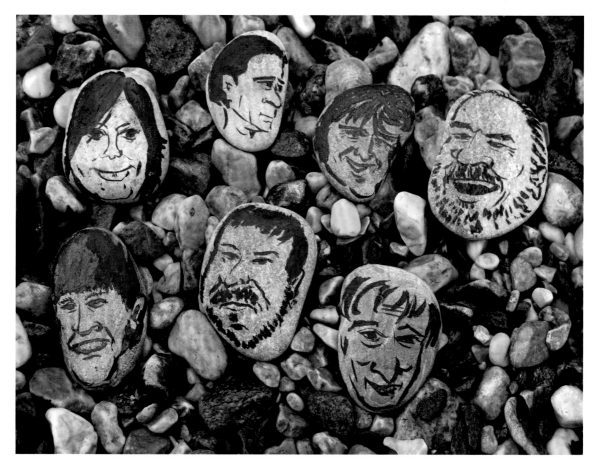

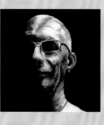
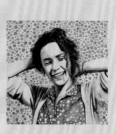
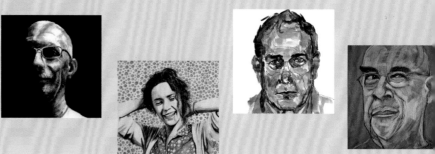
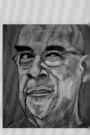

# PORTRAITS BY STYLE

"Experiment with new styles and allow yourself to be a 'beginner.'"

ANNA BLACK, UK

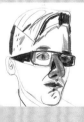

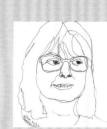

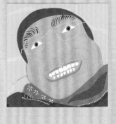

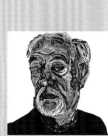

# REALISM

Realism is when all the proportions, tonalities, and details are exactly rendered, resulting in a strong resemblance to the subject.

*Elizabeth T., USA* by J. L. Meana, Spain
Photoshop on a PC using a Wacom Bamboo tablet, no fixed dimensions.

I used brush and blending tools to give the portrait a classic look. I used the oil filter to give a dimensional texture to the brushstrokes.

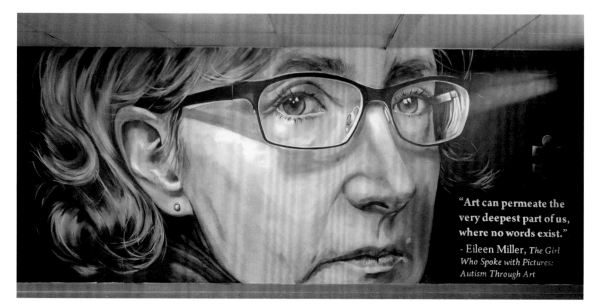

"Art can permeate the very deepest part of us, where no words exist."
- Eileen Miller, *The Girl Who Spoke with Pictures: Autism Through Art*

*Jane, UK* by Anat Ronen, USA
latex on plasterboard, 8½ × 26 feet (259 × 793 cm).

Painting large is challenging because you have to bring large surface areas to life. For instance, the entire area of the cheek was a pretty daunting task, because I had to achieve volume and yet maintain the smoothness of the color swatches. When working this way I use a grid for transferring the design on to the wall, and enjoy some artistic freedom in deciding what goes where.

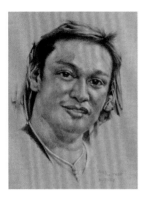

*Victor, Philippines*
by Philip D. Kinzli, USA
colored pencil on tan
paper, 12 × 9 inches
(305 × 229 mm).

I feel the eyes are the
most important part of
my portraits. Therefore
I focus on giving them
depth and the sparkle
of life.

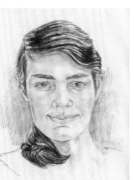

*Samar, Iraq* by Janet Burns, USA
charcoal pencil on paper,
11 × 8½ inches (279 × 216 mm).

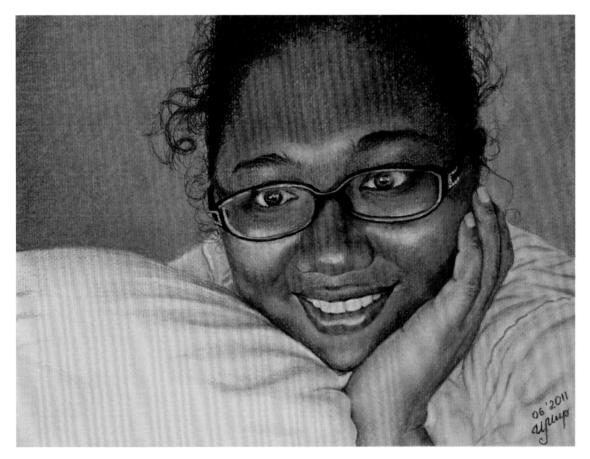

*Ismi, Indonesia* by Irina Miroshnikova, Russia
dry pastel, pastel sticks and pencil on cream Ingres Clairefontaine paper,
11¾ × 15¾ inches (300 × 400 mm).

# ABSTRACT

Abstract portraits frame the question, *how far from realistic can we get, and still have a portrait?* Abstraction can be minimalist, expressionist, cubist, or many other styles.

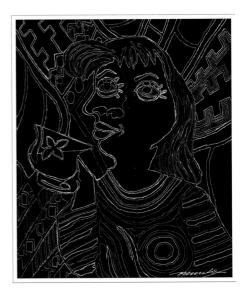

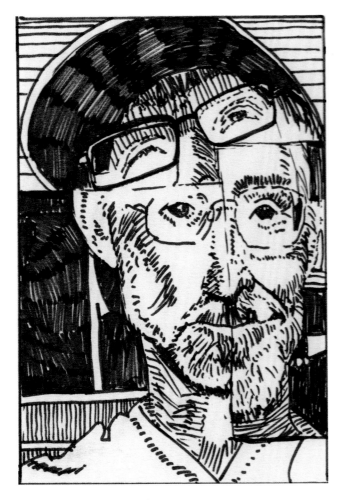

*Cooper, USA* by A. J. Tudury, USA
pen and ink, 7¾ × 5¼ inches (197 × 133 mm).

In his reference photos, Cooper only included segments of his face. I thought it would be fun to compile the segments into a composite portrait.

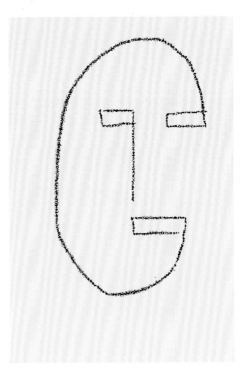

*Patricio, Chile* by Timothy Schorre, USA
Sketji app on an iPhone, no fixed dimensions.

The simplicity of the app and the small screen size of the iPhone contribute to visual clarity and economy of line.

OPPOSITE *Oksana, USA* by
Murilo Sergio Romeiro, Brazil
Photoshop on a PC, no fixed
dimensions.

I combined two of Oksana's
reference photos and took
inspiration from the Picasso
illustrations on her blouse.

*Kate, South Africa*
by Hans Muerkens, Germany
Charcoal, crayons and
markers, 11½ × 8¼ inches
(290 × 210 mm).

I had done another portrait
of Kate trying to catch a
likeness, but I did not like the
result. I should dare to think
abstractly more often.

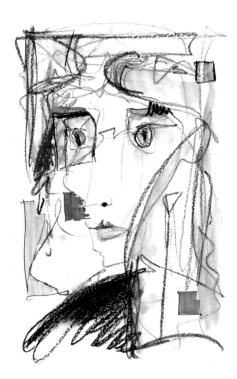

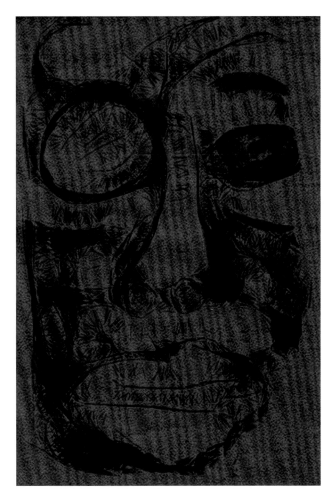

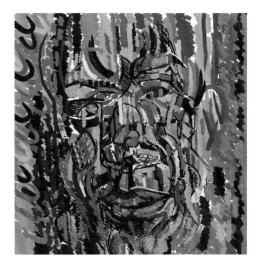

*Julia L. K., USA* by Dan Harris, USA
LiveSketch and Mill Colour apps on an iPod Touch,
no fixed dimensions.

Some of these apps can be vexing and tricky to use,
but lead to striking, if unusual, results.

*Jörg, Germany* by Clyde Semler, USA
ArtRage Studio Pro using a Wacom tablet and
stylus on a PC, no fixed dimensions.

This portrait was painted on a single layer.

# COMPOSING AROUND THE RECTANGLE

Composing around the rectangle is acknowledging the shape of the page by consciously drawing within, touching, or breaking out of a rectangle that roughly echoes the shape of the support.

**❝ You can bring the subject out from the flat paper by creating a 'false frame' … lines that butt up against the negative spaces that the background creates around the subject. ❞**

RODRICK DUBOSE, USA

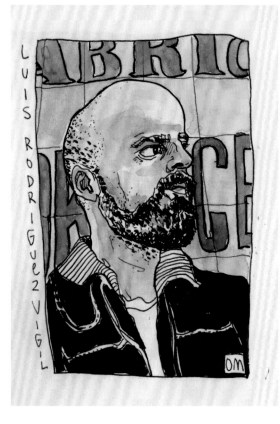

*Luis R. V. G. T., Spain* by Olivia Marcus, France
ink and watercolor on paper, 6 x 4 inches (150 x 100 mm).

I was drawn to this photo because of the bright lettering in the background, and also because of the attitude of the subject. I started in fountain pen, having a vague idea of the composition and framing in mind, then I added color. When it is done, it is done. With this method, there can be no corrections, and no regrets. If it worked out, great. But if it did not, then so be it.

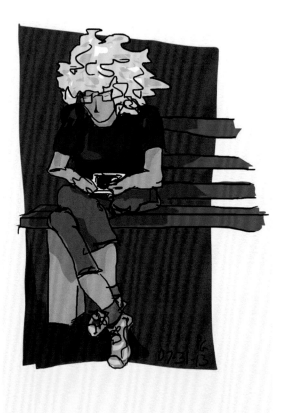

*Barbara J. W., USA* by Patricia Gaignat, USA
Sketch Club app on an iPad, no fixed dimensions.

Barbara was on the other side of a large group of artists sketching. I was finished (bored), spotted the wild white hair, and sketched her from life.

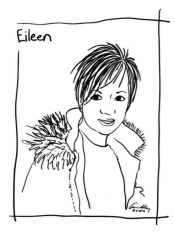

*Eileen, Hong Kong* by Anne M Bray, USA
Adobe Illustrator on a Mac using a Wacom drawing tablet, no fixed dimensions.

I traced over Eileen's photograph for this portrait.

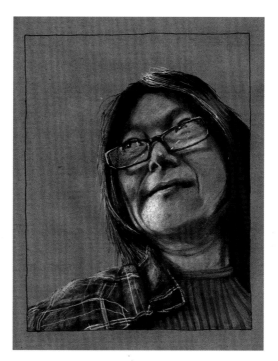

*Hwasook, South Korea* by Anat Ronen, USA
pen, markers, and colored pencil,
9 × 7 inches
(229 × 178 mm).

I like to keep things neat, and so I gave this portrait a more graphic design, with the thin line frame.

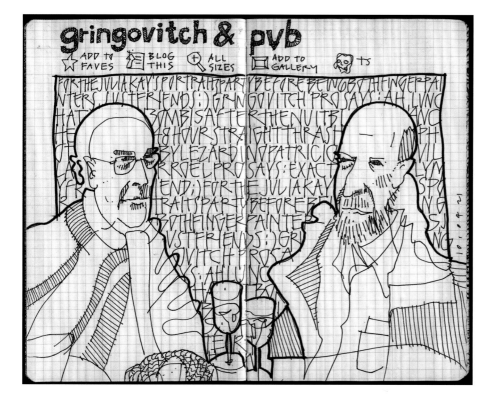

*Patricio, Chile, and Dan H., USA* by Timothy Schorre, USA
pen on paper,
8¼ × 10 inches
(210 × 254 mm).

Drawn from a photo of Patricio and Dan ("Gringovitch") together in Paris, I included elements of the Flickr interface on the computer screen surrounding the photo. The words forming the background are taken from various comments on the same screen.

# PORTRAITS OF JULIA L. KAY

## USA

"At the time I started the Portrait Party I had made upwards of a thousand self-portraits, so I thought I was pretty familiar with my face and I wasn't expecting any surprises. But to my delight, there were many views quite different from my own, ranging from strong resemblance to quite abstract. In all the different styles and media, and whether or not I see myself in each portrait, I love having been a catalyst for so much great artwork."

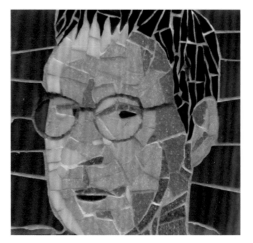

**Gila Rayberg,** USA
mosaic with glass, 5 × 5 inches (127 × 127 mm).

In this small work, one of the challenges was creating her glasses. This was achieved by leaving a wider space (absence of tile), around her eyes, that was then filled in with red-pigmented grout.

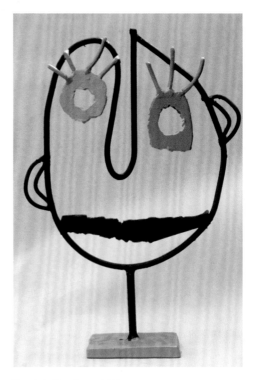

**David A. Friedheim,** USA
painted steel, 20 × 15 inches (508 × 381 mm).

My favorite "drawing" medium is a steel rod. It may lack the fluidity of a stylus but I love the solidity of the result. These "drawings" in steel can be seen as a cross between the work of Pablo Picasso and the Flintstones.

**Margarita Pérez García,** UK
Brushes app on an iPad, no fixed dimensions.

This is an (almost) continuous line drawing. The colors are assembled as if they were layers of papers underneath like for a collage using real paper.

**BELOW Jerry Waese,** Canada
pen, ink, and Neocolor II crayons on paper
7 × 7 inches (180 × 180 mm).

The verticality of the face and hair was so compelling, and the sense of embouchure (how the lips are held) really got to me, as if Julia were having an epiphany—herself inspired—and had paused between the moments of time rushing by.

# DRAWING BLIND

Drawing blind is when you draw while looking exclusively at your subject rather than your drawing. When you concentrate on looking while drawing very slowly in this way, you strengthen your eye-to-hand connection. In addition, the lack of focus on the drawing itself frees you from your own ideas about how your drawing should look and can yield exciting results.

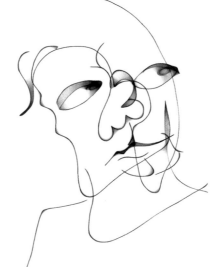

*Mariah, USA* by Julia L. Kay, USA
Sketch Club app on an iPad,
no fixed dimensions.

I love the free expressiveness of blind contours as an end in itself. My source was my acrylic painting of Mariah, created from looking at one of her self-portraits in oils, which she had probably done from life. Even at this many levels of remove, I hope to have caught something of her original glance in the mirror while she was painting.

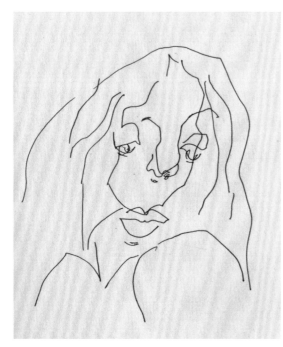

*Marie, France* by Jutta Richter, Germany
Copic multiliner in a Moleskine sketchbook,
5 x 4¾ inches (130 x 120 mm).

Blind contour drawing is a very good exercise to train the hand-eye coordination. The sketch was done within a minute. And the result is very fresh.

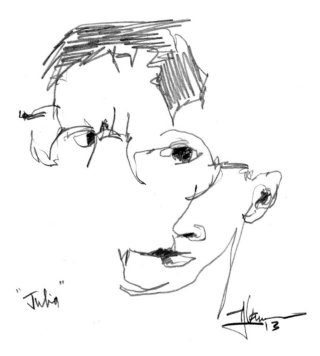

*Julia L. K., USA* by Jim Vance, Canada
pencil on paper, 10 x 8 inches (254 x 203 mm).

The drawing was done blind with subsequent shading in key areas. I like blind contour drawings because they are fast, surprising, and satisfying when you have only a few minutes to spare.

*Liz, USA* by Ira Prussat, Germany
oil-based colored pencil on paper,
9 × 8¾ inches (230 × 220 mm).

The sunglasses caught my eye and
inspired me to choose Liz as a
subject. The first try was a properly
tidy version but I wasn't satisfied
with it. When this happens I often
follow it with something silly like blind
contour, non-dominant hand, upside
down, and so on, just for fun.

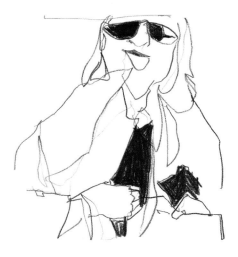

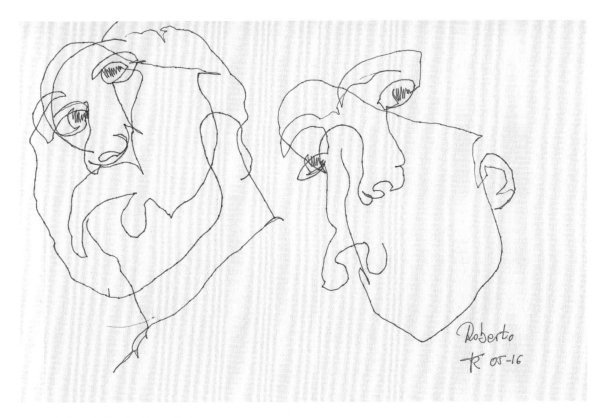

*Roberto A., Spain* by Toni Rodríguez, Spain
pen on paper, 5 × 7½ inches (125 × 190 mm).

Sometimes I make a blind contour drawing, followed by a continuous contour
(not blind) drawing, before doing more elaborate work. In this way I get to know the
subject's face more closely. Here I used a Pilot G-Tec C4 gel ink Rollerball pen which
I like for small-size line work because it gives a fine, intense, fluid, and controlled line.

# MONOCHROME

Monochrome allows you to concentrate on volume and form through modeling the lights and darks, and setting aside questions of color.

*Grace, South Korea*
by Mick Mulviel, UK
watercolor on paper,
Windows Photo Gallery
on a PC, no fixed
dimensions.

I usually use various shades of red or blue for my monochrome portraits. Here I experimented with greens but was unhappy with the result, so I edited the color out on my PC.

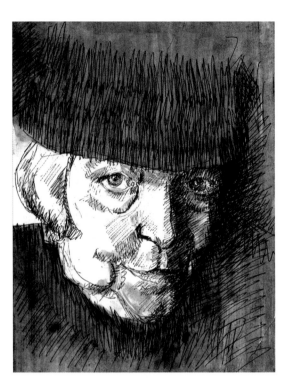

*Mary, USA*
by Ujwala Prabhu, India
Ink and wash on paper,
9½ × 7 inches
(240 × 180 mm).

This piece allowed me to have two extreme values in an unusual proportion: far more black than white.

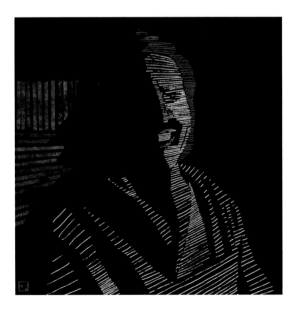

*Theresa M., USA* by John Thornton, UK
Procreate app on an iPad, no fixed dimensions.

I was inspired to make digital woodcuts by an M. C. Escher exhibition. I didn't have any idea how to do this so I experimented with Procreate on the iPad to get a similar feel.

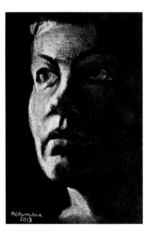

*Lena, Norway*
by Pedro Villarrubia, Spain
white pencil on black paper,
7¾ × 5 inches (200 × 130 mm).

In this small portrait I sought to capture the strength of her gaze through the contrast of light and shadow. I gently drew with a white pencil and blurred the marks with my fingers.

**OPPOSITE** *Cooper, USA*
by Richard Long, UK
gouache on paper,
10 × 7 inches
(254 × 178 mm).

Gouache, being matte and opaque, photographs and scans very well, making it an excellent choice of medium for work that is going to be seen in print or on screen. In this case, I used it for deeper blacks than I could achieve with watercolor or graphite.

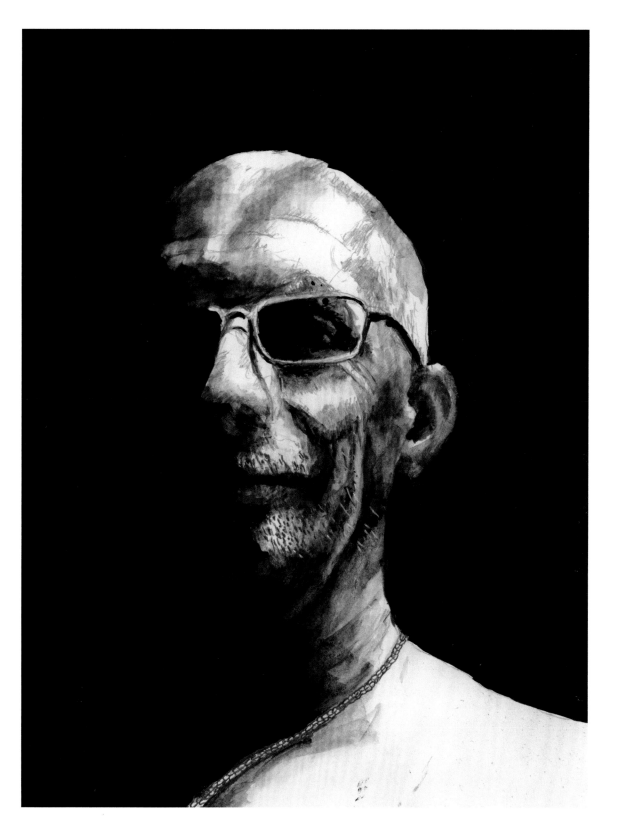

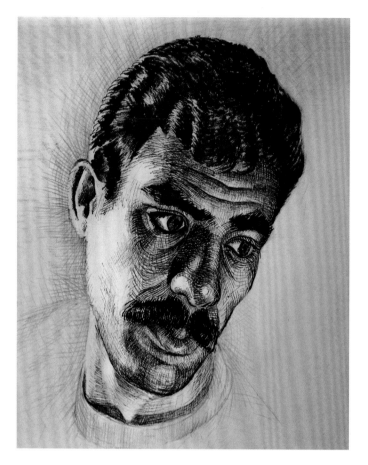

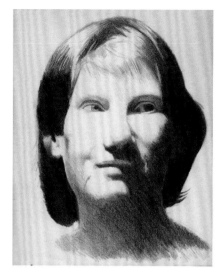

*Lindie, USA* by Eric Francis, USA
pencil on paper, 10 x 8 inches (254 x 203 mm).

It's a good idea for an artist to warm-up with a sketch. I sketched this reference photo because of the contrast between light and dark, like a chiaroscuro painting by Caravaggio. Great contrast creates three-dimensional depth in your work. The transition from light to dark is bold, therefore it catches your eye and holds your attention.

*Zaid, Iraq* by Ed Boldero, UK
pen and pencil on paper, 6¼ x 5 inches (160 x 130 mm).

I roughed out the composition and proportions in pencil before adding shading in pen. I used hatching with a small fiber-tipped pen on the face to portray the change in light and surface contours. I used a brush pen for the hair, capturing the larger areas of darkness and leaving the glossy highlights paper white.

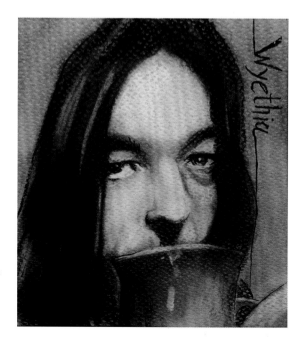

*Theresa K., USA* by Rafael Comino Matas, Spain
black and white Conté pencils on gray Canson paper, 140 x 125 mm (5½ x 5 inches)

Using a gray paper you don't have to paint the middle tones, only lights and shadows.

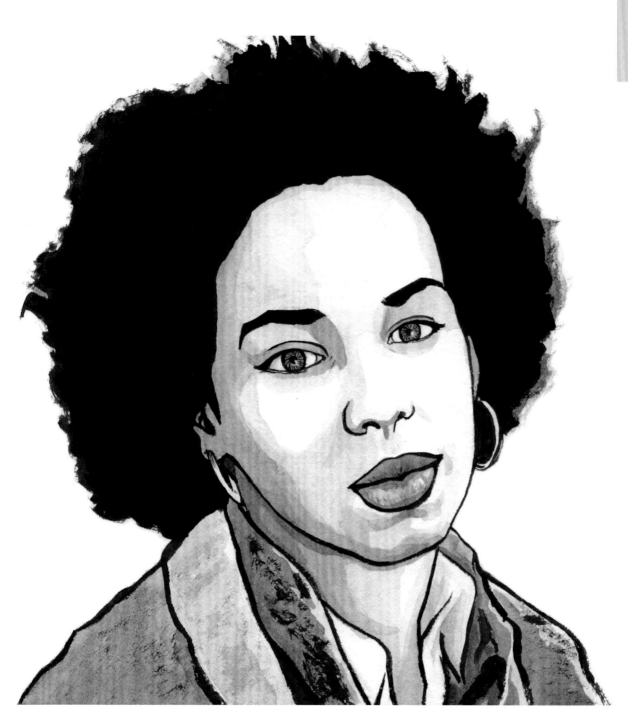

*Mellanie, USA* by Tim Clary, USA
ink and wash on illustration board,
6 x 6 inches (152 x 152 mm).

In retrospect the most interesting part of this portrait was using a variety of dry-brush techniques to get different textures in her clothing and around the edges of her hair.

# LIMITED COLOR

Limited color can make an otherwise monochrome piece "pop," directing the viewer's attention to an important focal point or creating a specific mood.

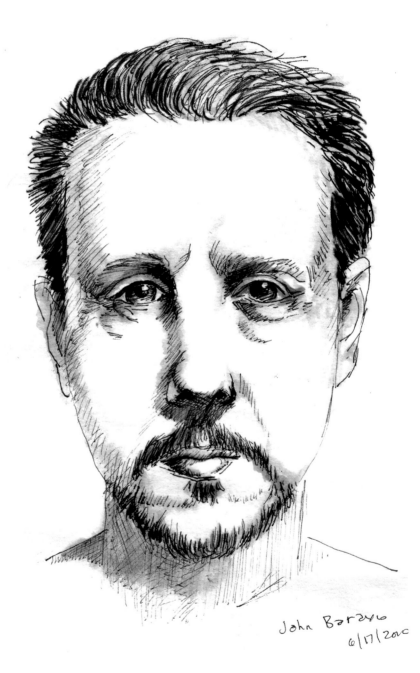

*John B., USA* by Mellanie Collins, USA ink and watercolor, 7 × 4½ inches (178 × 114 mm).

One of the things that struck me about the reference photo was how tired John looked. My initial ink drawing seemed really flat, but when I added a light watercolor wash the color and the light shadow that resulted really transformed the drawing and conveyed the mood that I was trying to capture.

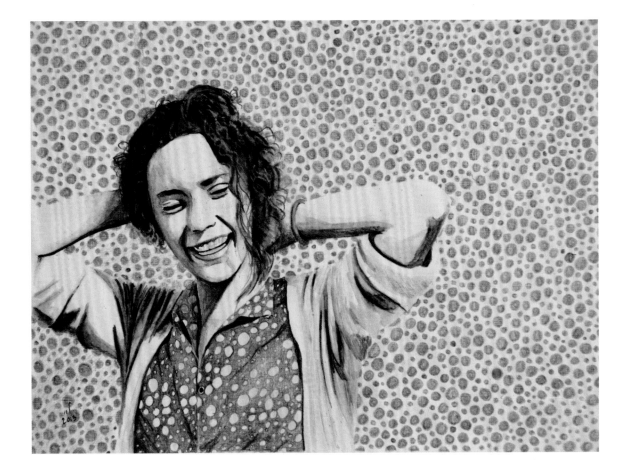

*Olga* by Irit Levy, Monaco
graphite and marker on
paper, 10¾ × 15¾ inches
(275 × 400 mm).

I decided to give the
drawing a strong
meaning using minimal
colors. I played with
the background, making
it a negative version of
her shirt.

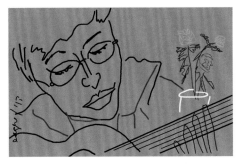

*Hansol, South Korea* by Elizabeth Lynch, USA
Doodle Dawg app on Kindle Fire, no fixed
dimensions.

I loved the translucent look and it seemed to need
just a dash of color. I like that I can draw on my
Kindle anywhere, without fear of running out of ink.

*Frank, UK* by Janet Burns, USA
charcoal pencil and watercolor on watercolor
paper, 8½ × 11 inches (216 × 279 mm).

I'm most comfortable with pen or pencil. But
Binky the bird was too vibrant a creature and
needed to be in color.

# PORTRAITS OF YIP SUEN-FAT

## Hong Kong

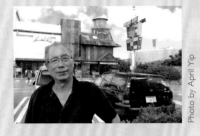

Photo by April Yip

"I started off painting in the traditional Chinese style and as I developed, my interests broadened to encompass different schools of painting. After posting my photos, I was honored to receive portraits in diverse styles and techniques. To this day, the passion and creativity of my fellow Portrait Party artists continues to inspire me to greater artistic expression on my own personal art journey."

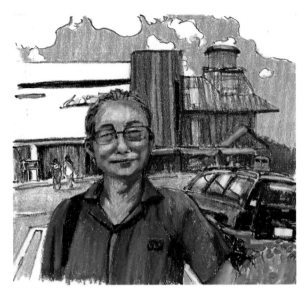

**Olivia Aloisi,** Switzerland
brush pen and Neocolor II crayons, 7 x 7¼ inches (180 x 185 mm).

I usually choose a reference photo that tells a story. The story can be told by the surroundings, by other people or animals within the photo, or by a certain light or atmosphere. I then try to accentuate that particular mood.

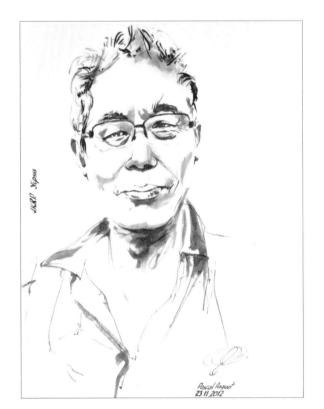

**Pascal Paquet,** Belgium
ink on Clairefontaine paper, 11 x 7¾ inches (280 x 200 mm).

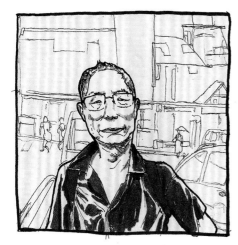

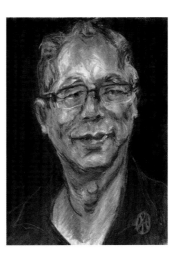

**FAR LEFT Vin Ganapathy,** USA
Micron, Tombow markers, and ballpoint pen in a Moleskine sketchbook and Photoshop,
3¾ x 3¾ inches (95 x 95 mm).

I used a Micron pen for the portrait and border, Tombow markers for the shading and shirt, ballpoint pen for the landscape, and Photoshop to whiten the border.

**LEFT Kristine Henshaw,** USA
charcoal, pastel and pastel pencil,
12 x 9 inches (305 x 229 mm).

Although we all share the same facial structure, the subtle differences between us are challenging and fascinating to render. My goal is to capture the mystery and dignity of the subject.

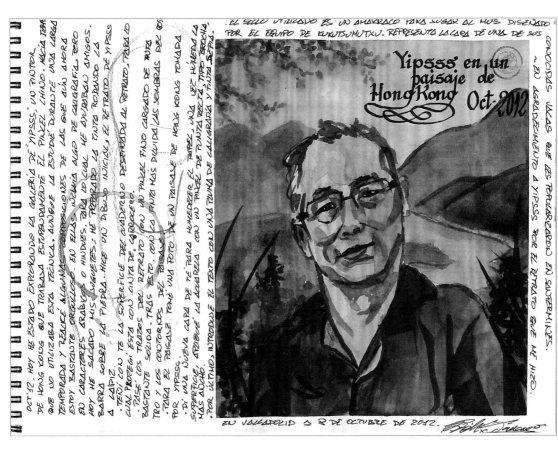

**Félix Tamayo,** Spain
ink, tea, and watercolor on fine grain Canson drawing paper, 9½ x 12½ inches (240 x 320 mm).

I combined two reference photos to create this portrait; one for the background and the other for the figure. I dyed the paper with tea, masking off the area with tape. I went over the sketched pencil lines with a fine Chinese brush using almost dry ink. Later, with a more diluted ink, I started to outline the landscape and then I shaded the portrait. I then wet the paper with a new layer of tea and immediately applied the watercolor. Finally, I wrote the text using a calligraphy brush and sepia ink.

# COOL TONES

The cool colors are usually defined as the half of the color wheel from green to violet, and many grays. There are also cool tones of the warm colors. A portrait does not have to be painted in realistic color, and allowing cool colors to dominate can contribute to the mood of the portrait.

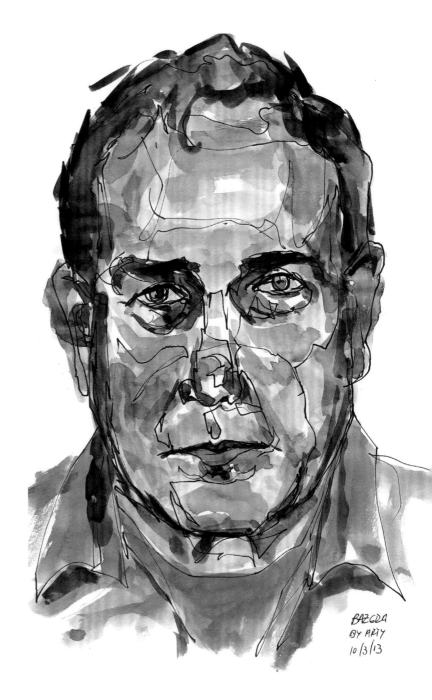

*"Bazgra," Netherlands*
by Arturo Espinosa Rosique, Spain
pen and watercolor on Fabriano paper,
11¾ × 8¼ inches (297 × 210 mm).

I am not methodical in how I do my work. Each one is done in a different way. I am very impulsive, and my work may show it.

*Claudia, Germany* by Rodney van den Beemd, Netherlands acrylic paint on canvas, 15¾ x 15¾ inches (400 x 400 mm).

In this work I went for an expressive and sketchy style portrait using a limited palette (phthalo blue, raw sienna, titanium white) and one single medium-broad brush. I prefer not to use small brushes for painting details in works like this as, in general, I find suggestion more powerful and intriguing than precise detail. That which can't be captured or suggested with a medium-broad brush is left out.

*Andrew, UK* by Jean-Pierre Godefroy, France watercolor on paper, 4¾ x 7 inches (120 x 180 mm).

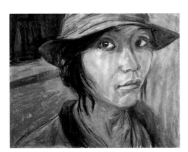

*Christina, China* by Mariah O'Neill, USA Neocolor and pen on paper, 9 x 12 inches (229 x 305 mm).

Neocolor crayons can be used to cover up mistakes in drawing, even with pen.

*Bill, USA* by R. J. Evans, USA marker and acrylic paint on canvas, 16 x 20 inches (406 x 508 mm).

I don't feel like an artist, but I keep making art. For me this painting was showing how he was tough and not getting taken advantage of. The facial and fleeting hair atop his head is augmented with coarse sand so as to stand out from the canvas.

# WARM TONES

The warm colors are usually defined as the half of the color wheel from yellow to red, including browns. There are also warm tones of the cool colors. Using a limited palette, such as letting warm colors dominate, can help create color harmonies.

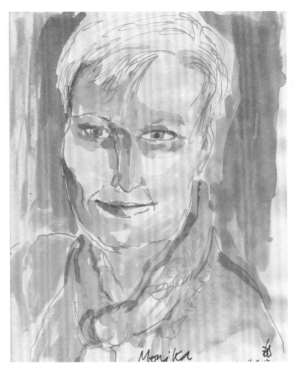

*Patrick C., USA* by Daniel Novotny, Slovakia
watercolor on paper, 11 × 15 inches
(279 × 381 mm).

*Monika, Germany* by Bénédicte Delachanal, Canada
Ecoline inks and felt pen, 10¾ × 8¾ inches (270 × 220 mm).

Ecoline inks are more vibrant, have a greater contrast between cold and warm colors and a more fluorescent effect than watercolor.

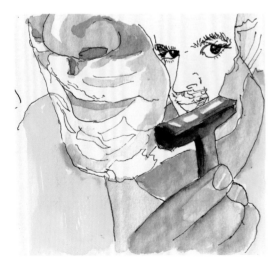

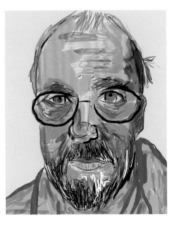

*Jörg, Germany* by Dalton de Luca, Brazil
watercolor on paper, 4½ × 4¾ inches (114 × 120 mm).

When I considered how the gesture of pulling a razor reveals smooth skin, I thought it could also reveal another image.

*Dan P., USA* by Kline Howell, USA
Sketch Club app on an iPad, no fixed dimensions.

I was intrigued by the brilliant colors available in Sketch Club.

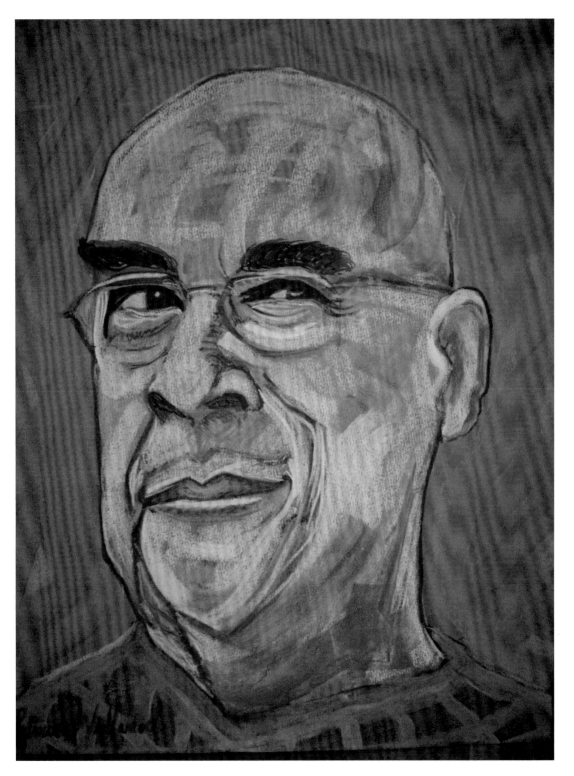

*Patricio, Chile* by Isabel Galve Burillo, Spain
pastel, 19¾ × 15¾ inches (500 × 400 mm).

# FULL PALETTE

Working with a full palette is the opposite of working with a limited range of colors. It can be a special challenge to include many different colors and still have all of the parts of the portrait work together in harmony.

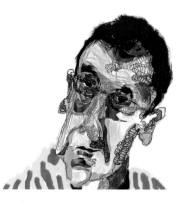

*Daniel C. A., Spain*
by Charlotte Tanner, USA
Harmony web app by Mr. Doob,
no fixed dimensions.

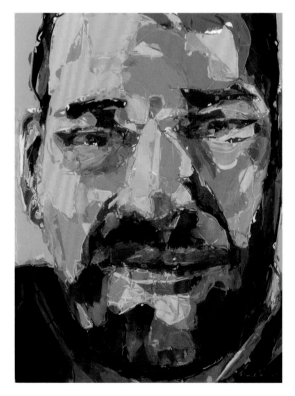

*Nick, UK* by Mike Ryon, USA
Paintbook, Glaze, and ArtStudio apps on an iPhone,
no fixed dimensions.

My goal was to emulate thick oil paint by eliminating most of the telltale signs of digital paint brushstrokes. By mashing together layers from several apps, I'm able to reduce their digital signature, sometimes evident when using one art app alone.

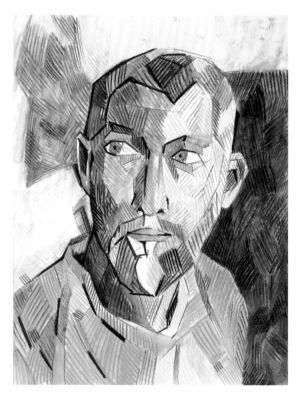

*Dave* by Cecca Whetnall, UK
water-soluble colored pencil on paper, 11¾ x 9 inches
(300 x 230 mm).

This painting was mainly created using water-soluble colored pencils although I also used some gel medium in parts of the background to create subtle texture. I tried to balance areas of strong bright colors with calmer sections of light and dark space.

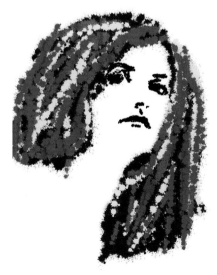

*Duncan, Canada* by Nick Kobyluch, UK
colored pencil in a sketchbook,
7¾ × 5 inches (200 × 130 mm).

*"AnAis," Spain* by Dalton de Luca, Brazil
SketchBook Pro on an iPad, no fixed
dimensions.

# CONTOUR DRAWING

In contour drawing, lines are drawn around and across the surfaces of the subject to show the forms and volumes. This is different from using lines to depict lights and darks or textures.

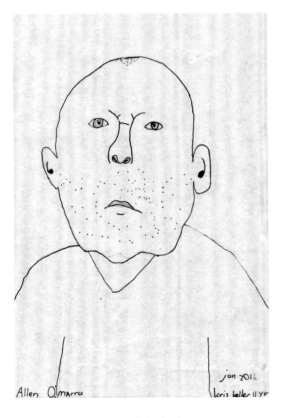

*Allan, Canada* by Kris Keller, Netherlands
pen and pencil on paper,
11¾ x 8¼ inches (300 x 210 mm).

*Norman, USA* by Jean-Pierre Welch, Panama
Brushes app on an iPad, no fixed dimensions.

Being able to capture somebody with just a few strokes is very challenging. Smartphones and tablets give artists the ability to express themselves differently and to share quickly.

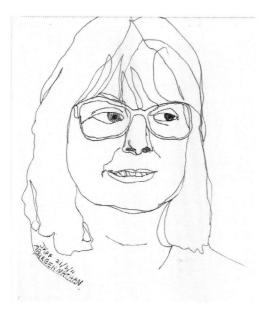

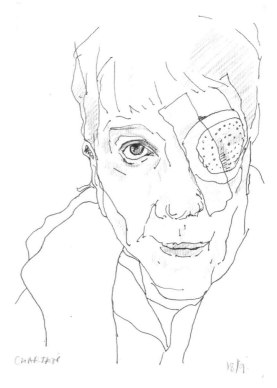

*Maureen, UK* by Grietje Keller, Netherlands
ink on paper using Lamy Safari fountain pen,
11¾ x 8¼ inches (297 x 210 mm).

When I draw a mouth with teeth I always think it is
difficult. Then I remember other artists saying they
also find it difficult. So I try not to think about drawing
teeth being difficult, but when you are trying not to
think something, often you just think it more. So instead
of thinking, I concentrate on the lines I want to draw.

*Charlotte, USA* by Ujwala Prabhu, India
pen on paper, 9¾ x 7 inches (250 x 180 mm).

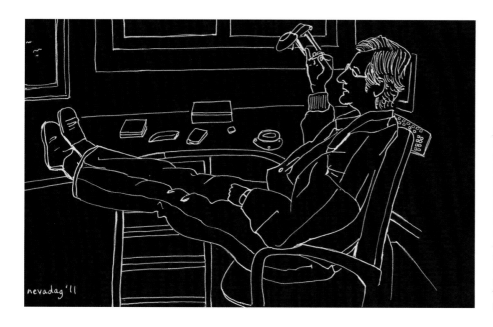

*Arturo, Spain* by Nevada
Gutierrez, USA
white gel pen in a
Strathmore Black Field
Drawing notebook,
6¾ x 10 inches
(171 x 254 mm).

I wanted to challenge
myself to draw without
a preliminary pencil
sketch. Drawing directly
in gel pen on black
paper is a great way
to free yourself from
perfectionist tendencies.

# PORTRAITS OF UJWALA PRABHU

## India

Photos by Ujwala Prabhu

"This was the first time that I had many artists drawing, sketching, scribbling, or painting me. I did not put up my photos looking for a likeness but to be a subject for artistic experimentation or practice. I have been continually delighted to see what each artist has done with these references in their unique way."

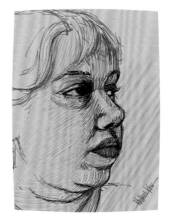

Michael F. King, USA
Sketch Club app on an iPad,
no fixed dimensions.

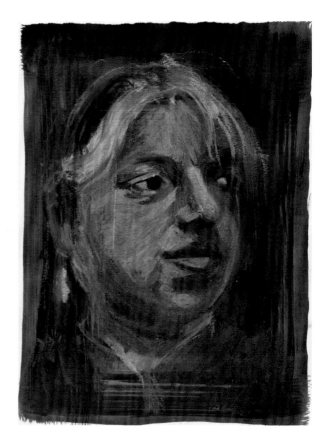

Irene Stellingwerff, Italy
oil pastel over acrylic paint background,
11¼ × 8¼ inches (286 × 210 mm).

By using a casually painted dark background you can give a specific depth and vivacity to a drawing. When you draw the light you make the figure emerge from the background.

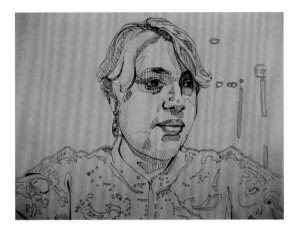

**Bill Rogers,** USA
ballpoint pen on drawing paper,
9 x 12 inches (229 x 305 mm).

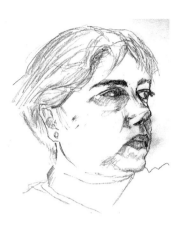

**Kline Howell,** USA
pencil on paper,
25 x 20 inches (635 x 508 mm).

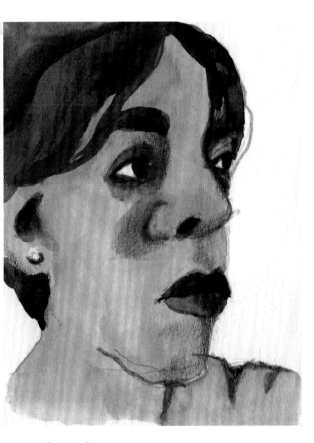

**Ira Prussat,** Germany
watercolor and colored pencil on paper,
4¼ x 3¼ inches (108 x 83 mm).

This is one of a series I made on a little
block of paper samples.

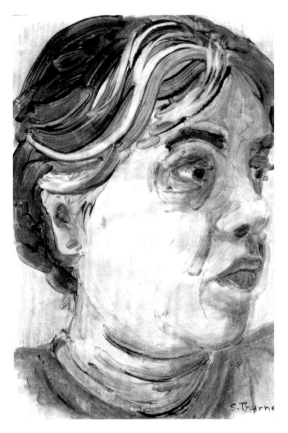

**Sherry Thurner,** USA
monotype, 7 x 5 inches (178 x 127 mm).

It's exciting to see the textures that result
from using this printmaking process.

# DRAWING WITH SHAPES

One of the easiest ways to draw with shapes is using a vector drawing app or program. You draw the outline, and the computer fills in the area with a flat color, pattern or gradient. You can work with opaque shapes or use transparent shapes to build up lights and darks, or simulate color mixing.

> " Working with shapes is a challenging way to draw a portrait, but the result can be very energetic. "
>
> JARRETT KUPCINSKI, USA

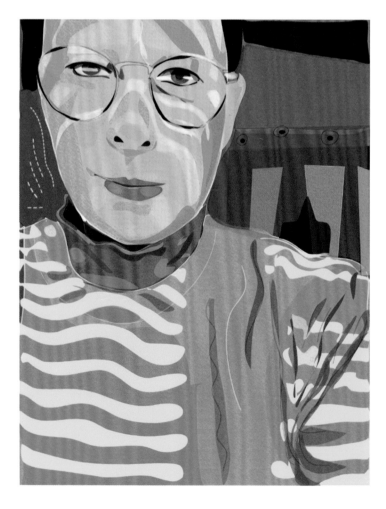

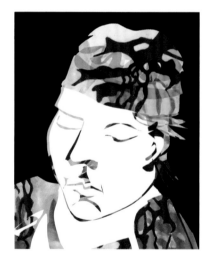

*Ann, USA* by Julia L. Kay, USA
acrylic paint on paper, Paintbook app on an iPad, Photoshop on a Mac, no fixed dimensions.

The batik effect was created by overlaying a scan of one of my acrylic paintings of plant forms with a vector drawing from life.

**LEFT** *Julia L. K., USA* by Rita Flores, USA
Inkpad and ArtRage apps on an iPad, no fixed dimensions.

This portrait was drawn in Inkpad, then imported to ArtRage to add texture.

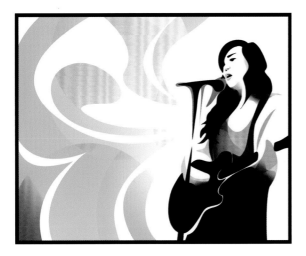

**LEFT** *Grace, South Korea* by Jarrett Kupcinski, USA
Inkpad app on an iPad, no fixed dimensions.

Often portraits can be static, so I like it when
there's some kind of action or story. The details
of the person weren't as important to me as
showing the emotions and the music. I tried
to portray those with vividly colored shapes in
superimposed layers using a vector drawing app.

**BELOW** *Ramón Carlos, Spain*
by Zoraida de Torres Burgos, Spain
Quill app on an iPad; blue background layer
added on Paint.net, no fixed dimensions.

This portrait was an early attempt at using a vector
drawing app. It was really fun to play with closed,
transparent shapes.

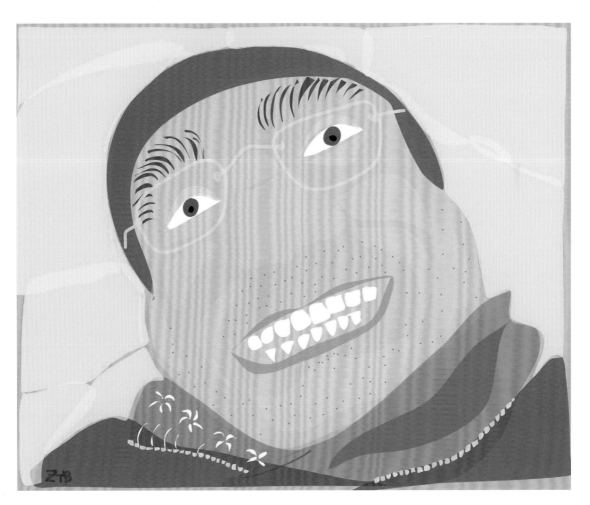

# PATTERNS

Patterns can liven up a portrait, providing contrast between busier and calmer areas. They can also bring energy and color to an otherwise low-key subject.

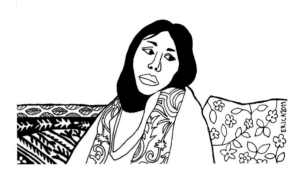

*Janet, Taiwan* by Erica Smith, UK
ink on paper and tweaked in Photoshop on a Mac, no fixed dimensions.

I loved the textiles in the reference photo and liked letting my pen wander and informally re-create the shapes.

*Kline, USA* by Leland Struebig, USA
Drawing With Carl app on an iPad, no fixed dimensions.

What I like about this app is that the paint roller tool will autofill any shape you draw with a pattern. This has the effect of making a line drawing look more painterly.

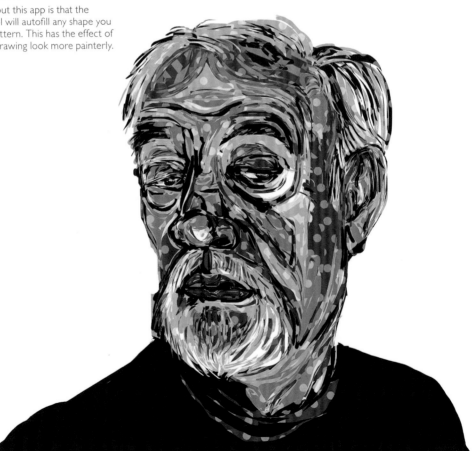

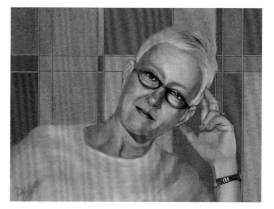

**RIGHT** *Melinda, USA* by Dan Hoffman, USA
ArtStudio app on an iPad, no fixed dimensions.

Making the most of the digital medium,
I experimented with several backgrounds for
this portrait before settling on this colorful,
abstract grid. With the portrait on one layer
and the background on another, I was able
to play with different background solutions
without disturbing the main subject.

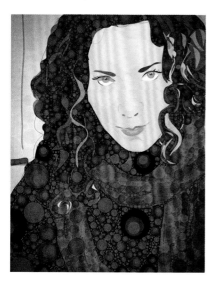

*Olga* by Rita Flores, USA
Inkpad, Percolator and SketchBook Pro apps
on an iPad, no fixed dimensions.

This portrait was drawn using the Inkpad
vector app on the iPad. I then applied effects
using Percolator and worked on it more using
Sketchbook Pro, to create an "app smashup."

**RIGHT** *Mireille, France*
by Béliza Mendes, Luxembourg
markers and washi tape, 7¾ x 5½ inches
(200 x 140 mm).

The rose-patterned tape suited Mireille's distinctive
features and gave the portrait an old-fashioned
look that I wanted. The striped background
added a modern touch. I decided to align the
washi tape to achieve a smooth pattern, but
you can play with it in different ways.

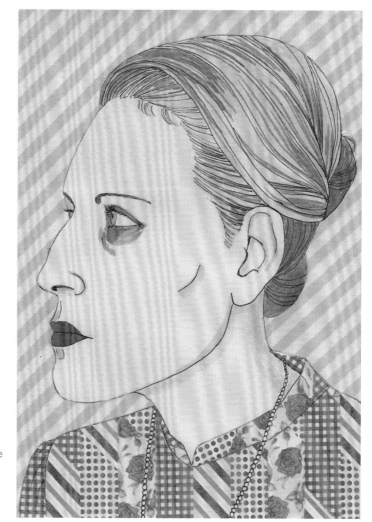

# PREPRINTED PAPER

Preprinted paper presents the interesting challenge of integrating compositional elements that are not part of your source subject.

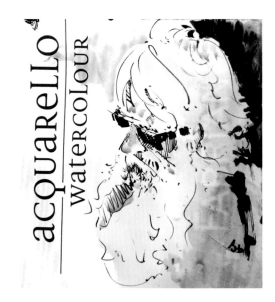

**RIGHT** *Philip, USA* by Uma Kelkar, USA
permanent ink and watercolor, 13 x 12 inches (330 x 305 mm).

Tree foliage and hair should never be feared. Draw them as freely as you like. The text provided a dark but sharp shape on the left to balance Philip's all-white beard. This composing happens in the head quickly but is ratified by the piece at a later time. I also chose to use watercolor along the right side so the embossed letters would show through and give it a multimedia feel.

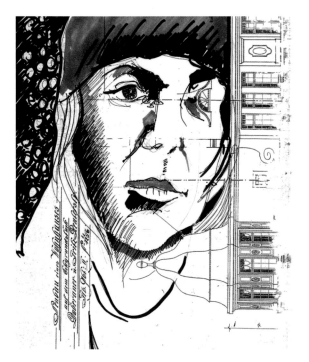

*Melisa, USA* by Hans Muerkens, Germany
black ink and felt tip pens on scrap paper,
11½ x 8¼ inches (290 x 210 mm).

Straying away from work to doodle a portrait on a piece of scrap paper, I saw one eye already there. The exquisite design of that 1900 building application was too good to throw away.

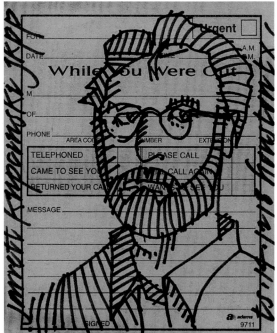

*Jarrett, USA* by Timothy Schorre, USA
pen on paper, 5 x 4 inches (127 x 102 mm).

I often try to express character in a portrait using extremely limited means. Using the preprinted telephone message sheet introduced some compositional dissonance and allowed for a "try and see" process.

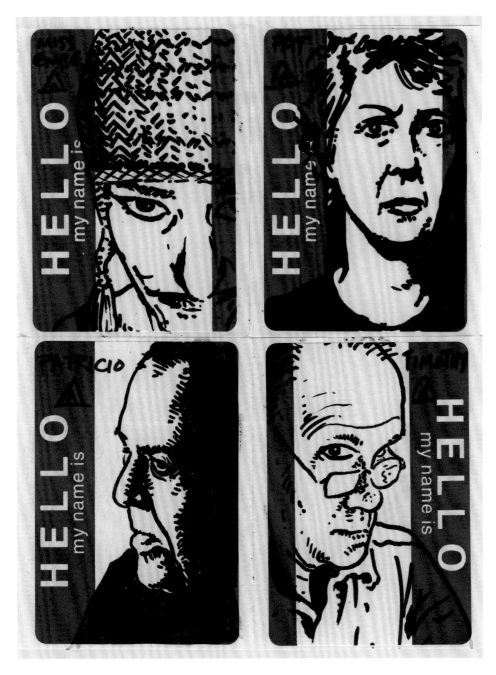

*JKPP goup* by Andres Musta, Canada
Sharpie on "Hello my name is" stickers, 6½ x 4½ inches (165 x 114 mm).

These images are part of a series of portraits made with a relatively thick marker on a small surface to force myself to pick out only the most essential and distinctive features of each face.

# DRAMATIC LIGHT

Dramatic light is a great opportunity for strong, emotionally charged portraits. It is also an opportunity to consider when you need to include details and when you can leave them out—both in bright highlights and dark shadows.

" **In order to capture the essence of the subject, whether the portrait is realistic or abstract, the structure and shape of the face, light and shadow, planes and dimensions and colors all have to be considered.** "

JENNIFER LAWSON, USA

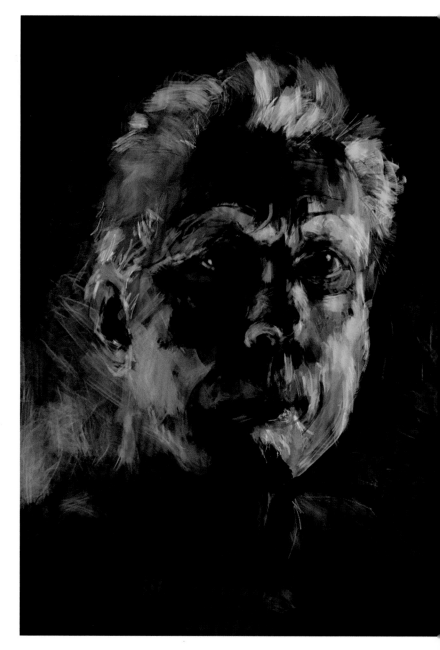

*Clyde, USA* by Roz Hall, UK
Procreate app on an iPad, no fixed dimensions.

Even though I paint digitally, I am inspired by classical portraiture, especially the work of Rembrandt. In Procreate I was using a brush called "Old Brush" which seemed to smudge the paint and scratch it away at the same time. I can't create art until I find a brush I can fall in love with. That is equally important when working traditionally or digitally.

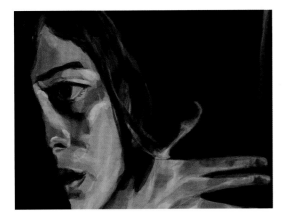

*Caitlin, USA*
by Timothy Schorre, USA
brush and ink on paper,
8¼ × 5 inches (210 × 127 mm).

Made with a Chinese brush
on one leaf of a watercolor
Moleskine sketchbook.

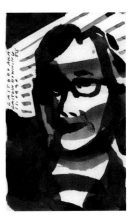

*Arron, USA* by Nini Teves Lapuz, USA
Sketch Club app on an iPad, no fixed dimensions.

The reference photo had a strong dramatic element that
reminded me of Rembrandt's self-portraits. It had all the
elements that make an interesting portrait subject for me.

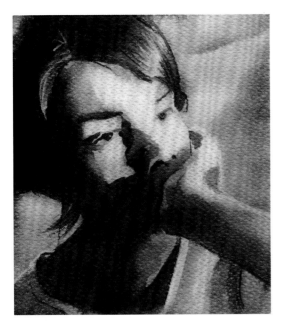

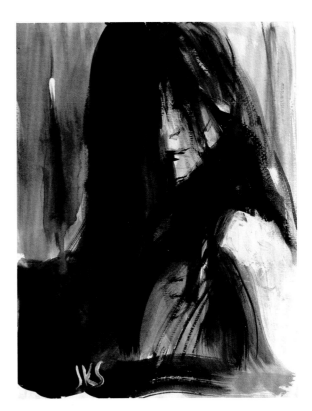

*Samar, Iraq* by Rafael Comino Matas, Spain
Payne's gray watercolor, black and white Conté
pencils on gray Canson paper, 5½ × 5 inches (140 × 125 mm).

You can modify a reference photo with a digital application
such as Photoshop to get a higher contrast reference image
to work from.

*Andrea, USA* by Jenny Sperry, USA
gouache and black india ink on cold press Arches
watercolor paper, 12 × 9 inches (305 × 229 mm).

Andrea's atmospheric reference photos drew me in, yet
paradoxically were somewhat difficult to see. In them, detail is
washed away to reveal pure mood and almost abstract form.
Painting this picture felt a bit like being in a trance. It was almost
as if a bell went off in my head telling me to stop at the end.

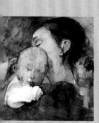
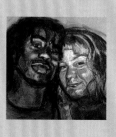
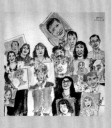
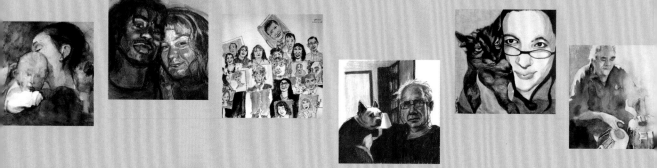
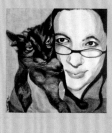
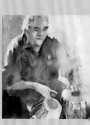

# PORTRAITS BY THEME

" When you see where and how
someone spends their time,
how they are with their family,
friends and pets; then you can
start to know them. "

JULIA L. KAY, USA

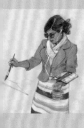
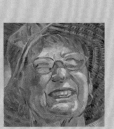
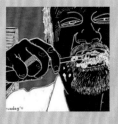
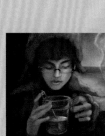
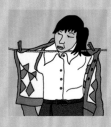
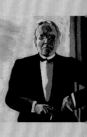

# BABIES

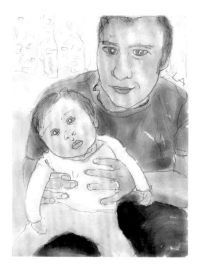

*Mark, UK* by Leslie Akchurin, USA
Paper 53 app on an iPad, no fixed dimensions.

I was trying to get the ratio of floppiness to rigidity in the baby's body . . . and not make her arms larger than they were in the photo, even though they seemed too skinny for her big head!

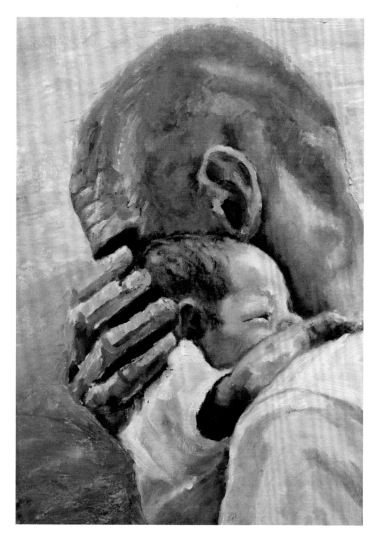

*Kris, Belgium* by Julia Sattout, Australia
oil paint on canvas, 15¾ × 11¾ inches (400 × 300 mm).

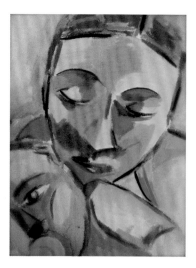

*Natalia, USA* by Marie Aschehoug-Clauteaux, France
wax pastel on paper, 8¼ × 6 inches (210 × 150 mm).

I love the tenderness shown in the reference photo and, as a mum, motherhood is a subject which moves me deeply.

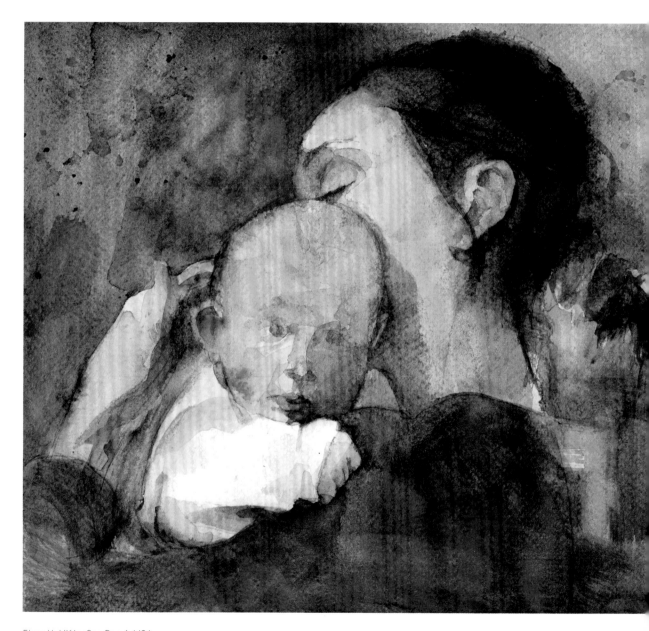

*Elena V., UK* by Sue Ramá, USA
watercolor, 8 x 8 inches (203 x 203 mm).

I was so happy for Elena when I saw the photo of her with her
new baby. Watercolor calls for a certain abandon; this came
from the abandon of the heart.

# DOUBLE PORTRAITS

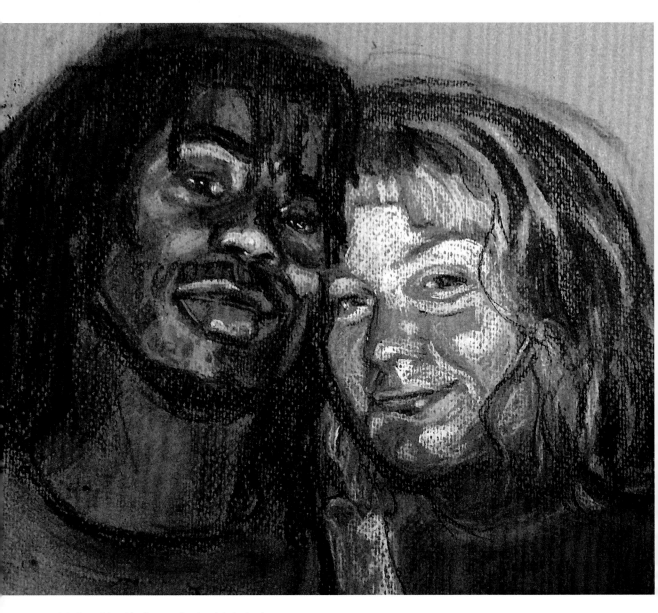

*Julia B. and friend* by Simone Geerligs, Netherlands
soft pastel on Canson paper, 13¾ × 16½ inches (350 × 420 mm).

For this portrait I used about seven colors. It was particularly challenging drawing
the different skin tones and making the light and dark colors harmonize.

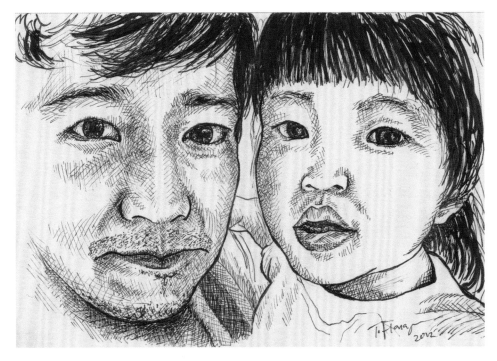

*Heanu, South Korea, and friend* by Timothy Flanagan, USA
pen on paper,
5½ × 8½ inches
(140 × 216 mm).

Two faces of love in extreme close-up. Their bond is so palpable I just had to try to capture it on paper.

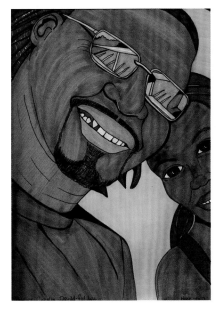

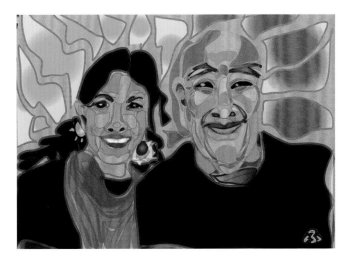

*Patrick C., USA, and friend* by Tammy Valley, USA
markers, 11½ × 8¼ inches (292 × 210 mm).

Cropping part of the subject can be more engaging to viewers, and pull them into your drawing.

*Nini, USA, and Patricio, Chile* by Francesca Andrews, USA
pencil on paper, Skribl app on an iPad, no fixed dimensions.

I sketched the subjects in pencil, then photographed the drawing and imported it to Skribl as the basis for my portrait.

# PORTRAITS WITHIN PORTRAITS

*JKPP group, UK* by Zoraida de Torres Burgos, Spain
Zen Brush app on an iPad using my finger, no fixed dimensions.

This quick freehand sketch was made from a screenshot of a Skype meetup in Hastings, UK.

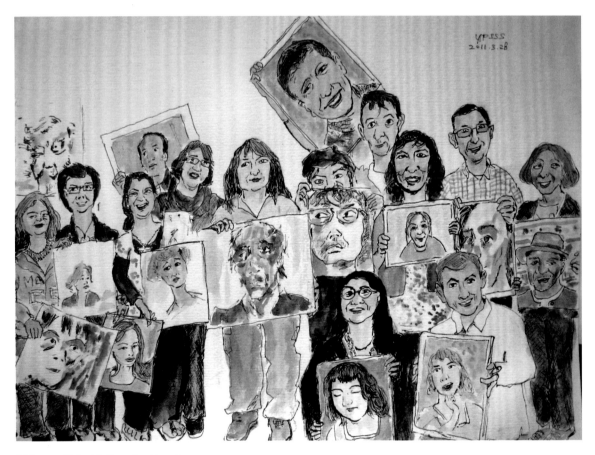

*JKPP group, UK* by Yip Suen-Fat, Hong Kong
ink and watercolor, 7¾ x 11¾ inches (200 x 300 mm).

This portrait looks complicated because there are many people, and their portraits.
I used pencil to roughly plan out where each figure should go, and then drew the
details, focusing on one person at a time. See Jane Sherwood's portrait of Rodrick
(above, far right) on page 133.

*Jane, UK, and Julia L. K., USA* by Janice Wahnich, UK Harmony app on an iPad, no fixed dimensions.

This is Jane sketching Julia over Skype at a JKPP meetup in Oxford, UK.

*Julia L. K., USA, and friends* by Pedro Villarrubia, Spain marker on paper, 12 x 11¾ inches (303 x 297 mm).

I wanted to emphasize the double portrait in the reflection in the mirror. I also wanted to draw it with only the hatched lines of a black marker.

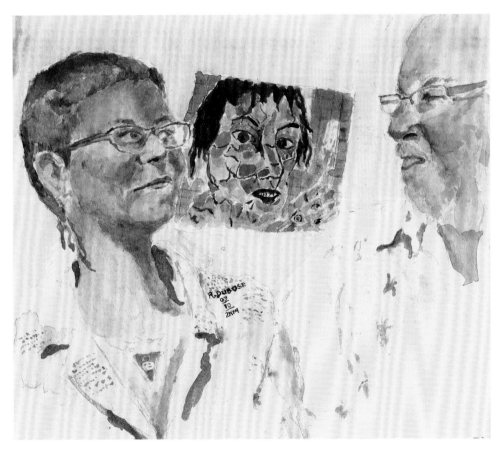

*Gila, USA, and friend* by Rodrick Dubose, USA watercolor and gouache, 9½ x 11 inches (244 x 279 mm).

I wanted to portray the artist Gila with an example of her artwork (see original mosaic on page 188). The representation of her mosaic in the picture was almost like doing a portrait within a portrait.

# PORTRAITS OF RODRICK DUBOSE

## USA

"I get a sense of joy when I see my portrait done by someone I don't know, from anywhere in the world, in any medium or style."

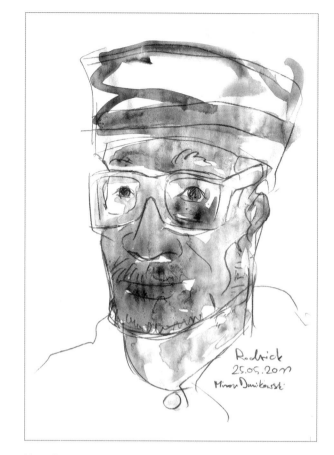

**Miron Dunikowski,** Poland
pencil and watercolor, 8¼ × 5¾ inches (210 × 148 mm).
This is an early portrait, made when I was about twelve years old.

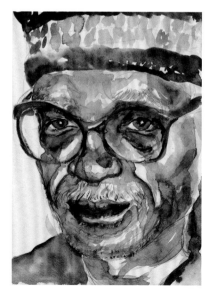

**Sean Cronin,** Ireland
watercolor on paper, 9¾ × 7 inches (250 × 180 mm).

I find it useful to have a satisfactory pencil sketch before applying any paint, as corrections in watercolor are notoriously difficult. I recommend using clean water as colors become flat and muddy if the water is not changed regularly.

**Nicole Little,** Canada
marker and ink in paper,
5½ × 7 inches (140 × 180 mm).

The paper on the larger
Moleskine notebooks is too
porous to take marker well.
However, the 3½ × 5½ inches
(90 × 140 mm) Moleskines
have lovely smooth paper
which allows the ink to sit on
the surface and shine.

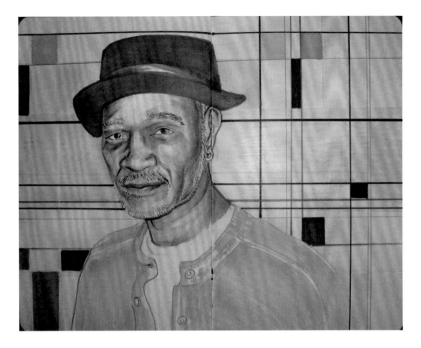

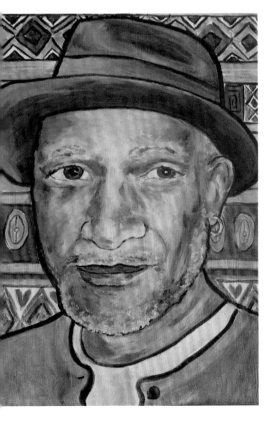

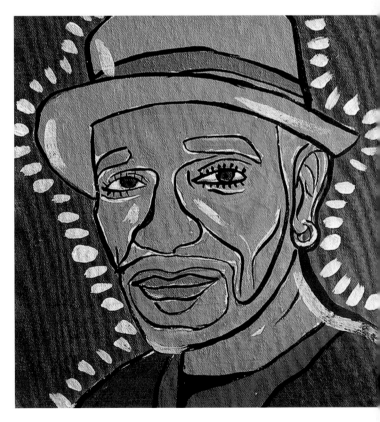

**Jane Sherwood,** UK
acrylic paint on canvas, 15¾ × 11¾ inches (400 × 300 mm).

**Patricia Brasil,** Brazil
acrylic paint on board, 6 × 6 inches (150 × 150 mm).

# ANIMAL COMPANIONS

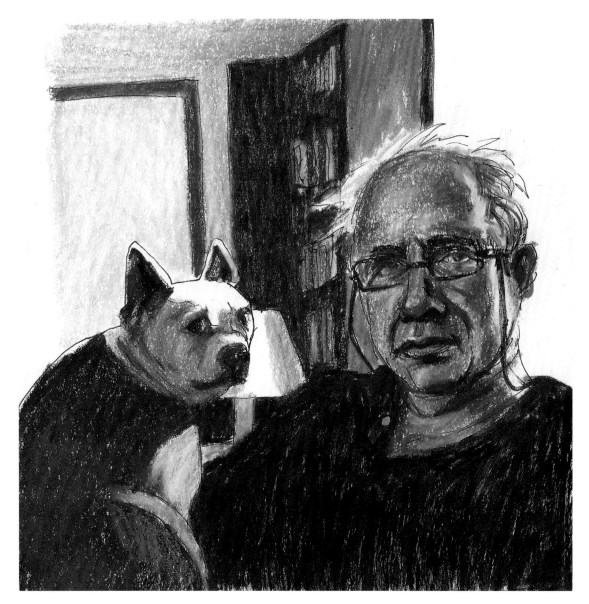

*Mitt, USA* by Olivia Aloisi, Switzerland
ink pen and wax crayons, 7 x 7 inches (180 x 180 mm).

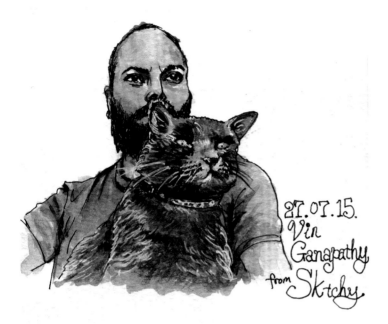

*Karen S. L., USA* by Barry Wayne Farmer, USA
pencil on printer paper, 6¾ × 9 inches
(171 × 229 mm).

*Vin, USA* by Angel Zhang, China
watercolor, pen and ink, 5 × 5¼ inches (126 × 136 mm).

I used pen to draw the outlines directly without making a pencil sketch first, and to add some texture. Then I moved on to watercolor, and highlighted the cat's fur at the end.

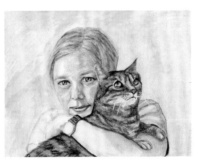

*Ineke, Netherlands* by Sally Sheen, UK
Neocolor II and ink on watercolor paper,
9 × 12 inches (229 × 305 mm).

There is something special about the relationship between animals and their people which makes bringing them together in a portrait such fun. There is an unintended child-like quality to this painting which perhaps reflects the playful nature of that relationship.

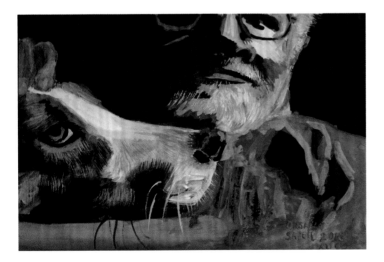

*Walt, USA* by Oksana Shiell, USA
gouache in a sketchbook, 5 × 7 inches (127 × 178 mm).

I paint with gouache or other water media when I don't have time for lengthy set-up and clean-up.

> **Use the white of the paper; you don't have to draw everything. When you suggest a large part of the portrait, everyone has a unique interpretation of the drawing, made of what the artist puts on the paper and what the brain of the viewer imagines.**
>
> SVEN JORDY, FRANCE

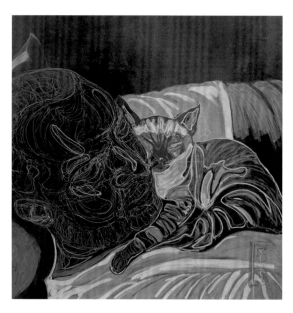

*Andy, UK* by Kim L. Thieu Domingo, France
acrylic paint on wood, 31½ × 31½ inches (800 × 800 mm).

The relationships between people and their animals interested me, and this portrait is one of the five portraits I did for my research on different links between living beings.

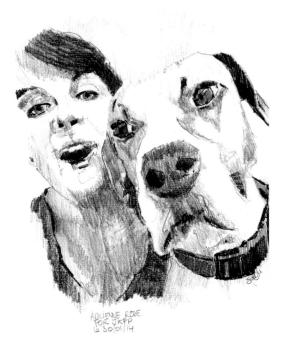

*Adrienne, Germany* by Sven Jordy, France
pen on paper, 8¼ × 5¾ inches (210 × 148 mm).

They come out of the paper, especially the dog. I feel I can touch his nose with my hand. And they look so cool together, like I am with my dog, who's more than a dog, a companion.

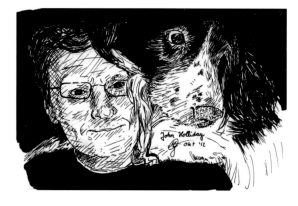

*John H., UK* by Manuel Grote, Germany
ink on Moleskine paper, 5 × 8¼ inches (130 × 210 mm).

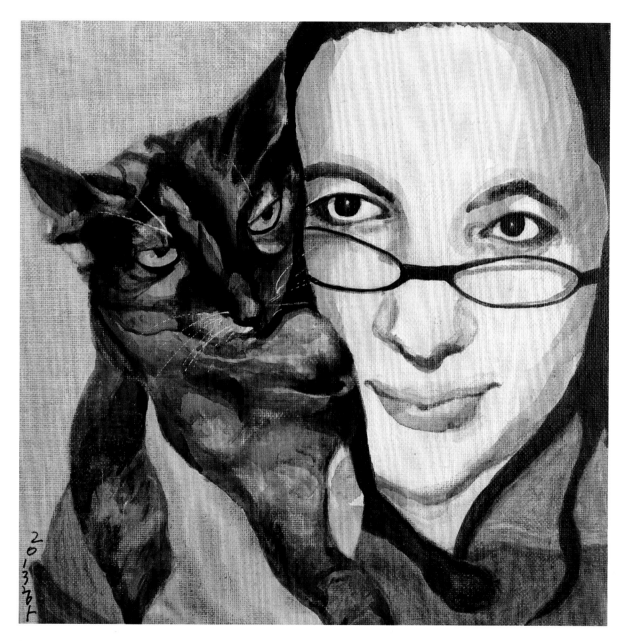

*Rebecca M. D. G., USA* by Hwasook Hwang, South Korea
acrylic paint on canvas, 10¾ x 10¾ inches (270 x 270 mm).

When members post reference photos with their cats, they always
catch my attention and captivate me. Whenever I draw them, I'm so
happy. They are really good friends for all people.

# MUSICIANS

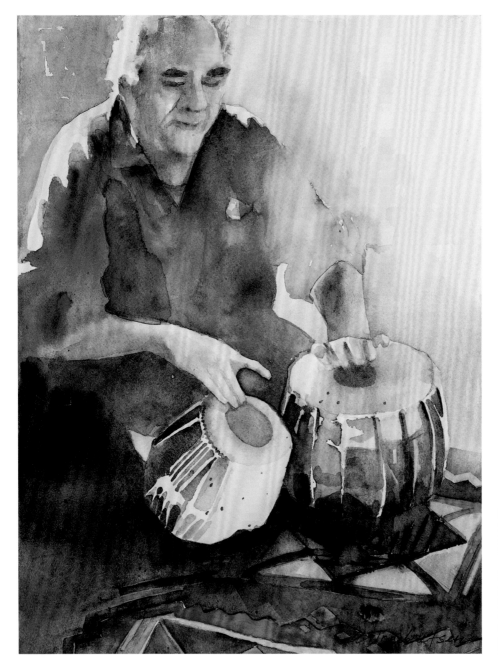

*Patricio, Chile*
by Elizabeth
Ingebretsen, USA
watercolor on paper,
14½ × 10½ inches
(368 × 267 mm).

I was interested in
the carpet and its
reflections on the
drums' surface, the joy
on Patricio's face and
his intense focus.

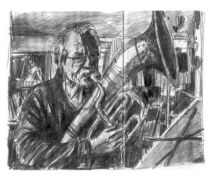

**ABOVE** *Mitt, USA* by Nick Kobyluch, UK
pencil on paper, 6¾ x 8¼ inches (170 x 210 mm).

I used pencil because this pad has very thin, poor quality paper and the inks that I normally use bleed through—so this was a chance to get back to basics and use a 4B.

**LEFT** *Heanu, South Korea* by Cooper Renner, USA
ArtRage app on an iPad, no fixed dimensions.

I used the pastel chalk tool, set to a very thin line, aiming to reduce the portrait subject and his setting to only the most essential lines. It is a freehand treatment and not a manipulation of the reference photo.

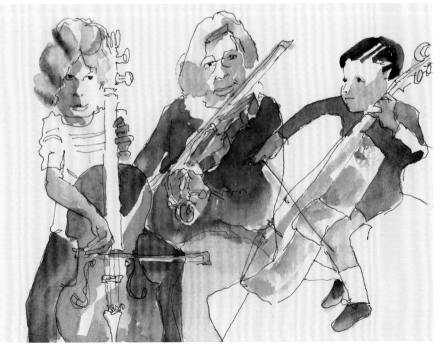

*Gila, USA, and friend*
by Dalton de Luca, Brazil
watercolor on paper,
7 x 9¼ inches
(178 x 235 mm).

When I learned that Gila played cello in childhood, as I did, I created this trio which included both of us. This is a feat possible only with community and imagination which extend across all borders.

# PORTRAITS OF PEPE FÁRRES

## Spain

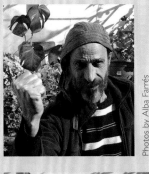

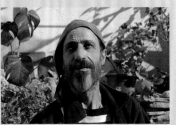

Photos by Alba Fárrés

"At first the sensation of being portrayed is somehow bittersweet. It is so exciting and funny when someone whose work you admire makes a drawing of you, and it feels odd when you see your features made with rough strokes in a less accomplished painting.

However, when you are portrayed so often and so rapidly the acceptance of your own image is absolute in a short time. Indeed, those portraits gave me the keys of my external appearance and personality, which helped me to create my first self portraits."

Kristine Henshaw, USA
charcoal and pastel, 12 x 9 inches (305 x 229 mm).
Many of us had fun with the very animated photo of Pepe Fárres. It immediately broght to mind Winslow Homer's painting *The Lookout*, which I adapted.

Michael F. King, USA
Sketch Club app on an iPad, no fixed dimensions.

**Vin Ganapathy,** USA
ink and markers on Moleskine paper,
9¾ x 7¼ inches (248 x 184 mm).

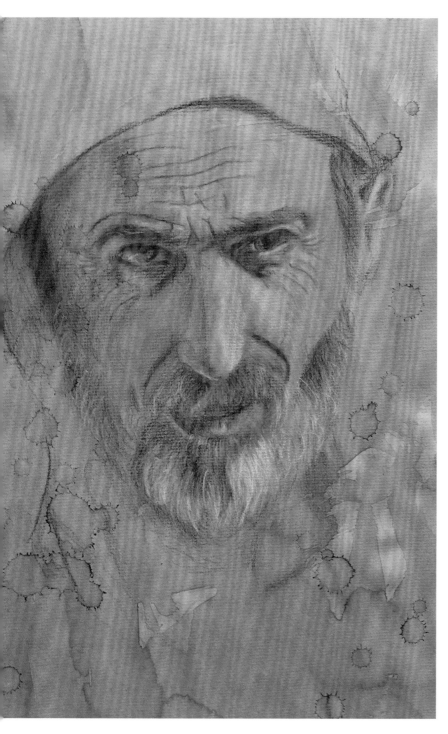

**Dan Powell,** USA
pastel pencil on distressed paper,
14 x 11 inches (356 x 279 mm).

Before drawing, a wash of coffee, gouache and watercolor was
brushed, dripped, and splattered onto gray paper and allowed to dry.

**John Holliday,** UK
pen on paper,
8 x 5¾ inches (205 x 145 mm).

I work fast and do my portraits in one
go. I start at the top and work my way
down trying to get the shapes correct
and also the proportions right. Not
everything always goes to plan but
that's the nature of portrait work.

# ARTISTS AT PLAY

*Sally, UK, and Jenny, USA* by Gila Rayberg, USA
Pocket Etch-A-Sketch,
2¼ × 3 inches (57 × 76 mm).

When I pick up the Etch-A-Sketch, I'm aiming for a fast and loose interpretation . . . a quick exercise, as if doing a semi-blind contour drawing.

*"Mr. Flibble," UK* by Giorgio Bordin, Italy
ballpoint pen, scanned and colored in Photoshop on a Mac, no fixed dimensions.

I had fun drawing this and many have told me it has made them smile. I think that the reason lies more in "Mr. Flibble's" performance, than in my own.

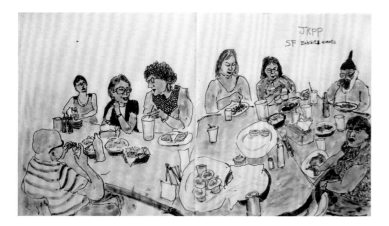

*JKPP group, USA* by Yip Suen-Fat,
Hong Kong
pencil, ink, and watercolor in a sketchbook,
10¾ × 18¾ inches (275 × 475 mm).

I did a rough drawing with pencil to
plan out the composition, paying
attention to the perspective and the
size of each person. I then drew
the details of each person and finally
colored the drawing using watercolor
wash, leaving white space as highlights.

**ABOVE** *Tom, Australia* by Shalini Raman
Parakkat, India
pencil on paper, 8 × 6 inches (203 × 152 mm).

Tom's photo had an energy and a sense of
fun, which I wanted to capture. I considered
using this pose to draw Tom as a magician
with top hat and glitz, but then the scene
on its own had a lot of energy so I stayed
with what was in the photo. It felt like
drawing while listening to a pop song.

**LEFT** *Patrick M., USA*
by Richard Shulman, USA
SketchTime and Brushes apps on an iPad;
drawn with my finger, no fixed dimensions.

I was interested in capturing the reflection
of light in the pool. As this was an early
iPad piece, the resolution available from the
painting apps was not very good. But instead
of being limiting, this was quite freeing, since
I didn't get as caught up in details as I
would today. This lends a more painterly
feeling to my work from this period.

# ARTISTS AT WORK

*Simone G., Netherlands*
by Linda Jackman, USA
pencil, ink pens, and colored pencils on medium-weight sketchbook paper, 8 × 6 inches (203 × 152 mm).

This "Portroodle" combines a portrait with doodle designs to show an artist at work whose creativity flows from her brush into designs that swirl off into her surroundings. First Simone's silhouette and the desk were lightly sketched in pencil. Then Simone and the freehand doodles were inked and colored.

**OPPOSITE, TOP** *Kim, South Korea*
by Vin Ganapathy, USA
ink and markers on Moleskine paper,
7¼ × 9¾ inches (184 × 248 mm).

**RIGHT** *Uma, USA, and friends*
by Patricia Gaignat, USA
Finngr Pro and ArtRage apps on
an iPad, no fixed dimensions.

Uma was posing for us at a JKPP
meetup. I am unable to resist other
sketchers: they are perfect models
because they rarely change position.

*Uma, USA* by Laurie Wigham, USA
gouache and Conté pencil,
14 × 11 inches (356 × 279 mm).

You can make a very tightly
controlled painting with gouache;
here I added the rough black lines
on top to loosen it up a bit. I picked
the salmon-colored paper to
coordinate with the colors on her
skirt and jacket (and I put dabs of
those colors on her palette too).

*Marga, UK*
by Amy Lehr Miller, USA
graphite sketch, painted
digitally with SketchBook
Pro on a Mac using a
Wacom tablet, no fixed
dimensions.

Often I like to work on
paper and then scan
and paint with digital
brushes on the tablet.
This one was about fast
and loose lines creating
spontaneous energy,
but with a little more
detail in the face.

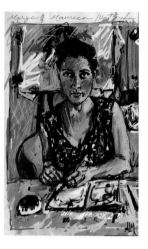

*Martin, UK* by Valérie
Mafrica, France
watercolor and pencil,
7¾ × 6 inches
(200 × 150 mm).

After a quick contour
line drawing in pencil, I
used watercolor washes
to capture a moment
of concentration and
sweetness: a man is
drawing in an art gallery,
without paying attention
to the curiosity of the
passersby.

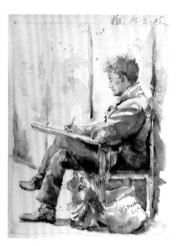

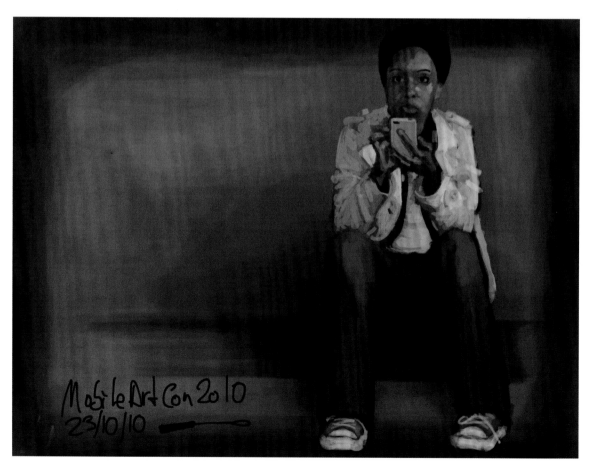

*Mia, USA* by Joseandrés Guijarro, Spain
Square brush tool in Brushes app on an iPad, no fixed dimensions.

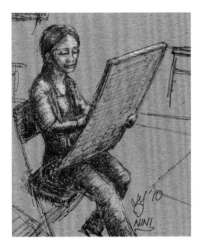

*Nini, USA* by Lorraine Young, Canada
Micron pen on St. Armand Canal
paper, 10 × 9 inches (254 × 229 mm).

This was a very quick sketch. Nini's
relaxed body combined with her
intense focus on her art just shouts
out to me: "artist at work."

**" Drawing other
artists gives
me a chance to
experiment without
having to worry
about likeness or
the end result. "**

UJWALA PRABHU, INDIA

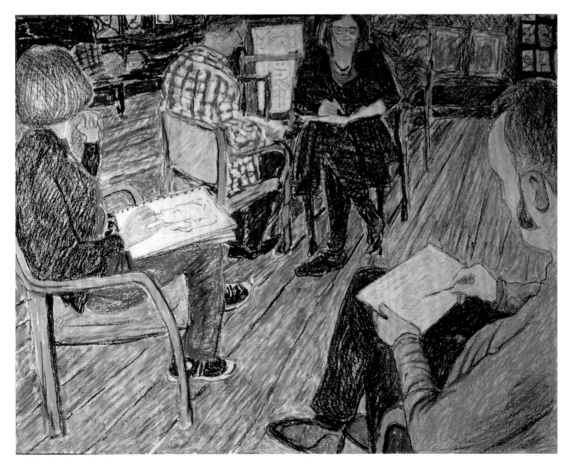

*JKPP group, UK* by Martin Beek, UK
oil pastel on Canson pastel paper, 20 × 28 inches (508 × 711 mm).

# PORTRAITS OF MARIAH O'NEILL

## USA

Photo by Peter O'Neill

Photo by Mariah O'Neill

"Although I felt honored by many beautiful portraits, I am more interested in doing them than being a subject. I am not a huge verbalizer about art either. I feel that art should go beyond words and that using words to construct concepts about it limits it."

**Zoraida de Torres Burgos,** Spain
Brushes app on an iPad using an iFaraday stylus, no fixed dimensions.

In this digital linocut the eraser tool was used over a black layer to expose the white layer underneath.

**Herman Schouwenburg,** Netherlands
acrylic paint on wood, 7¾ x 6 inches (200 x 150 mm).

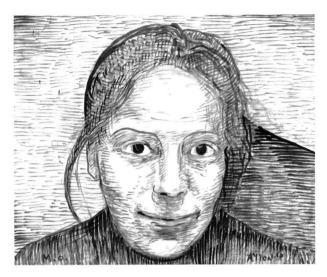

**William T. Ayton,** USA
brush and ink on paper, 8½ × 11 inches (216 × 279 mm).

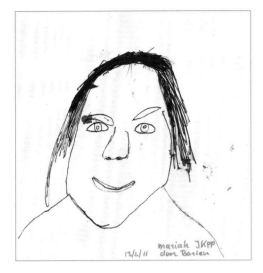

**Barien Kanie,** Netherlands,
India ink on paper, 7¾ × 7½ inches (200 × 190 mm).

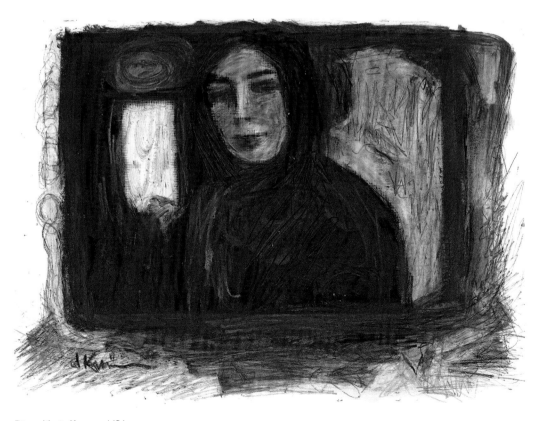

**Diane Marie Kramer,** USA
oil pastel and pencil on paper, 7 × 10 inches (178 × 254 mm).

I did this sketch quickly—just one pass with no edits or remakes. This is the way I usually like to work.

# HATS

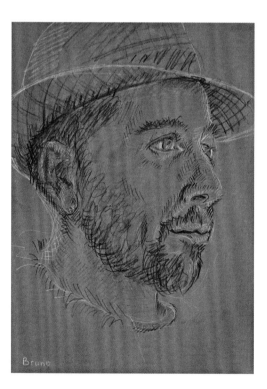

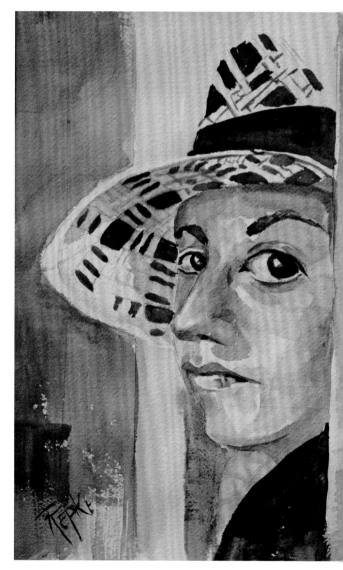

*Bruno, Spain* by Elena Vataga, UK
sepia, charcoal and chalk on green paper,
14 × 10 inches (356 × 254 mm).

Try using colored paper: on white paper, a drawing can develop only from light to dark. On colored paper, you can work in both directions: with lighter and darker marks.

*Carmen, Spain* by Judith Repke, USA
watercolor on paper,
20 × 13 inches (508 × 330 mm).

The background is a combination of freeflowing wash and dry brush drags. The face is layered washes. Parts of the hat pattern are left to the imagination and not fully rendered

*Patrick C., USA* by Nick Kobyluch, UK
colored pencil in a sketchbook,
7¾ × 5½ inches (200 × 140 mm).

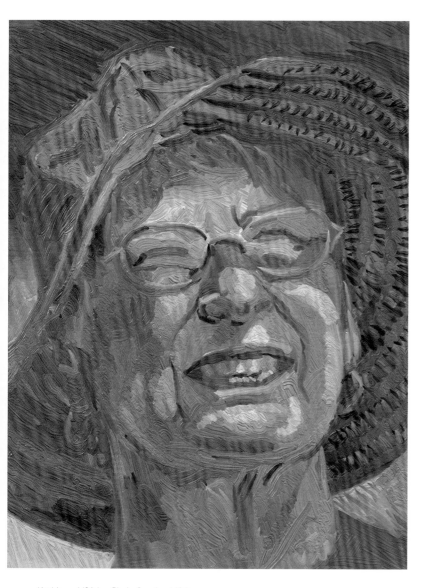

*Kathleen, USA* by Clyde Semler, USA
Thick oil brush tool in ArtRage Studio Pro on a PC
using a Wacom tablet and stylus, no fixed dimensions.

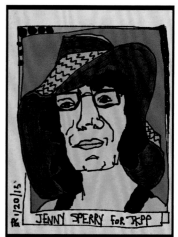

*Jenny, USA* by Patricia Gaignat, USA
Finngr Pro and ArtRage apps on an
iPad, no fixed dimensions.

When I saw the reference photo of
Jenny I was immediately drawn to that
large, wonky hat.

# ON LOCATION: INDOORS

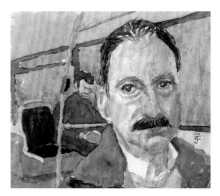

*Roberto P. A. D., Spain*
by José Zalabardo, UK
watercolor on paper,
7¾ × 8¾ inches (195 × 225 mm).

When painting, the artist uses colors and shapes which prime the viewer's brain to magically transport them to the scene, in this case the inside of a bus.

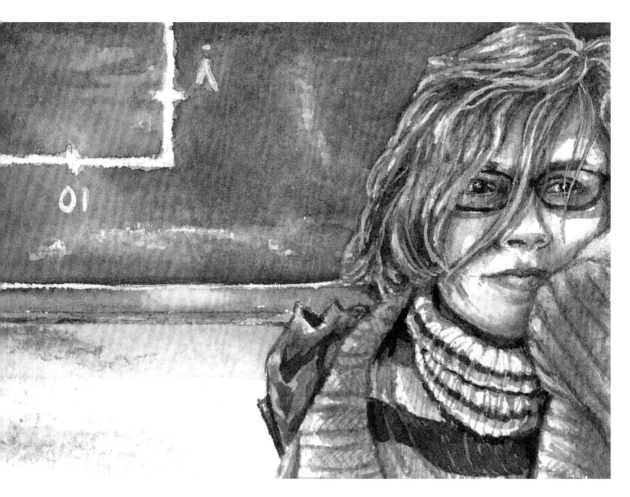

*Inma, Spain* by Joan Yoshioka, USA
watercolor on watercolor paper, 2½ × 3½ inches (64 × 89 mm).

I love how Inma's hair falls over her face, that she is wearing textured clothing and in a classroom setting, all of which I found presented unique challenges and were fun to paint.

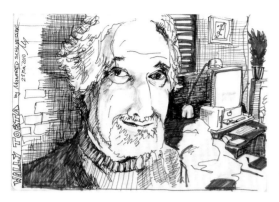

*Walt, USA* by Manfred Schloesser, Germany
ink pen on paper, 6¾ × 10 inches (173 × 257 mm).

Try combining several pens that make marks of different sizes.

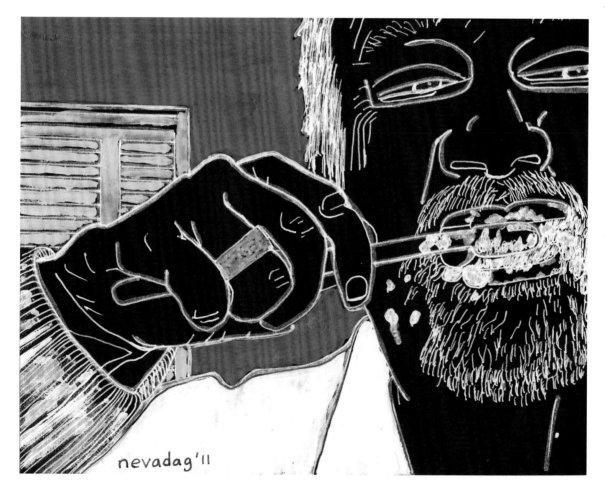

*Kline, USA* by Nevada Gutierrez, USA
white gel pen and acrylic paint on Strathmore Black Field Drawing paper, 6¾ × 8 inches (171 × 203 mm).

As soon as I saw the original reference photo, complete with toothpaste foam, I knew I wanted to try drawing this portrait with a white gel pen.

# ON LOCATION: OUTDOORS

*Gila, USA* by Jean-Pierre Godefroy, France
charcoal on paper, 17¾ × 12½ inches
(450 × 320 mm).

What is she looking at: a bird, a plane, or
a funny face in the clouds? The drawing
does not say.

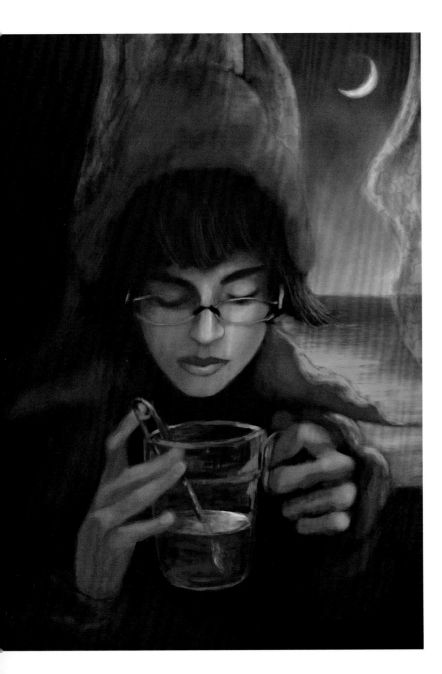

*"Niyousha," Iran* by Dan Hoffman, USA
Procreate and TileDeck apps on an iPad,
no fixed dimensions.

The moon and ocean are favorite
subjects of mine. One or the other often
ends up in my portraits, whether or not
they were in the original reference photo.

**RIGHT** *Vin, USA* by José Zalabardo, UK
watercolor on paper, 9¼ × 6½ inches
(235 × 165 mm).

A portrait doesn't have to have a
background but if it does it has to be
conceived together with the figure
as one image. A limited palette helps
with this, as a reminder that what
looks like sky and what looks like
a shirt, or what looks like a face and
what looks like a wall, are in fact only
patches of paint on a piece of paper.

**LEFT** *Karen H., USA*
by Giovanni Benedettini, Italy
ArtRage and Photoshop on a PC
using a Wacom Bamboo Fun stylus,
no fixed dimensions.

The subject was taken from the
reference photo; the composition
with brick wall, cat and sunflower
is my creation.

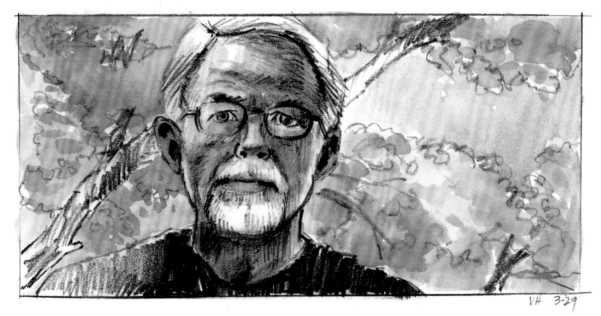

*Barry, USA* by Virginia Hein, USA
pencil and watercolor, 5 × 10¼ inches (127 × 260 mm).

The fun of doing these portraits of fellow artists that I have never met in person
was seeing what their photos suggested, as well as getting a sense of the
person from his or her art. The foliage in this portrait was inspired by Barry's
reference photos as well as by some of his own artwork of interlacing branches.

# PORTRAITS OF GIORGIO BORDIN

## Italy

"It's strange to see so many interpretations of my face. And the funny thing is that each picture is different but each one is me. Each one has a fragment of the truth of me, but all of the fragments are equally real. They are not parts that need to be put back together like a puzzle to see the whole. Instead, each one is enough in itself, to reveal me. This is one of the manifold mysteries of art."

**Uma Kelkar,** USA
watercolor on cold press paper,
8 × 6 inches (203 × 152 mm).

I love when artists share their attitude in their reference photos; these are the subjects I choose. When the intent of making a portrait is storytelling, aims of accuracy of proportions and color matching become secondary.

Giorgio Bordin

**Tom Pellett,** USA
watercolor and ink, 10 × 7 inches (254 × 178 mm).
I enjoy finding the face with lines and tones.

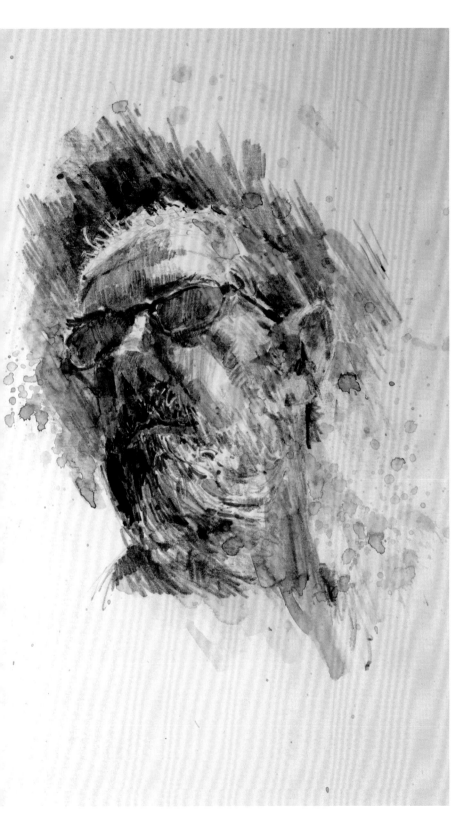

**Jim Vance,** Canada
water-mixable oil paint on clear acrylic, colored paper, Photoshop on a PC, no fixed dimensions.

I used water-mixable oil paint on clear acrylic, thus the "run of paint" look. Behind the clear acrylic I experimented with the effects of different colored paper or objects behind the painting. When I had an effect I liked, I photographed it and worked on it more in Photoshop to produce the final image.

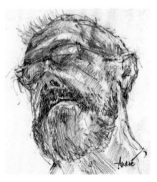

**André van der Kaaij,** Netherlands
pencil on paper, 11¾ x 8¼ inches (297 x 210 mm).

I draw because I have to: on envelopes, newspapers, magazines, and so on, without any system . . . I just draw.

**LEFT Carl Purcell,** USA
Graphite and watercolor, dimensions unknown.

# TELLING A STORY

**" I like reducing a complex portrait to simple elements to get to the essence of the subject and their story. "**

JARRETT KUPCINSKI, USA

*Elisa, Philippines* by Jarrett Kupcinski, USA
Paper by 53 app on an iPad, no fixed dimensions.

I liked the playful nature of the reference photo, so I drew with quick, stylized lines; the result is something of a caricature. My portraits may sometimes be more abstract and other times more realistic, depending on my mood or response to the reference. When working digitally, the app that I use can also influence my style.

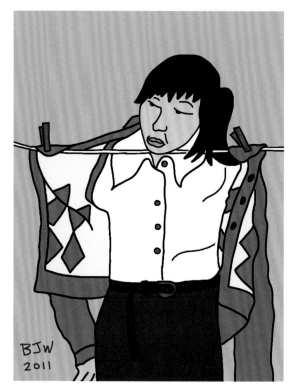

*Grace, South Korea* by Barbara Jaye Wilson, USA
Brushes app on an iPad, no fixed dimensions.

I couldn't resist this great pose.

*Philip, USA* by Hans Muerkens, Germany
black ink pen, watercolor and Paint program on a PC, no fixed dimensions.

I found it funny that Philip might be unaware of what was going on behind him and so I emphasized that more than getting his likeness—except for the red hat.

**OPPOSITE** *Charlotte, USA* by Murilo Sergio Romeiro, Brazil
Photoshop on a PC, no fixed dimensions.

This digital drawing is based on a mix of four images: Charlotte's photo after her eye surgery, a *Life* magazine cover, and photos of a British crown and a gala dress.

# DRAWING FROM
# ART HISTORY

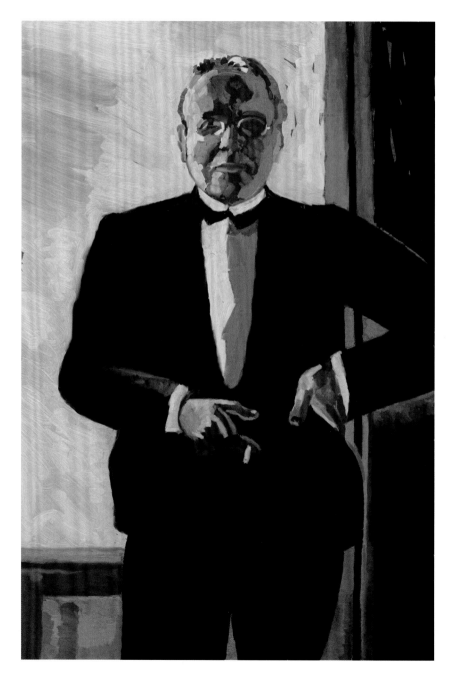

*Joan Ramon, Spain*
by Clyde Semler, USA
ArtRage Studio Pro with
Wacom tablet on a PC,
no fixed dimensions.

Inspired by Max Beckmann's
*Self-Portrait in Tuxedo, 1927.*

**LEFT** *Nasir, USA*
by Félix Tamayo, Spain
watercolor, golden marker,
tea and ink on Canson
paper, 4¼ × 6¼ inches
(110 × 160 mm).

This portrait is part
of a series in which I
incorporated the head of
the model with the first
letter of their name, in this
case Nasir, in Lombard
Gothic-style lettering.

**ABOVE** *Darren, Taiwan*
by Gary Tausch, Canada
ink and marker drawing manipulated
with Flickr Toys software, no fixed
dimensions.

This portrait is very much a result
of the new technologies and display
possibilities for artists. I used Picasa
software to crop and create a very high
contrast version of Darren's reference
photo, which I then used as the basis
for an ink and marker drawing. Next, I
photographed the drawing and created
this "Warholized" version using Flickr
Toys' online Pop Art Poster program.

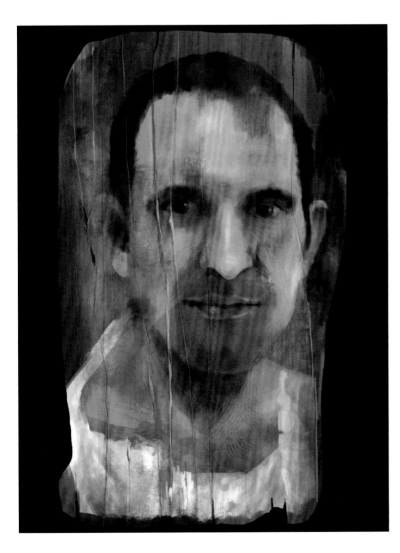

**LEFT** *Richard, USA* by John Bavaro, USA
Brushes app on an iPad, no fixed
dimensions.

My "iPhone/iPad Fayum Portraits"
series represent exquisite, time-
intensive "faux antiquities." This
series mimics the timeless Fayum
portraits from Egypt during the Roman
era. Richard posed for me, then I
went on to sketch him in Roman-era
costume, based on the clothes worn
in the original Fayum portraits.

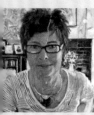
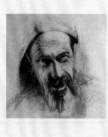
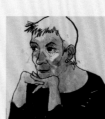
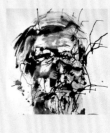
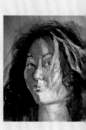

# FEATURED ARTISTS

> **❝** Look at other people's portraits: in a gallery, in a book and online. Work out what you like and what you don't, and why. **❞**
>
> GEOFF R. BRYAN, AUSTRALIA

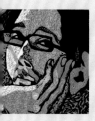
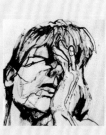
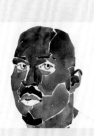
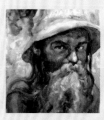
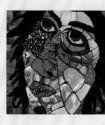
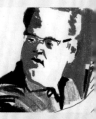
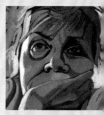

# PORTRAITS BY SAMAR ALZAIDY, IRAQ

I started drawing when I was six years old and I haven't stopped since! I discovered this gift thanks to my father's love of drawing and his influence. Although I attended an institute for the deaf and mute in Baghdad, before being forced to leave because of the war, I never studied art formally.

I usually work in watercolor and more recently, digitally on an iPad. Although I am "painting," on the iPad, the color and effects are different than traditional watercolors. I prefer working digitally as it is easier to change colors and faster than working in watercolor.

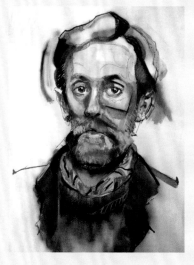

Juan, Spain
pen, pastel, watercolor and ink on paper,
16½ x 11¾ inches (420 x 297 mm).

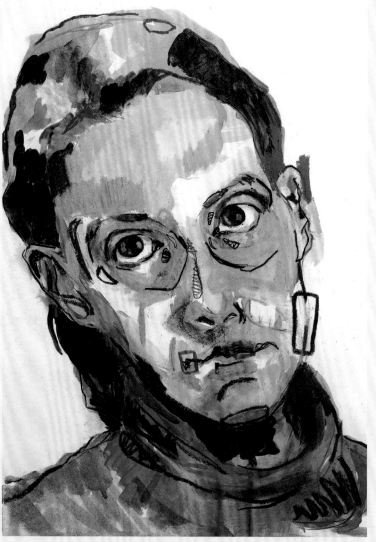

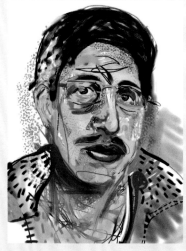

Rajesh, India
SketchBook Pro app on an iPad, no fixed dimensions.

Mariah, USA
pencil, pastel and acrylic paint on paper, 14 x 10 inches (356 x 254 mm).

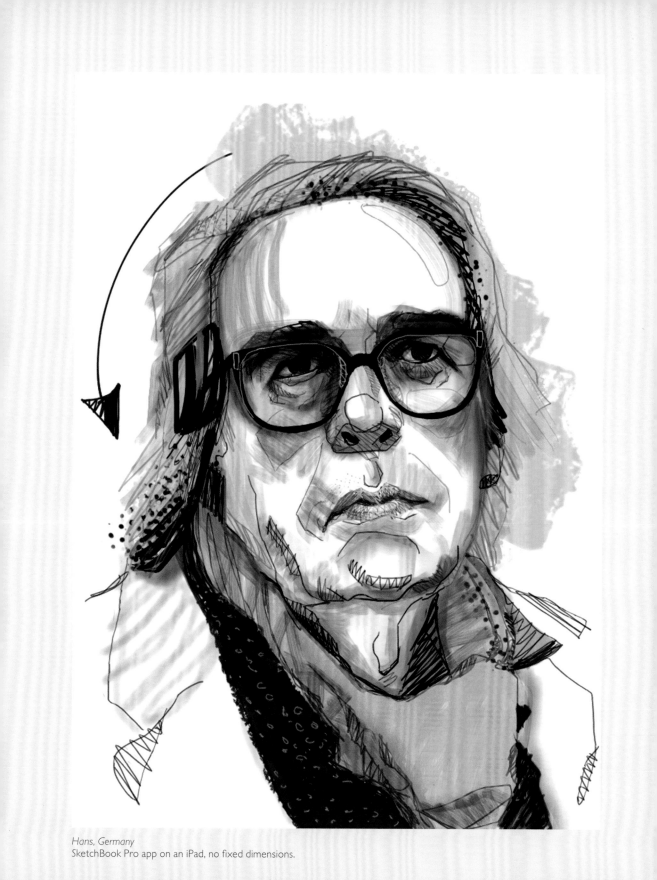

*Hans, Germany*
SketchBook Pro app on an iPad, no fixed dimensions.

# PORTRAITS BY MARTIN BEEK, UK

The concept of the Portrait Party appealed to me, and I joined very early on. I was already active on flickr.com, sharing my past and current work, commenting and pooling ideas with other artists. Many of these artists also joined the party.

My current work is primarily engaged with the landscape, and the Portrait Party is a periodic diversion. I'm very interested in how Peter Doig and David Hockney continually wrestle with the idea of photography and visual information. Along those lines, I've often toyed with the idea of how much information could be gleaned from a photo or a snapshot. Since most of the portraits are created from reference photos, the Portrait Party has been a great way of engaging with this concept. I think the group gave me license to just draw people with no thought of how that work might fit in with anything else I was doing. This meant that I drew in pencil, pen, crayon, collage, gouache, oil paint, and oil pastel.

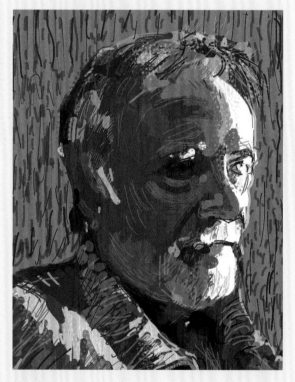

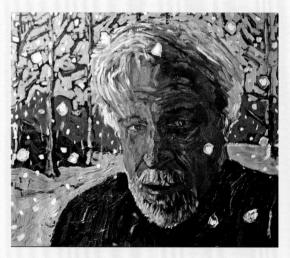

*Walt, USA*
oil paint on masonite, 13 x 17½ inches (330 x 455 mm).

Here I introduced a random element on the surface, the snowflakes. The wintry background shows my interest in atmosphere and how that alters the way we read a face. I painted this on a crimson background.

*Magi, Spain,*
Brushes app on an iPad using a Wacom stylus, no fixed dimensions.

I used the photo as a reference and a guide to the types of expressive marks that suggested Magi's face. In my view, the trouble with much digital work is that it either becomes too photographic, therefore eliminating artistic expression, or tries to mimic other media, which I believe is pointless. In this portrait I tried for a happy compromise.

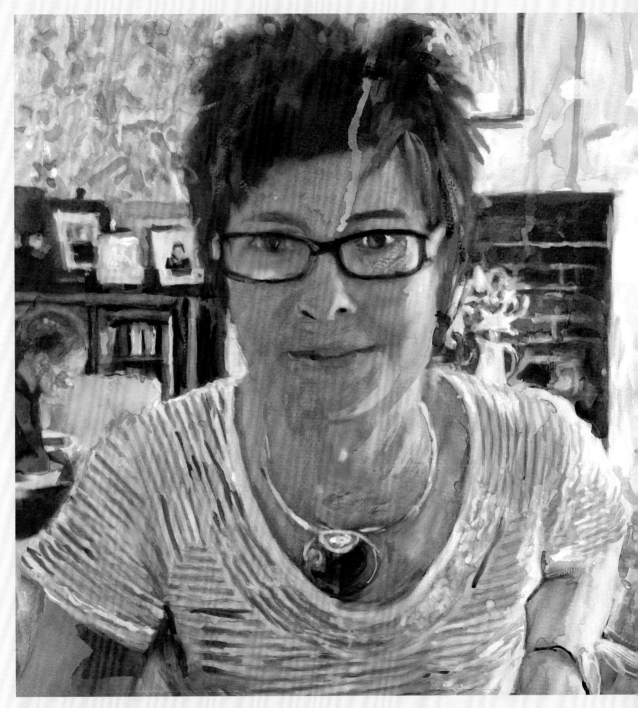

*Sue, UK*
digital collage of multiple graphite and gouache studies, scanned and reassembled using Photoshop, no fixed dimensions.

This portrait was drawn from a number of blown-up sections of a black and white photograph. Each portion was painted in gouache over graphite and then digitally reassembled in Photoshop. The physical portrait exists in a number of versions. The initial influence was David Hockney's "joiner photographs" where one focuses in on parts of an image and considers each in a specific way. I added raw and strong primary color.

# PORTRAITS BY ANNA BLACK, UK

I work in different ways according to the medium. However, I usually go from the general to the specific. That is, I block in large areas of light and dark and gradually "sculpt" the face before moving into the details of the features. This gives me more flexibility for moving elements around and "discovering" the face as I go.

I also like to work by looking primarily at the subject and at the same time moving my drawing tool really slowly, keeping it in contact with the paper, and feeling my way across the landscape of the face. I find this quite meditative and it helps me to see and draw what is really there.

## WORKING IN CHARCOAL

I love the way features and emotion can appear by simply moving charcoal around. Despite the possibility of running into problems from oils on the skin, I prefer the control I get from using my fingers instead of tortillons. I use different types of charcoal—the marks achieved with willow are very different to those from compressed charcoal. You can also soak charcoal in linseed oil to get another kind of mark, although it then becomes difficult to erase. I use erasers as a drawing tool and I have several, including electric. I like working at an easel so I can stand back. It also allows a freedom of arm movement that influences the marks I make.

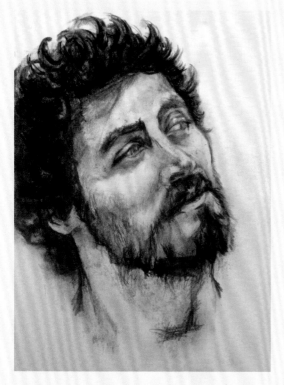

*João, UK*
charcoal, 14 × 12 inches (356 × 305 mm).

The reference photo was a good quality image with great contrasts. This made it easier to use as a starting point.

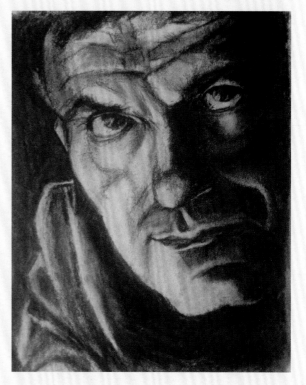

*Martin, UK*
charcoal, 10½ × 8 inches (267 × 203 mm).

I was interested in capturing the intensity of Martin's expression and sculpting his face in charcoal and with erasers—and with my fingers.

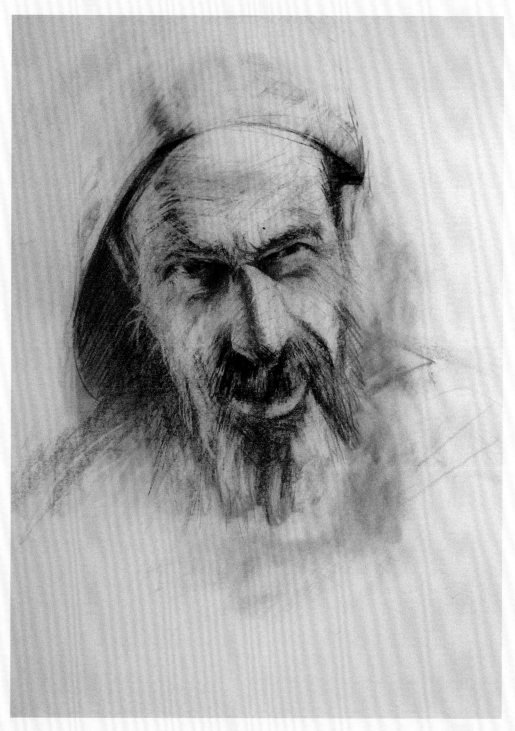

*Pepe, Spain*
graphite, pencil and erasers, 23½ × 16½ inches (594 × 420 mm).

Working at a large size was liberating. The first layer of the portrait was just random scribbles and marks made with pencil, graphite sticks, graphite powder and erasers. Gradually I began feeling my way around and across the face, and building up further layers of marks. I continued to work into it, particularly with different erasers: a kneadable eraser, a pencil eraser and even an electric one. The result is as much erased as drawn in graphite.

# PORTRAITS BY PATRICIO VILLARROEL BÓRQUEZ, CHILE

Although portraits are not my main thing in art, I do like the challenge! All of my portraits for Julia Kay's Portrait Party are digital and are done on some combination of a computer, iPhone and iPad, using the photo as a subject and also as a palette to pick up the color tones. So far, I have completed approximately 300 portraits.

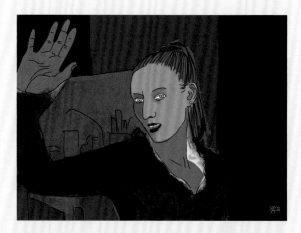

*Isabel G.B., Spain*
Photogene, PhotoTropedelic, Artrage and Brushes apps on an iPad, no fixed dimensions.

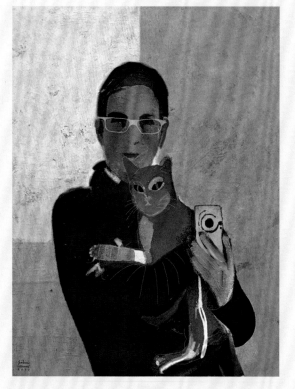

*Anne, USA*
Photogene, ArtRage and Brushes apps on an iPad, no fixed dimensions.

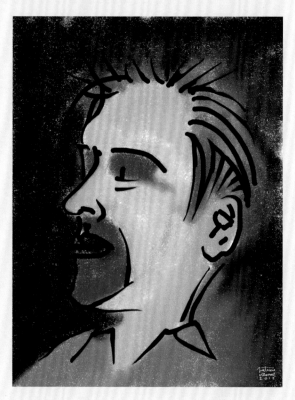

*Jerry, Canada*
Artrage and Brushes apps on an iPad, no fixed dimensions.

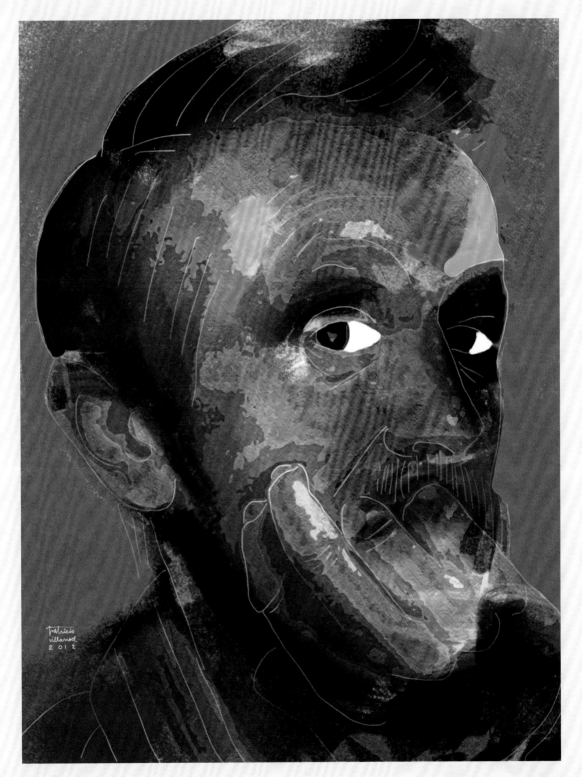

*Juan, Spain*
NPtR (Non Photorealistic Painter), Artrage, Photogene
and Brushes apps on an iPad, no fixed dimensions.

# PORTRAITS BY JOAN RAMON FARRÉ BURZURI, SPAIN

I start each portrait using the rational part of my brain to capture the likeness of the model. I pay particular attention to the eyes, "the windows of the soul."

The most important thing for me in making a portrait is to bring it to life. So once I am satisfied with the likeness, I take a short time to meditate and then start working in color. At this point my heart is guiding my hand to apply color and discover the soul of the model.

## WORKING IN WATERCOLOR

My favorite watercolors are Winsor & Newton. I work with a limited palette: raw sienna, cadmium red and Payne's Grey plus whatever is the color of the subject's eyes. I like to keep previously mixed colors on my palette and use these to "'dirty" the new colors. I build up depth of color by applying multiple washes in layers.

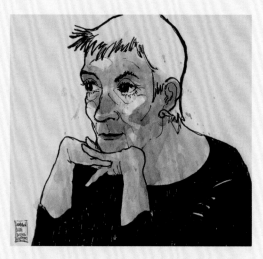

*Mercè, Spain*
Sailor pen with carbon ink and watercolor, 8 × 8 inches (203 × 203 mm).

Drawing from life (ten minutes) at the monthly meetup in Spain (see page 213).

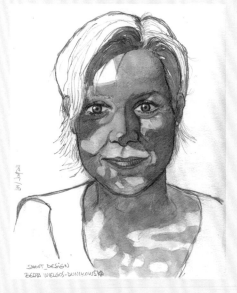

*Beata, Poland*
pencil and watercolor, 10 × 8 inches (254 × 203 mm).

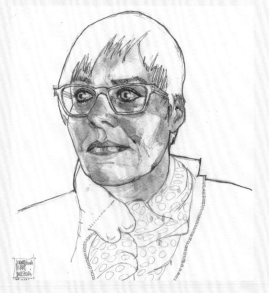

*Simone K., Germany*
pencil and watercolor, 11¾ × 10½ inches (300 × 265 mm).

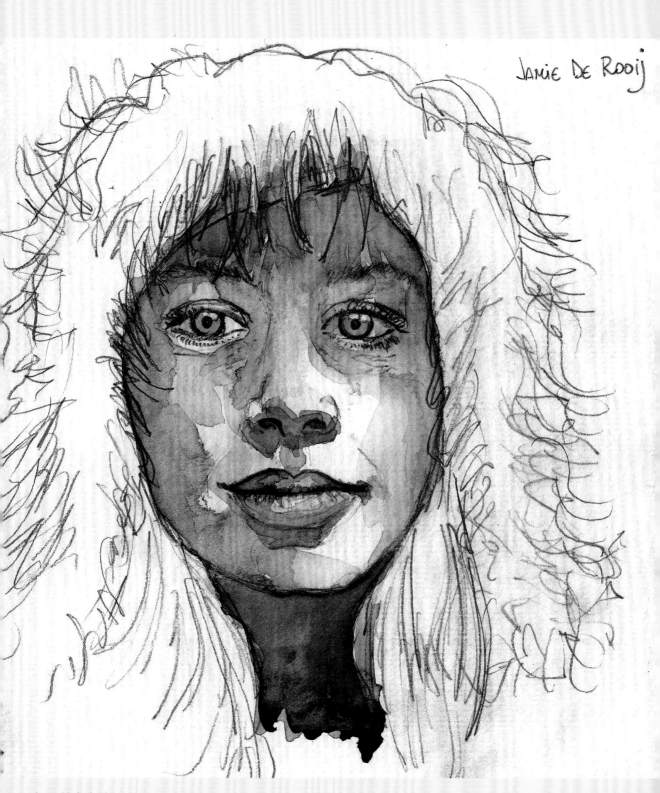

Jamie, Netherlands
pencil and watercolor, 8 x 7¼ inches (203 x 182 mm).
I used monochrome to emphasize the cast shadows on the face.

# PORTRAITS BY SUE HODNETT, UK

I usually work on large, heavy paper using watercolor or ink as a base. I prefer to work on a large board on the floor rather than at an easel or a table, and I like to work outside when I can.

When working large scale I use appropriately sized brushes—these are often household paint brushes from 1 inch (25 mm) up to 4 inches (102 mm).

Before I start I make up several pots of watery paint using watercolor paint from tubes rather than pans. I use pens or pencils to create a rough outline of the portrait and then begin splashing and flicking the paint across the paper. I have a water spray at hand to help spread the paint in unusual directions. I will also tip and shake the board to make the paint run. I work with both my left and right hand to create interesting lines.

My portraits are completed rapidly in one session.

*David A. F., USA, holding up his sculpture of Julia L. K., USA*
watercolor, pen, ink and oil pastel, 22 × 28 inches
(559 × 737 mm).

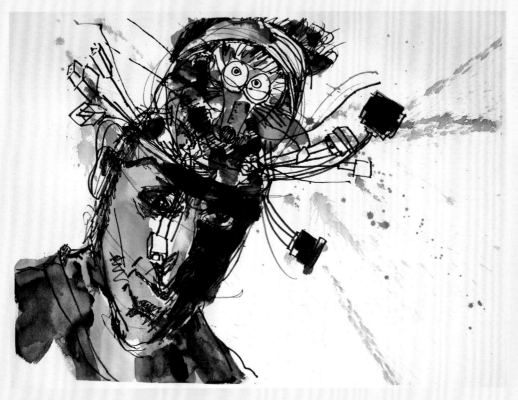

*"Mr. Flibble," UK*
watercolor, pen, and ink, 22 × 30 inches (559 × 762 mm).

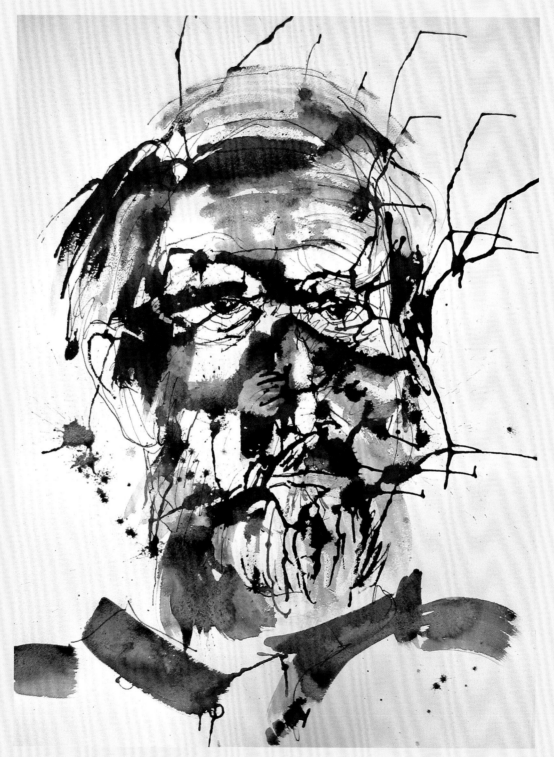

*Dan H., USA*
watercolor, pen, and ink, 30 x 22 inches (762 x 559 mm).

Dan commented, "I really like this wild and crazy guy side of myself. I thought it only happened when I play bass clarinet!"

# PORTRAITS BY JULIA L. KAY, USA

I have a fascination with different kinds of mark-making, and love to experiment. If I'm having trouble with a drawing, I take a break and sweep the studio floor or go for a walk around the block. When I come back, I put the drawing aside and give myself a challenge to draw in a way where I have to overcome some obstacle. For instance, I use a brush that's too big for the paper, or hold the pencil in my other hand or between my toes. Or I use an app that has a random element, such as Paint for Cats, or hold the iPad to my face and draw with my nose.

Since it's not reasonable to have expectations about the results of doing something I can't control, it frees me to see and draw in a fresh way. It also makes drawing in the usual way seem a lot easier! I frequently like the results of these experiments and in addition the fresh perspective and new feeling of ease are often exactly what I needed to get past the problem I was having with the original drawing.

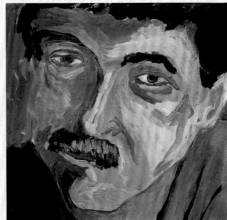

*Vladimir, Belarus*
acrylic paint on paper,
8 × 8¼ inches (203 × 210 mm).
Painted with a brush in each hand.

*Timothy, USA*
Paint for Cats app on an iPad, Photoshop on a Mac, no fixed dimensions.

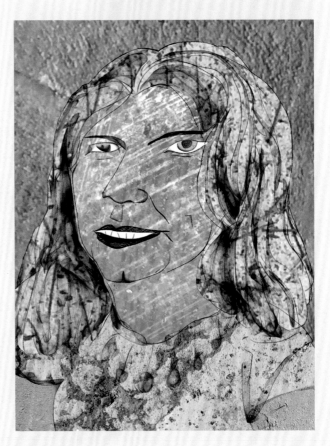

*Cecca, UK*
Sketch Club, Camera and Juxtaposer apps, on an iPhone and an iPad, no fixed dimensions.

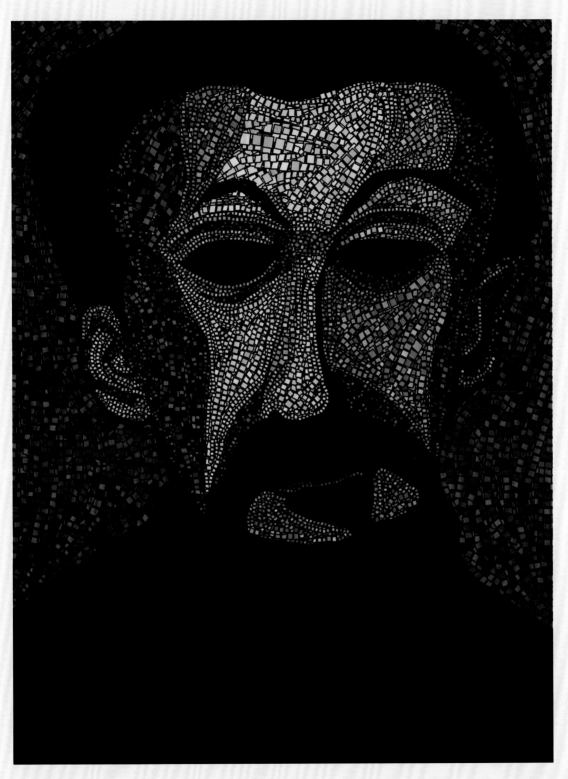

*Juan, Spain*
TypeDrawing app on an iPad, no fixed dimensions.

# PORTRAITS BY MARION LOKIN, NETHERLANDS

Drawing has always been my favorite pastime and portraits have always interested me. At art college we used to draw each other or a model. To achieve a likeness of someone on paper is exciting, especially when you manage to catch some of the subject's personality, too.

In 2002 I was diagnosed with Parkinson's disease, which was devastating. I was still physically able to do my art, but I didn't do very much. This was partly because not many people wanted to sit for a portrait, but also because I was focused on learning to cope with my illness. The Portrait Party changed that. There were as many models as I wanted and lots of inspiration from other artists. And last but not least, it distracted me from my condition.

Historically, I mostly drew with charcoal. When I worked in color, I used pastel pencils. The Portrait Party inspired me to use other materials, like soft pastels, oil pastels, Neocolor crayons and then mostly Neocolor II, which are water-soluble and allow for beautiful watercolor effects.

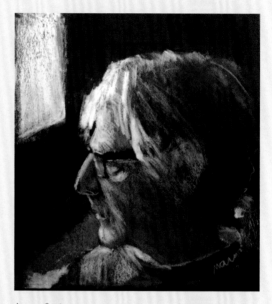

*Arturo, Spain*
Neocolor II crayon on black paper, 12 × 10 inches (305 × 254 mm).
Although water-soluble, Neocolor II can also be used dry, as here.

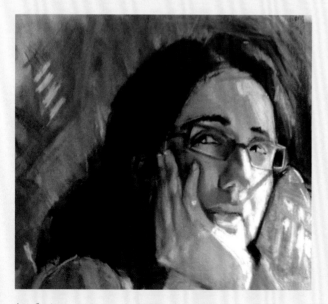

*Ana, Spain*
soft pastel, 11¾ × 14½ inches (300 × 370 mm).

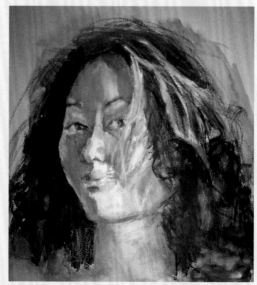

*Kim L. T. D., France*
Neocolor II crayon, and water, on rough watercolor paper,
15¾ × 11¾ inches (400 × 300 mm).

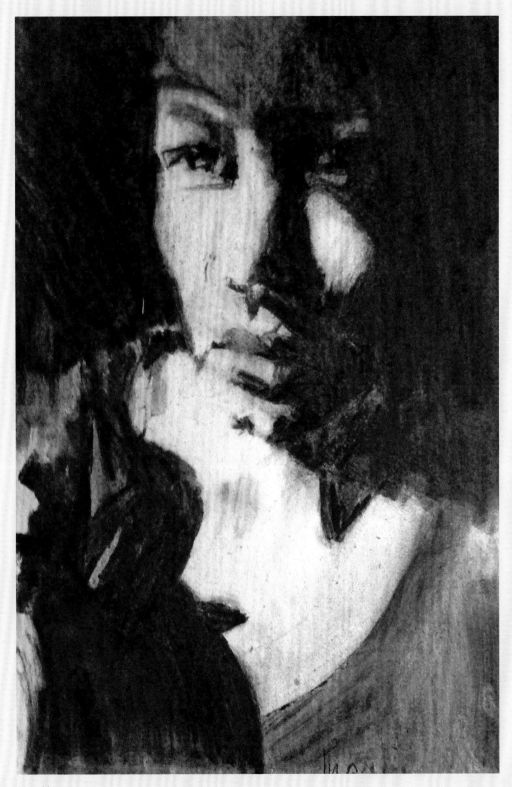

*Lena, Norway*
compressed charcoal, 19¾ × 11 inches (500 × 280 mm).

# PORTRAITS BY THERESA MARTIN, USA

I am interested primarily in human faces. I find them endlessly fascinating. I am always looking at them—the way the light hits them, the way a nose or chin will jut out, the way crinkle lines appear when someone laughs. Faces convey the story of being human, and the longer a person has been on this earth, the more that person's face tells its story. This is why most of my prints and drawings are of older people, whose faces have had time to develop character.

As well as the texture of the faces themselves, I am also interested in texture that comes from the medium used.

Different media prompt different kinds of mark-making, and I have been experimenting with this—for example in the gouache resist portrait of Sean, below. In a world in which all things are interconnected, my faces are connected to the space around them through the energy of the texture.

Since I work full-time as a teacher, I only have limited time for art-making. I often get up early in the morning and work for an hour before I go teach, then come home in the afternoon and work some more. And though I'd like more time, I am satisfied with the progress I am making.

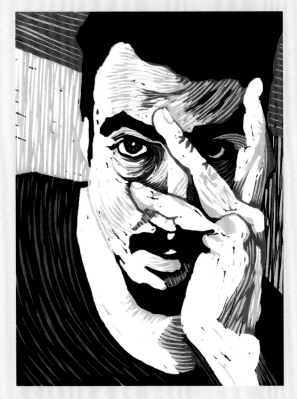

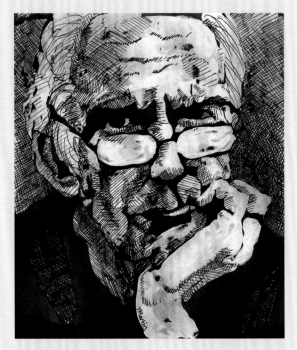

*Sean, Ireland,*
gouache resist and India ink, 8 × 7 inches (203 × 178 mm).

Pen and ink was my first love, and this combines that with a gouache resist technique that I learned from Janice Wahnich (see page 192). It is an exciting method because the results are somewhat unpredictable.

**OPPOSITE** *Ana, Spain*
reduction linocut, 8 × 6 inches (203 × 152 mm)

I was playing around with both textures and colors in this print.

*Tim C., USA*
reduction linocut, 8 × 6 inches (203 × 152 mm).

In reduction prints, a single block of linoleum is carved and printed with multiple colors (three in this portrait of Tim), and the block is destroyed in the process of making the prints.

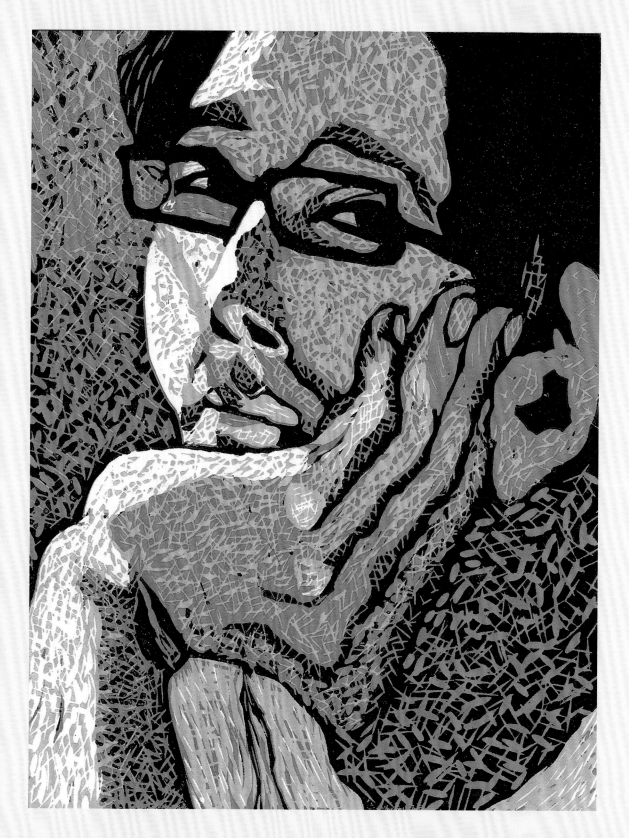

# PORTRAITS BY MAUREEN NATHAN, UK

Draw what you see rather than what you know or think you see—that is, draw what your eye actually sees. If you make a mistake don't worry about it; draw over it or around it. The marks create a lively drawing which is often more interesting than something that is a "perfect" representation.

Trust your eyes and when you finish you will see a portrait on your paper that resembles the subject with your own unique view of them. If you don't like it, do another one—it is only drawing!

**RIGHT**
*Jutta R., Germany*
ink (drawn using a chopstick) and white chalk on paper, 11 × 8 inches (279 × 203 mm).

*Joan Ramon, Spain,*
ink (drawn using a chopstick) and soft Unison pastels on paper, 11 × 8 inches (279 × 203 mm).

The pastel highlights the texture of the ink drawing. It also covers up mistakes!

*Magi, Spain*
ink (drawn using a chopstick) and soft Unison pastels on paper, 11 × 8 inches (279 × 203 mm).

*Daniel N., Slovakia*
ink (drawn using a chopstick) and white chalk on paper, 11 × 8 inches (279 × 203 mm).

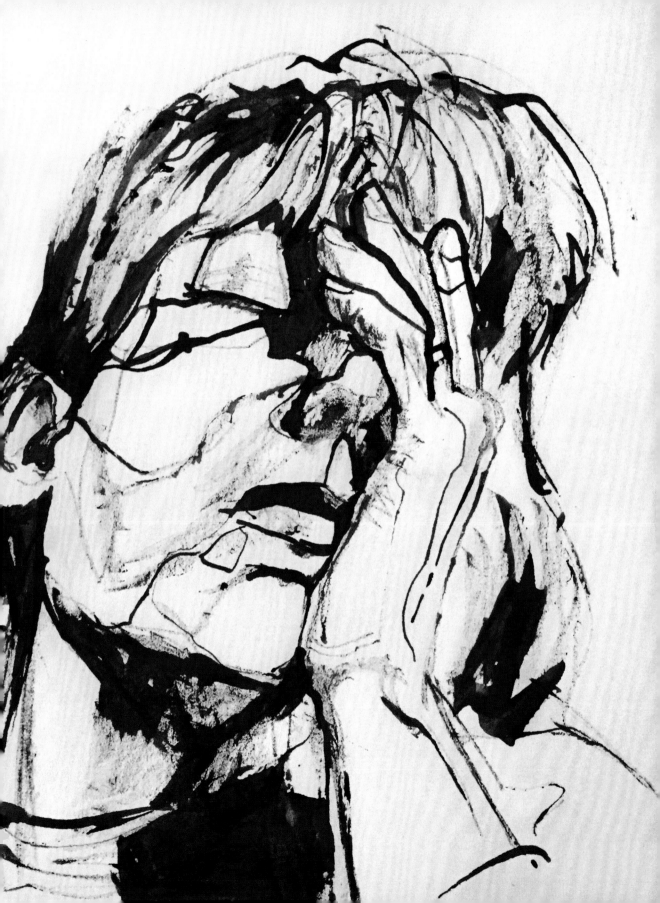

# PORTRAITS BY DANIEL NOVOTNY, SLOVAKIA

I think in shapes and my work reflects this. I have always strived for strong shape distribution in my work—whether portraits or landscapes.

To a certain degree, portraits limit my freedom in terms of inventing shapes but faces can still offer interesting interactions, often yielding surprising results. Despite being limited, the shapes still have the ability to excite and I emphasize this through a contrast of likeness and idiosyncrasy.

Shapes can be both positive and negative. Positive shapes describe, negative shapes complement. To me negative shapes—or background—are as important as the positive ones. They are there to support, to complement, to harmonize and to unify.

The negative shapes—or space around the face—are still important even when the background is absent—or white. I always bear the negative areas in mind from the start. Despite having no value or color, their shape was considered with a great deal of attention.

I pay such attention to the negative shapes because I want to make them interesting and fun, whether subtle or demanding, muted or bright, large or small. I allow them to stand out but I don't want them to be calling for attention. It is a portrait and the person is the subject. Subject is the positive. As in life, there needs to be a balance of the two. Positive and negative cannot exist without each other.

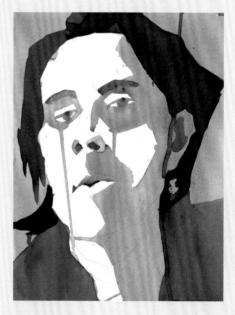

**ABOVE** *Ilza, Chile*
watercolor on paper, 15 × 11 inches (381 × 279 mm).
**OPPOSITE** *Eric, USA*
watercolor on paper, 15 × 11 inches (381 × 279 mm).

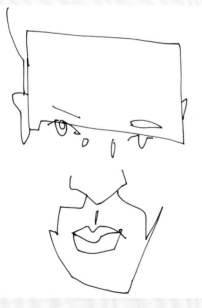

*Jean-Pierre, Panama*
ink on paper, 8½ × 11½ inches (210 × 292 mm).

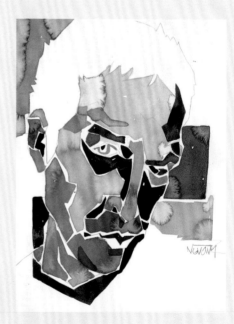

*Michael, USA*
watercolor on paper, 15 × 11 inches (381 × 279 mm).

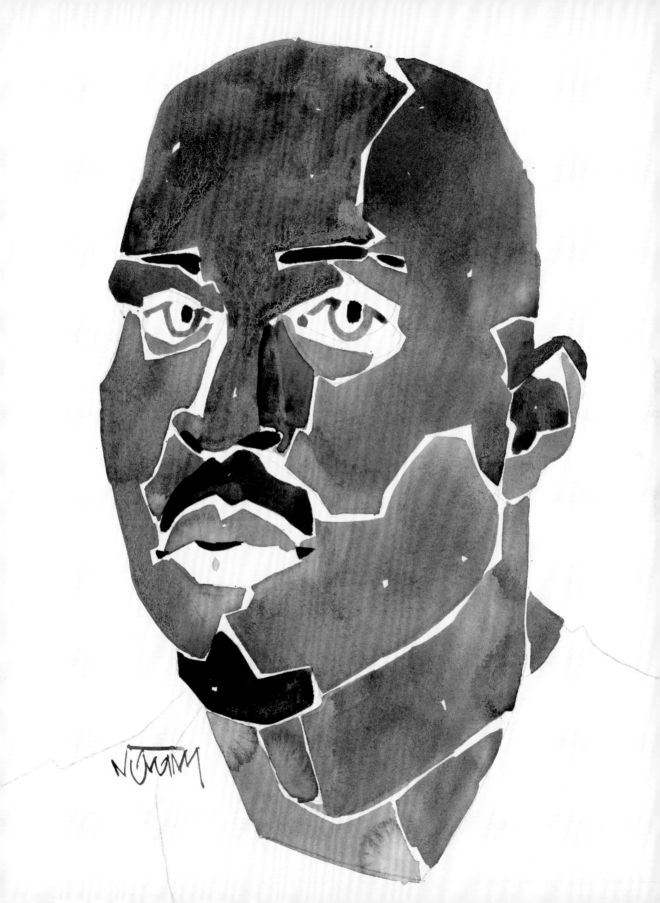

# PORTRAITS BY MARIAH O'NEILL, USA

I am mostly self-taught. I learned to draw during the course of a long illness, by copying drawings that I liked, many by old masters. Then I learned to use paint by doing a series of still lifes. Most of what I learned has been the result of looking at good art.

Over time I loosened up, and recently I have become more interested in the process of doing a piece rather than in the result. I love to explore, to find out what happens if I do this or that … as a result many of my pieces seem—and are—experiments and unfinished.

Art has been very healing for me and also a training in meditation, of learning to look and be in the present moment and working without expectations. I love it when I disappear into my work.

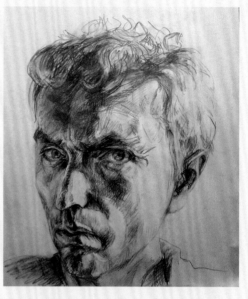

*Frédéric, France*
pencil on paper, 12 x 10 inches (304 x 254 mm).
I learned by copying old masters, sometimes it shows.

## MARIAH'S TIPS
- Practice a lot (and some more).
- Really look! Really looking is the single most important thing.
- I do recommend studying perspective and anatomy from a book. I used *Drawing Lessons from the Great Masters* by Robert Beverly Hale (Watson-Guptill Publications, 1964).
- Look and learn from artists you love.
- Override the inner critic until it shuts up.
- Go with your strengths and be yourself. If you simply follow your own interests, your personal style will develop.
- Connect with like-minded people and learn from and be inspired by them.

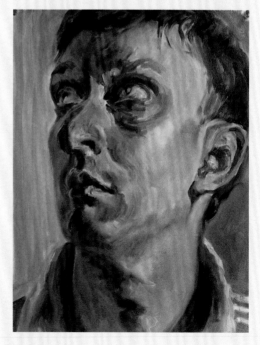

*Neil, UK*
water-mixable oil paint on canvas,
16 x 11 inches (406 x 280 mm).

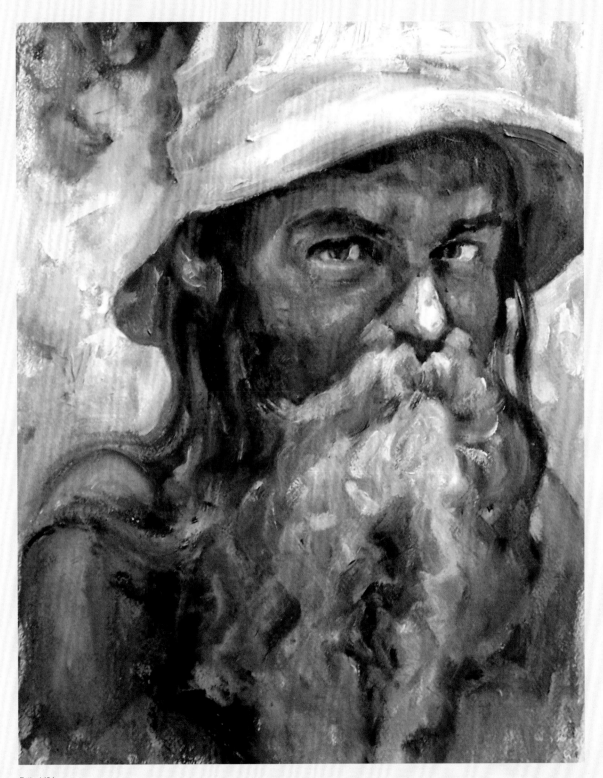

*Erik, USA*
water-mixable oil paint on watercolor paper, 12¾ x 10 inches (324 x 254 mm).
This was painted very rapidly.

# PORTRAITS BY GILA RAYBERG, USA

I am first and foremost a mosaic artist. I never used to draw much but seeing other JKPP portraits inspired me. I began a daily practice of drawing and painting, as well as studying and comparing the portraits done by other Portrait Party artists. This led to developing new processes for creating my mosaics. Portraiture became my primary focus and remains so today.

Each mosaic portrait is a brand-new challenge; the challenge is a big part of what spurs me on to experiment and to try new materials and techniques.

Generally, I start by making several drawings or paintings of my subject. As I am drawing, I try to get a feel for the contour of the person's face, where there are deep crevices, how their ears recede and noses jut out. The psychological impact, mood and the look of what is in front of me become my focus, rather than the likeness of the person.

I'm repeatedly surprised at the many looks one individual can have in different photos or at different moments. The angle from which they are seen, the way the light hits their face and the shadows fall, how they change as they age and even their different expressions from moment to moment: the lines in faces are constantly changing. I attempt, in my mosaics, to use the structure of the face and those ever-changing lines to guide the cutting of the pieces and the flow of the design. The addition of dinnerware into my work adds layers of interest, with texture, patterns and words. Each shard has its own history, yet when combined with others, creates an entirely new story.

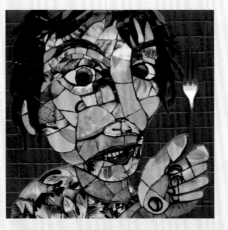

*Charvel, Canada*
mosaic with pottery shards from around the world, ceramic, glass, and a fork, 12 × 12 inches (305 × 305 mm).

Creating *pique assiette* (broken pottery) works is always a wild ride. It's fun to see how various unrelated patterns can be combined to create a fresh face!

*Jutta, Germany*
mosaic with stained glass and dinnerware, 11 × 10 inches (279 × 254 mm).

Using flat stained glass for her face and thicker shards from the underside rims of dishes to create her hands, I was able to create texture and a sense of depth—both visually and literally.

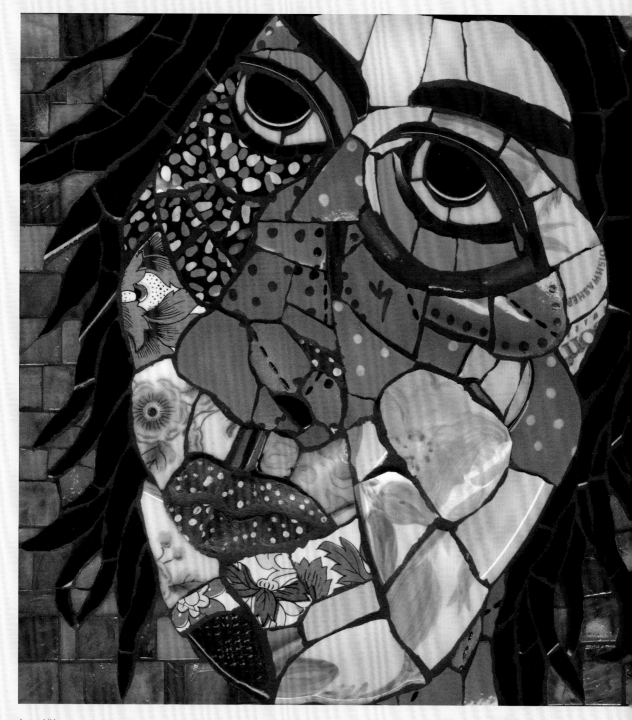

*Anna, UK*
mosaic with pottery shards from around the world, ceramic, and iridescent glass,
9 x 8½ inches (229 x 216 mm).

I had done a few drawings and a painting of Anna where she had an archetypal angelic
upward glance. The pink flowered piece that makes up her cheek was one of the first
pieces I committed to the substrate. It came from my grandmother's dishes that I loved
as a child. It gives me great joy to incorporate memories into my art.

# PORTRAITS BY JERRY WAESE, CANADA

I only draw what I like. The subject has to be interesting to me, and then I draw or paint what it is that I love about the subject.

However, I also draw or paint to compose a totality, in which the whole rectangular area has to be made into a thing of its own. It is not so much a drawing of the person, but it is a work unto itself in which you may be able to see the resemblance to a person, but the piece is a complete artwork whether there is or was any figure that had inspired it. It is not a photograph or a rendering of any thing other than itself. I believe any work that is not substantive in itself is not worth doing.

*Ujwala, India*
pen, ink, and Neocolor II crayon on paper,
7 x 7 inches (178 x 178 mm).

The composure of the face in the light was compelling, and the way the crayon was able to throw light and shadow in sheer flatness was exciting. I think it works on that level and each color has abstract integrity of its own.

*Marga, UK*
pen, ink, and Neocolor II crayon on paper, 8 x 11 inches (203 x 279 mm).

The whole scene appealed to me, and my inclination was to spread out from the concentrated fingers and lino cutting action and breathe energy into a person shape that would be recognizable. The effort in the finger is echoed in the angled shapes behind and the many triangles that anchor and activate the rectangular area.

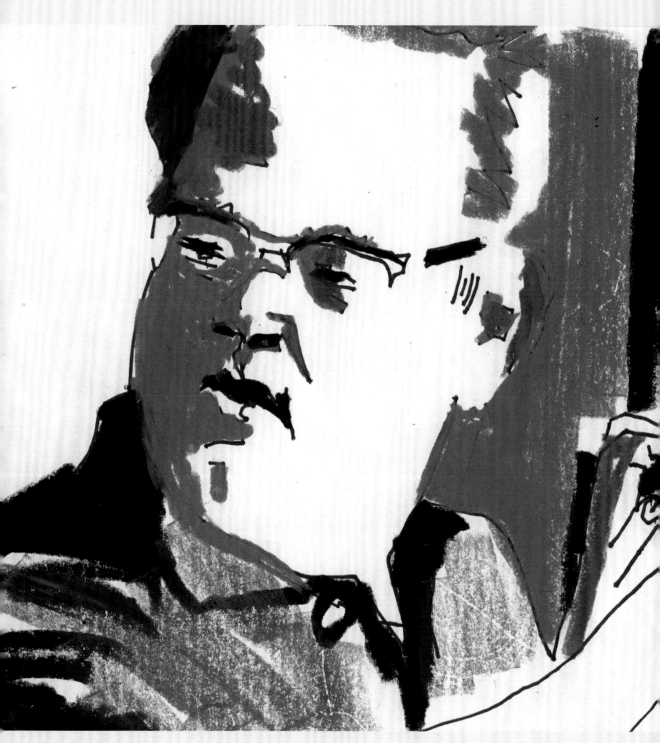

*Marty, USA*
pen, ink, and Neocolor II crayon on paper, 7 x 7 inches (178 x 178 mm).

I found a cumulous cloud formation that really worked to express the character of the face.

# PORTRAITS BY JANICE WAHNICH, UK

For many years I pursued a career in ceramics, and only returned to two-dimensional work on discovering Julia Kay's Portrait Party. For these portraits, I prefer quick-drying media and my portraits normally take no more than two hours to produce.

The human face has always fascinated me. I am quite selective when deciding whom to paint or draw. I don't always require a photo of high quality or detail. I am drawn to a mood, a look, an angle; the drama and strength in the subject as well the contrast of light and dark. I also look for sculptural qualities and strong features—a kind of edginess. I deliberately exaggerate, distort and enhance my subjects.

I am very conscious of composition and I begin by thinking about the placement on the page. Then I loosely map out the main divisions of the face and the angle of the head. I build my portraits in broad areas of darks and lights, finally working up to detail. Curiously, I leave the mouth to last.

When it comes to color choices, I rarely stick to what is in the source photo, and will exaggerate some detail or outline. I love color and tend to use warm to hot colors, with a bit of punch.

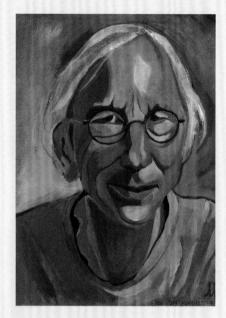

**ABOVE** *Jan Jaap, Netherlands*
acrylic paint on Arches Oil Paper,
12 × 9 inches (305 × 230 mm).

**OPPOSITE** *Marion, Netherlands*
acrylic paint on Daler Board,
12 × 9 inches (305 × 230 mm).

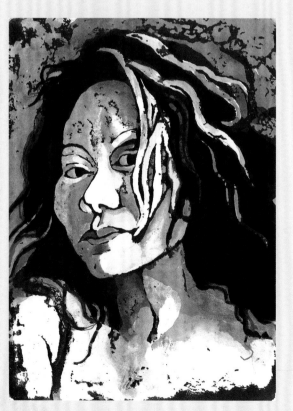

## WORKING WITH GOUACHE RESIST

I start by roughly mapping out my image. Any areas that I want to remain white, I cover thickly with undiluted white Schmincke gouache, and allow to thoroughly dry. Then I cover the page with India ink, working lightly and swiftly and trying not to churn up the white. Again I let it dry, ideally overnight, but sometimes I cheat with a hair dryer. When completely dry, I wash it gently under warm running water. The gouache washes off, leaving behind ink only where there was no paint. For me, the joy with this technique is the element of surprise.

*Kim L. T. D., France*
gouache resist using ink and wash on bamboo
paper, 9½ × 6¾ inches (240 × 170 mm).

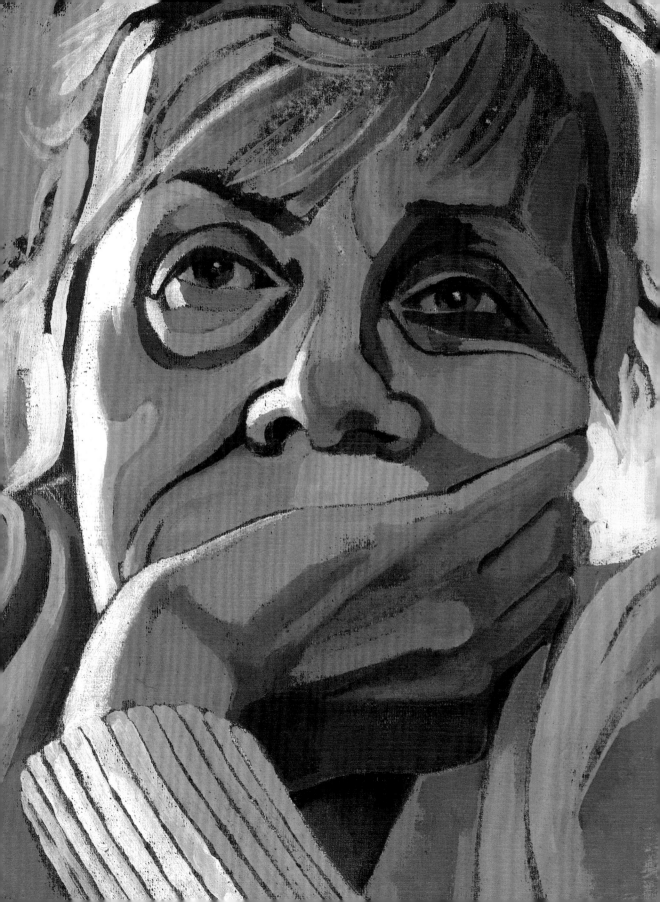

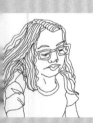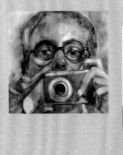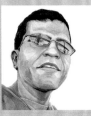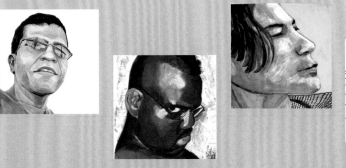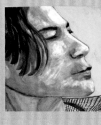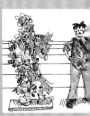

# ON MAKING PORTRAITS

**"** Be open and experiment a lot, and don't worry about mistakes. Often they actually improve your picture. **"**

MARIAH O'NEILL, USA

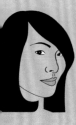
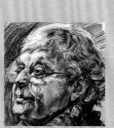
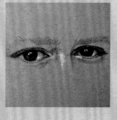
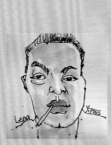
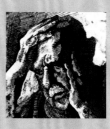
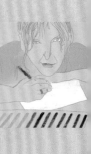

# WHY MAKE PORTRAITS?

> **"I keep doing portraits because they're a huge challenge. I'm always trying to go beyond the face and likeness to the expressions and the emotion behind them."**

GILA RAYBERG, USA

"My deliberately prolonged focus over the years on a small area of subject (portraits) and materials (pen) gives me precise learning feedback to improve in this particular small niche. In the end I'm just a sucker for particular faces that are visually interesting to me, or I feel a connection with the person, or best, both."

PIETER VERBAARSCHOTT, NETHERLANDS

"We see other people's faces more than we see our own. I think it is a beautiful gift for us to draw or paint someone and vice versa. When someone draws us we see an aspect of ourselves as seen through other people's eyes."

NINI TEVES LAPUZ, USA

"We connect with another human being by the process of looking at them and making marks to correspond with what we see. It is very personal looking so closely at another's face and the result is that we also become part of the portrait we are making. By connecting with others in this way we are connecting with ourselves, discovering things about others and ourselves."

MAUREEN NATHAN, UK

"Our instinctive ability to distinguish and recognize faces is hardwired. As social animals, we learn to read expressions and nuances of facial communication to stay safe and live successfully in a group. This hardwiring is demonstrated by our ability to see facial shapes in patterns everywhere. We are drawn to faces as we need to read them to survive, understand, love. Portraiture for me is a personal quest of understanding, interpreting and creating intimacy."

LUCY CHILDS, UK

*5th Anniversary Meetup in San Francisco* by Julia L. Kay, USA pen on paper, 5½ × 48 inches (140 × 1219 mm).

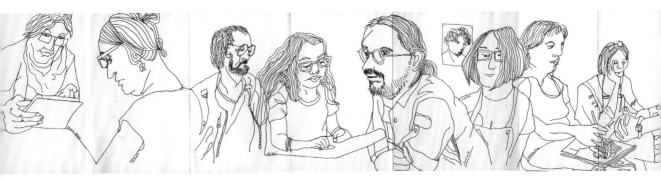

"It is quite some trick that with a single line, an arrangement of stones or smears of pigment on a surface, it is possible to put into viewers' minds, not just a face but the face of an individual among billions of alternatives. It is a trick that is compulsive and addictive."

RICHARD LONG, UK

"Shape-making is a lot of fun when working with the human face. There are lots of interesting shapes to be found and no two of them are ever quite the same. Also, the maker earns a special kind of friend. If for nothing else, this is why it's worth it."

DANIEL NOVOTNY, SLOVAKIA

"The main reason for making a portrait is to make someone smile."

HANS MUERKENS, GERMANY

"A photo or a painting captures a moment in time, but our need to interpret a face won't let us stop there. Our mind is always suggesting the start of some kind of story inspired by the face it sees. Is it sad or happy? If so, why? Old or young? Pensive or ebullient? But, whereas a video can tell a whole story, a single image can only suggest the beginning of one and from that follows both the mystery and charm of the portrait."

GEOFF R. BRYAN, AUSTRALIA

"I am drawn to the shared human experience and the fact that I can see aspects of myself and what I go through in the lives of others."

BARB WRIGHT, USA

"I make portraits because people and their faces are so fascinating! Superficially we're all more or less the same but the details of our eyes, noses, mouths, and so on, are different. So in one subject we have patterns of regularity and subtle variability. This means when you're creating a portrait, you can't just draw two eyes, a nose, and a mouth and expect it to be representative of and recognizable as a particular individual. As an artist, you have to ask questions, like what makes this person's eyes unique? Why is this smile distinctive? Why does this expression tell me the person is happy? Why doesn't the nose I drew look like the subject's nose? The details are everything, and this is true whether the portrait is photo-realistic or abstract."

JARRETT KUPCINSKI, USA

"Drawn and painted portraits evoke emotive communication while playing with the essence of identity. So when we are involved with portrait-making we are involved with two core human processes and the whole conundrum of self and other."

JERRY WAESE, CANADA

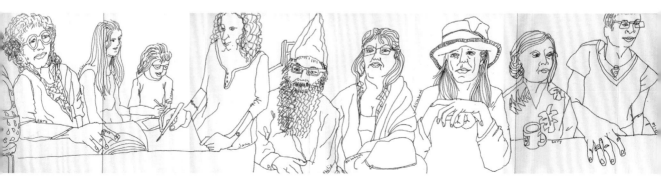

# WORKING WITH PHOTOGRAPHS

Using a photograph as a reference is a good option when you don't have a ready supply of people willing to sit for you—friends and family rarely have the patience to pose for any length of time! Using a photo is often considered "easier" than drawing from life as the image has already been "flattened" to become two-dimensional, and the subject doesn't move. However, using photos does present unique challenges. If you know some of the potential pitfalls, you can avoid them and instead maximize the benefits of using photographs as a reference.

## TAKING PHOTOGRAPHS FOR REFERENCE

If you are taking photographs of yourself or a model specifically to use as a reference, take lots!

- Experiment with different angles and lighting and frame the image in the camera to match your intended composition.

- Avoid taking photos standing in front of the bathroom mirror with a harsh overhead light. Instead, try outdoors for an even light or in front of a window for more dramatic light.

- Experiment and take some smiling and others not smiling; try face-on, profile and three-quarter views. Take some shots looking straight at the camera and some looking away, both to the distance and up/down. If the expression in the photo is something a model would not be able to hold for at least ten minutes, then it will be obvious the portraits were done from a photo.

- In general, a longer lens is better for portraits than a wide-angle lens, so zoom in and back off.

- On iPhones, the back camera is better than the front camera. Ask a friend to take some photos or experiment with taking photos of yourself without being able to see yourself when you click the shutter. You can do this by holding the camera away from yourself or, alternatively, set up a tripod and use a self-timer. Inexpensive widgets allow you to attach a smartphone to a tripod, and if you dislike using a self-timer, remote controls are also available for some smartphone cameras. It can be helpful to place a stool or other object where you plan to be in the photo, so you can set up the camera correctly.

*Joan Ramon, Spain* by Elizabeth Ingebretsen, USA watercolor on Arches hot press paper, 15 × 11 inches (381 × 279 mm).

## CHOOSING A REFERENCE PHOTOGRAPH

Choosing the subject of a portrait is extremely personal. When you are working from a photograph the choice of reference image is not just about the subject. The image resolution, quality and type of source photo also have a bearing. Many artists prefer high-resolution photos. However, sometimes the blurriness or bad-lighting in a technically poor photo can be deliberately made a feature of the portrait. Although each artist is drawn to different things, there are some elements commonly taken into consideration when choosing a photo.

### SUBJECT

Older, more lived-in faces, can have more distinct lines and volumes, providing opportunities for mark-making and tonal exploration.

"Sometimes I challenge myself to draw a smooth evenly lit young woman's face. There is less contrast to work with so each mark matters more; this makes it more difficult."

PIETER VERBAARSCHOTT, NETHERLANDS

### SUBJECT'S ATTITUDE

The attitude and expression of the model creates a specific mood or emotion that is exciting to capture.

"A certain wistfulness in the gaze—or a very direct one—is attractive."

GEOFF R. BRYAN, AUSTRALIA

"I am always looking for interesting faces—the ones that look like they've been places and seen things. I also look for dramatic light—where there are blacks and whites that interact in interesting ways. That part is almost abstract: a building up of forms, a pattern, a movement. But they are all faces that I fall in love with as I am working with them, and it has absolutely nothing to do with the person in the reference photo, and everything to do with what is happening on the linoleum."

THERESA MARTIN, USA

*Devon, USA*, by Janice Wahnich, UK
oil paint on Arches oil paper, 12 × 9 inches (305 × 230 mm).

### DRAWN TO EYES

"I look for portrait subjects whose eyes are making a statement … that could be the color, the lighting in the eyes or any emotion that I interpret."

RODRICK DUBOSE, USA

### CREATING A NARRATIVE

An image might prompt a particular story or emotion in the artist which they seek to draw out through the medium, marks or content of the portrait.

"I prefer natural, expressive faces, which show an inspiring personality and mood or story."

SIMONE GEERLIGS, NETHERLANDS

## CONTEXT

Portraits of the subject set within a particular context can provide rich opportunities for interesting backgrounds, whether indoors or outdoors, in an urban setting or landscape. These may provide additional information about the subject and their interests.

## LIGHTING

A range of light and dark values in a reference photograph will reveal the form and planes of the face.

"Some images work well for a specific medium. For example good tonal contrast in a reference photo is great for linocut prints and working in charcoal."

ANNA BLACK, UK

## VIEWPOINT

"I am interested in unusual perspectives, extreme angles, views we wouldn't normally see."

THERESA MARTIN, USA

## ACCESSORIES

Hats, glasses, mismatched socks, scarves and jewelry all add elements that will appeal to some artists but put off others.

"A bit of whimsy (whether inherent in the photo or applied by the painter) is always fun too."

GEOFF R. BRYAN, AUSTRALIA

*Julia L. K, USA* by Mitt Cheevey, USA
ink and colored pencil on paper, 8 × 10 inches (203 × 254 mm).

## AS A LEARNING TOOL

"I try to find photos that will challenge me. If I haven't drawn hands for a while, I will pick a photo with hands. If I want to work on teeth, I will look for a photo with a nice smile. Then there are the pictures that just grab me. I love hats and scarves and photos with bright busy backgrounds."

TAMMY VALLEY, USA

## COMBINING REFERENCE PHOTOGRAPHS

Combining elements from different references can be particularly rewarding. For example, you can include two or more subjects with a common interest or theme. Or you can depict multiple poses of the same subject. You can also introduce an element from imagination or from different reference photographs, such as an interesting object, animal, background or even the artwork of the subject.

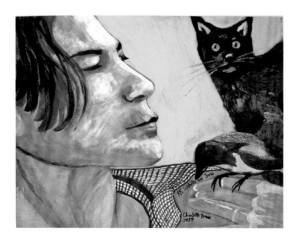

*Rachel K., USA* by Charlotte Tanner, USA
acrylic paint and marker on watercolor paper,
12 × 16 inches (305 × 406 mm).

I noticed that the bulk of Rachel's paintings consisted of cats, so it felt only fitting to add one when I painted her. Rachel and her bird were based on her reference photo, while the cat was directly inspired by one of Rachel's cat paintings.

> **" I rarely stick rigidly to what is there in the source photo, and will exaggerate some detail or outline. "**
>
> JANICE WAHNICH, UK

## USING PHOTOGRAPHS AS A REFERENCE

Once you've chosen an inspiring photo, you might want to consider the following:

- If you struggle with depicting color as a value (a tone of light or dark) import the photograph into an image editing program and convert your image to grayscale. You can also play with filters and the contrast to darken or lighten the original.

- Enlarge your image as much as possible—you can view it on a computer or tablet device while working rather than print it out if that is easier.

- Treat your photo reference as a starting point and then take your own work in whatever direction inspires you. There is no need to feel constrained by the original reference photograph's background, for example, or a particular color.

- Copyright of a photograph belongs to the person who took it, so always obtain the permission of the copyright holder of any references you use.

- If you are drawing from life and take photos to assist you, be aware that how the camera sees the scene with one lens is quite different from how a human sees it with two eyes. In addition, if you take a photo from a different height than your eyes, the scene will not look the same. As a living person, you are always moving slightly. This means that what you see and portray is shifting all the time.

## DEPICTING TEETH

You are more likely to encounter a wide smile with teeth when working from a photo than from life. This is because people tend to smile for the camera, and because of the difficulty of posing with an open mouth. However, depicting teeth in a portrait presents unique challenges which cause many artists to avoid them. If you include teeth in your portrait, look carefully at your subject's mouth, including how the teeth recede. As always, draw what you actually see rather than a symbolic rendition of teeth.

". . . the key for me was being very careful with the shading around the individual teeth. Most of the time I find it's best to just hint at the shadows along the gum line. Also, the teeth at the corners of the mouth will be more in shadow and might have more individual differentiation.

I think overall I avoid the toothy grin portrait as it seems to me a mask that we all put on in pictures that doesn't really tell us anything about the person in the portrait."

TIM CLARY, USA

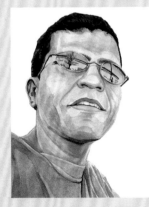

*Nasir, USA* by Tim Clary, USA
ink wash and watercolor on illustration board,
6 x 5 inches (152 x 127 mm).

# TRACING

When working with photographs, you have the option of tracing all or part of the reference image, or working directly on top of it. While this is very easy to do using layers in a digital piece, it is equally possible in traditional media using tracing and transfer papers, or painting directly on top of a photographic print. Tracing can be used to lay down some key landmarks of the face or to check positioning, or it may be a more substantial part of the artistic process.

To trace or not to trace is a much-debated question, and seems to come up especially frequently in discussions of digital art. However, tracing an image is not a twenty-first century phenomenon. Artists since the Renaissance have used tools to trace a projection of their subjects, often so they could work faster on their commissions and maximize their earnings. And in later times, artists such as Degas welcomed the possibilities that photography brought to their work.

## IS TRACING CHEATING?

"Tracing is sometimes considered 'cheating.' However in order to know if you're cheating, you have to know what your goal is. If your goal is to improve your observational skills, you may be cheating yourself as tracing only has limited use for that goal. If your goal is to impress your friends with your observational skills, it's cheating because that's not what you're doing.

If your goal is to develop a distinct, personal, body of work, it's not cheating if it's helping you create your art. And if your goal is to become a famous artist, there's no requirement to draw at all. Non-drawing activities of artists currently being shown in museums include designing slogans for billboards and putting mass-produced objects on pedestals.

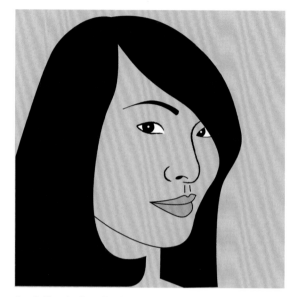

*Angel, China* by Erica Smith, UK
Adobe Illustrator on a Mac
I tried drawing from this photograph several times and while I liked the drawings, they did not look like the model. By tracing directly from the photograph, I realized why—I was making the features much bigger than they really were. I used a brush filter to soften the lines around the eyes and nose.

I think as artists we often confuse the goal of improving our observational skills with the goal of making our art, especially since skills are often emphasized (with good reason) by all those authority figures called teachers, and what they told us lurks in our brains. Also, our friends are impressed, and we're suckers for that.

And of course, there's the question of what we enjoy doing—some find tracing more or less fun or interesting, others find observation more or less fun or interesting.

I think, as so much in life, it gets down to knowing what we're doing and why. Then it becomes clear what is 'cheating' and what isn't."

JULIA L. KAY, USA

> **"To me the key difference between a 'copy' and a piece of original art is the ability to discern the artist's hand in the art."**
>
> TIM CLARY, USA

## TRACING AS ARTISTIC PROCESS

"Sometimes I trace a continuous line over the photo and I don't stop until the portrait is finished. For other portraits, I trace with my left hand as well.

More often I draw on paper while looking at the photo on the computer screen, and then I trace my own drawing on the iPad. For some portraits I prepare several sketches on paper (continuous line, right or left hand) and I take photos and put these in several layers, tracing different parts of my own drawings.

I even enjoy tracing and tracing again at different stages and seeing how the drawing changes over time. And then I strip down the lines progressively until I have a minimal drawing that I will trace one more time before playing with colors.

When preparing my papercut portraits (see page 77) I've also traced photos, my drawings based on observation and my emotive drawings made with my left hand. Then I put them all together and trace, again and again, on transparent paper and then on colored Canson paper until I finish making the shapes I want to cut out. I enjoy very much the process of drawing again and again."

MARGARITA PÉREZ GARCÍA, UK

## LOOSENING UP

Of course, you can work from photos without tracing. One of the pitfalls of working from a photograph is that the resulting portrait can look "frozen." To avoid this, instead of tracing or staring at the photo the whole time while drawing, try glancing at it, getting an impression, and then looking away and drawing a little bit from memory; then glance at the photo to remind yourself or look for some proportion you've forgotten, then look away and draw some more from memory.

If you're feeling stuck, or in a rut, trying something experimental can help you loosen up and get past what's blocking you. Even if you don't embrace the results of these experiments as an end in themselves, you can combine elements of this approach with more traditional methods to find a balance between accuracy and the unexpected liveliness that can result from loosening up (see "Drawing Blind," page 36). Here are some experiments to try.

- Draw with your other hand, both hands together or with a pen between your toes.
- If you wear glasses, take them off.
- Hold the pencil or brush in a funny way, i.e., don't use your thumbs.
- Hold multiple pens or brushes in your hand.
- Draw with your eyes closed.
- Change subjects mid-portrait.
- Draw from an upside-down photo.
- Use media you have never used before and don't know how to control.
- Assume you're going to throw out whatever you draw next without photographing it or showing it to anyone.

# ON SEEING AND DRAWING

"Drawing is as important to an artist as the alphabet is to a writer. It's our language. Sit down and learn it. Start by drawing what you see but be ready to abandon what you see for what you feel. Go beyond technique. Expression and design rule, technique merely provides us with the means to make it visible."

DANIEL NOVOTNY, SLOVAKIA

"I don't want to make perfect drawings but ones that capture something of the sitter and at the same time acknowledge that it is two-dimensional and show the workings of it, even the 'mistakes.' They show my part in it and give an energy and emotion to the image."

MAUREEN NATHAN, UK

"I carry my iPad everywhere. It is my sketchbook. I look forward to drawing while waiting for food in restaurants, standing in lines, sitting over coffee. Drawing all the time makes you better and better."

KATE BARBER, USA

"Think of the head as a series of planes, just like you would a box or other inanimate object."

BARB WRIGHT, USA

"Draw every day, even if only for a few minutes, and don't judge what you make. If you don't like it, make another. If you wanted a resemblance, and there isn't one, still ask yourself if it would be an interesting drawing to someone who does not know what the subject looks like. If not, put it aside, make another one—either right away, or the next day. Just keep looking and drawing."

JULIA L. KAY, USA

"Drawing a 'portrait' can feel loaded but it is no different to drawing a building or a bowl of fruit. It's just our preconceptions that get in the way. A portrait is just a landscape that happens to be facial."

ANNA BLACK, UK

"Practice, practice, practice. Take your time. Be patient. Don't listen to the little devil in your head. Never judge a drawing directly after finishing."

IRA PRUSSAT, GERMANY

"Skip texting, draw."

DAN HARRIS, USA

"It is important to spend as much time assessing and looking as it is making a mark or laying in a tone."

MARTIN BEEK, UK

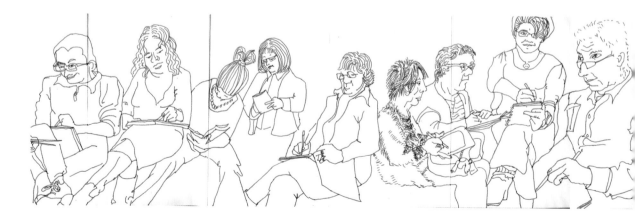

"See the world as a two-dimensional mosaic of shapes and values. The negative shapes are as important as the positive ones."

RICHARD LONG, UK

"I overcame my fear of failure by rapid sketching. I drew every member of JKPP in under sixty seconds (with a strict timer). By working so quickly I found my brain had no time to panic and it took down the main visual information in an increasingly successful way. It taught me to look for the main visual hits in a work. These experimental methods seem to give confidence in experimenting with other areas such as mediums, techniques, and so on."

LUCY CHILDS, UK

"The most important thing is to draw what you want to draw. That is the only thing that matters. Interest in a topic drives you to work with it. Don't think what others might like or about how it 'should' look."

JÖRG KRÜHNE, GERMANY

"Try not to be 'precious' with your drawing, do not be afraid to constantly question, and be prepared to adjust marks along the way, even if you find them pleasing. Try to see the bigger picture."

JANICE WAHNICH, UK

**" Look at the directions of visible and invisible lines which you will see in every subject: draw them, connect them, wipe out what you don't need. "**

MARION LOKIN, NETHERLANDS

"I am not for the idea of 'practicing,' just go and do it and enjoy the material you have chosen to work with and choose an object you like."

HANS MUERKENS, GERMANY

"It's okay to copy—of course you don't claim it as your own—but it's a great way to learn color and composition. I learned a lot about drawing by copying the work of other artists. I also learned what I didn't like. It gives you a different perspective."

TAMMY VALLEY, USA

*JKPP groups in Oxford and London, UK, and Paris, France by Julia L. Kay, USA pen on paper, 5½ × 31½ inches (140 × 800 mm).*

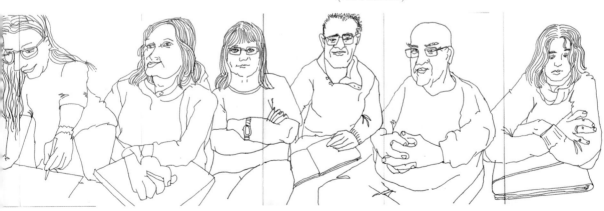

# THE PROCESS OF MAKING PORTRAITS

The process of creating a portrait is influenced by personal preferences as well as the medium being used. The approach used for a line drawing which explores contours may be very different from the approach used for a charcoal drawing which explores light and shadow.

Some portraits develop organically, others are meticulously planned. Certain media, such as printmaking, require planning. Some artists may be planners in general, while others may be more interested in working spontaneously. No process is right or wrong. The same artist may use completely different processes for each piece they make, or they may have a standard process they always use.

## HOW TO START

"Often I'll begin by roughing in the major topography of the face. Sometimes, if I'm captivated by a particular line or shape, such as a shadow or jawline, I will start there. The medium is also a contributing factor. If what I'm using lends itself to a painterly approach, I'll start by thinking about the light and shadow and building up the values, as opposed to focusing on the contours of the face."

JARRETT KUPCINSKI, USA

"I treat the image as if it were already there and I am easing it from the unformed universe. The first marks give the work a kind of root, or axis of tension. There is something intentionally backwards about my approach where seemingly flowing lines are created with very slow movements, as if I were backing a car into a very tight parking spot."

JERRY WAESE, CANADA

" **I am more interested in the dance than the end result.** "

MARIAH O'NEILL, USA

"I start by staring at the reference photo, trying to get into the space of it—falling in love with it. Then I roughly block out the composition, and make a loose sketch. Then comes the part where I always completely fail—and that's making a more complete sketch. No matter how I block it out (and I do think about composition a lot), when I start drawing for real, the parts that I'm interested in get bigger and bigger, and the rest has to get bigger to accommodate it, and then it no longer fits on the page. Sometimes I will draw a much smaller box in the middle of my paper and make the composition there, so that when the whole thing explodes (as it always does), then there is the paper to accommodate it. Because I am almost exclusively doing printmaking now, it's a little easier. I just keep taping more pieces of paper onto the original composition, and then crop it later to fit my blocks. Or I scan the whole thing, and reduce it, and then print it out.

When I am drawing though, I work on all parts of it at the same time. Whatever I'm doing to one part, I'm doing to all the other parts, so at any given moment, the whole thing has the same degree of 'finish.'"

THERESA MARTIN, USA

"I always begin with excitement and trepidation in equal measure. I draw different things first each time depending on what shouts itself to me loudest."

MAUREEN NATHAN, UK

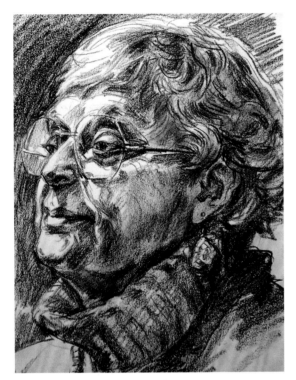

*Joan G. S., USA* by Mariah O'Neill, USA
Neocolor on paper
13 × 10 inches (330 × 254 mm).

"I start on an already marked surface: an old abstract drawing or swiped ink or paint from a finished palette or print reject. Anything but a clean sheet of paper! My pre-marked canvas or paper can be formed in many ways but the general appearance is of textures, marks, drips, rubs or scraped shards. It allows me to access the facial point which the whole portrait is to be built around. Perhaps an eye or ear, or an interesting curve beside the mouth, which fits with the under-image. There is a lot of serendipity involved in what features will meld well as I lighten or darken across the under-markings 'finding' my image. It is an organic process and I blithely and defiantly mix mediums, oil with water, ink with bleach, pastel and acrylic, in any permutation, to do my mark-making."

FAY STEPHENS, UK

## CHECKING RELATIONSHIPS

The challenge with realistic drawing is to separate what you know from how things actually look. For instance, you may know two people are the same height. But if one is further away, they don't look the same size. You may know the face is roughly symmetrical, with the eyes equidistant from the nose. But if the head is even slightly turned, that's not what you actually see. Separating what you know from how things look is especially hard with faces, as they are made up of features whose symbols are deeply embedded in our subconscious. To capture a likeness, you need to disregard what you know and focus instead on seeing the minute variations in shapes, proportions and angles that make each face uniquely recognizable. This includes the relationships of all the facial features to each other, and how they are placed within the enclosing shape of the head.

"I'm always referring back to the last element I've drawn—this is the reference point so I can relate one feature to the next."

RAJESH KUMAR JOHN, INDIA

"To draw something realistically it helps to see the subject in the abstract, as shapes and values rather than an eye or a nose. To position them, use imaginary horizontal and vertical lines. How does the corner of the mouth line up with the eye? Where does that line intersect the jaw? The most common mistake I see is when the head is rotated and the features, especially the eyes, aren't rotated by the same amount. Simply laying a pencil horizontally on the reference photo cures that."

RICHARD LONG, UK

"I start by looking for a long time at the photo: looking, looking, looking—until it clicks and I know the interesting features, areas of detail and caution. Then I outline a bit, to get proportions within reasonable limits. Then it is a matter of scribbling longer where it is dark, and trying to stay off the light bits with my pen. I don't draw eyes, noses or features, just light and dark patches. The best advice I was ever given is to postpone drawing and nailing down things on paper. This, combined with the recommendation to work in a non-erasable medium such as pen."

PIETER VERBAARSCHOTT, NETHERLANDS

"I usually start with an eye and let the pencil or pen wander around the paper building the forms next to the eye, trying to feel the relationships between the forms and then looking for the effects of light. Then I check it against the subject to see what creates the expression—perhaps the angle of the eye or opening between the lips."

JUDITH REPKE, USA

"I usually begin by distinguishing the larger areas of darks and lights, and getting them down loosely. Composition is considered at this stage. Once I'm relatively happy I start to mark lightly the main divisions of the head. I use my pencil to help find relationships: holding it horizontally and vertically to map out where the features lie in relation to each other. Features start to emerge out from the lights and darks."

JANICE WAHNICH, UK

## DRAWING WITH LINES

"If I can draw a portrait with just one line, I'll do just that. If I can draw a portrait with a single dot, I'm all for it. Simplicity is the king. The proportions do give away whom those lines and dots represent but the process is not as much about the person I'm drawing as it may seem. I do like drawing faces, though the viewer's brain does ninety percent of the work for me and makes up what I leave out."

DANIEL NOVOTNY, SLOVAKIA

*Florian, Switzerland*
by Philip D. Kinzli, USA
colored pencil, 3 x 4 inches
(76 x 102 mm).

"If I am drawing I begin with a line and one line leads to another. I don't have a conscious method. I just keep going until the end, when I hope I will be surprised."

TOM PELLETT, USA

## CAPTURING A LIKENESS

"A likeness comes from accurate observation and depiction of the subject but also likeness or expression can suddenly emerge from a smudge of light or shadow or some other mark-making."

ANNA BLACK, UK

"Sometimes when you are drawing there is no sense of likeness until after the whole face, including the hair, is completed. With other portraits, the likeness emerges instantly."

RAJESH KUMAR JOHN, INDIA

## EYES AND OTHER FEATURES

"Really study the eyes and allow at least as much time for them as for the portrait as a whole. Allow for messiness, subtlety and complexity."

BILL ROGERS, USA

"If you are struggling to get the shape of the eye, draw the shape between the eye and brow."

RICHARD LONG, UK

"When rendering hair, the important thing isn't every individual hair. The important thing is the shape and feel of the hair. You can use light and dark to achieve almost sculptural effects and the right use of more detailed markings to add emphasis when and where that is appropriate."

BILL ROGERS, USA

"You can tell a lot about the angle of the head from the nose. If the chin is raised even slightly, you start to see the underside of the nose. This area is fairly complex and worth studying."

JULIA L. KAY, USA

## EYEBROWS

Although artists often focus on the eyes as being essential to capturing the subject, research suggests that eyebrows are more important in face recognition. It is sometimes said that capturing the shading on the forehead and above and between the eyebrows accurately is essential when attempting a likeness.

"Eyebrows are like expressive accents above our visual vowels embedded in our cranial consonants."

JERRY WAESE, CANADA

"I've had portraits almost finished except for the eyebrows and I've noticed even without the eyebrows the portrait looked similar to the person . . . but when I've added the eyebrows, and if they were slightly wrong, the similarity would be compromised."

RODRICK DUBOSE, USA

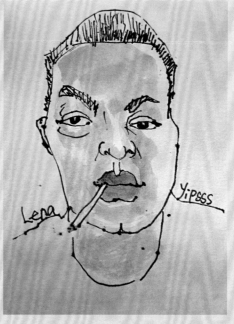

*Lena, Norway* by Yip Suen-Fat, Hong Kong
ink and watercolor on paper, 4¼ × 3¼ inches
(110 × 80 mm).

## CONSIDERING THE BACKGROUND

When creating a portrait, it is easy to focus on the head as the most important element, thereby forgetting about the setting or background of the subject. However, including a background can contribute to the narrative of the portrait as well as strengthen composition or add a decorative element. A "background" may simply mean a consideration of the whole page rather than just the subject's face. The decisions made will vary from artist to artist and portrait to portrait.

"To me the background is as important as the foreground. It's there to support, to complement, to harmonize, to unify and to work with the foreground toward a common goal. My current portrait painting is about balancing the two. I always give the background more thought than seems necessary. I want to make it interesting and fun, whether subtle or demanding, muted or bright, large or small. In other words, I allow it to stand out without clouding the purpose of my overall design, without it fighting for attention. Focus is on one while the other silently, but purposefully, makes the magic happen."

DANIEL NOVOTNY, SLOVAKIA

"Whatever I have going on in the face (or positive space), I also have going on in the 'background' (or negative space)—similar kinds of marks, colors, degree of development, and so on. I work on the whole thing all at the same time, so there is never any point where one part of it is more developed than the other, and I could stop at any point and it could possibly be called finished."

THERESA MARTIN, USA

"I am always aware of what is in the background. I tend to start the portrait with the overall background color, then work in the skin tones and the rest of the portrait. I think indistinct, blurry backgrounds are fascinating."

FRANCESCA ANDREWS, USA

*Dalton, Brazil* by Theresa Martin, USA
gouache resist and India ink, 6 × 4 inches (15 × 10cm).

"Even a few added marks escaping the container shape of the head can add structural integrity to the page. The marks don't need to have any particular narrative significance if you are adding them ad lib. More important is that the exterior marks relate formally to some tonal or linear passages within the subject. Don't be afraid of marking outside the container form even if there's nothing there in the reference photo. Simply react to and touch the whole page—inside and out."

CLYDE SEMLER, USA

"What is in the background explains the light on the face."

UMA KELKAR, USA

"I sometimes like to use the background to give additional information about the subject. So for example I might include a work made by the model in their portrait."

JAN JAAP BERKHOUT, NETHERLANDS

## BENEFITS OF WORKING DIGITALLY

Working digitally can be useful even for artists primarily using traditional media. For instance, you can manipulate and combine reference photos. You can photograph a work in progress, and experiment with altering colors, proportions or composition digitally, before touching your original. And if you are trying to exactly reproduce a reference photo, you can superimpose a photo of your art over the reference photo to see what changes you need to make. Last, if you have a drawing app on your phone or tablet, you might find it handy to be able to sketch in museums, on public transport, while traveling and in other situations where it might be difficult to set up an easel.

"I am primarily an iPad painter so I am lucky to be able to try different styles in the way I paint a portrait, without wasting paper or paint in unsuccessful attempts. That gives me a real freedom to experiment."

KATE BARBER, USA

"When I'm working digitally, I might start a particular drawing a dozen or more times, because it is so easy to wipe the canvas and begin fresh. While not always productive, one advantage to this approach is that I can experiment to find the best point of entry into a portrait. When that happens, usually all the other details seem to fall into place."

JARRETT KUPCINSKI, USA

"Working digitally is a good way to save resources. Although you can easily take another sheet of paper (or, more expensive, another canvas) working digitally has the advantage of staying 'clean.' It is also easy to use a previous state of a drawing as a layer, so it is a starting point in another version of the drawing."

JÖRG KRÜHNE, GERMANY

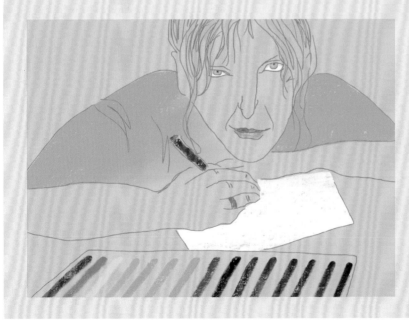

*Jutta R., Germany* by Bénédicte Delachanal, Canada
Procreate app on iPad, painted with my finger, no fixed dimensions.

With digital, I can work on many layers. Each layer has a specific part of the image. Then I can move and alter the separate layers to create different effects, sometimes complete surprises which would be hard to obtain in traditional media.

"Swatch tests save time and money. Primarily a watercolorist at the time of this painting, I hadn't painted in acrylic in a while. I didn't want to go out and buy new paint, so I did a swatch test of Janice's flesh tones with the paints I had on hand. It was an excellent reference and saved me both time and money." (See portrait of Janice on page 52).

ELIZABETH GAYE MACDONALD, CANADA

## ON PAINTING

"When painting in watercolor I have to think of the background and bring it into the portrait and vice versa, or it will look cut out and pasted with a hard edge. It is difficult to try to soften edges after they have dried, so you have to integrate before the paint dries. I often float colors into other colors for the background when painting portraits, trying to put in some lost edges to avoid the cut-out look."

BARB WRIGHT, USA

"A good way to start painting is to do a grisaille, that is a painting using a grayscale palette. I use burnt umber, ivory black and white to render each form, balancing the tones (lightest light to darkest dark). A painting will only work naturalistically if you can balance these tones accurately.

Once you begin using color it is easiest to start painting with a limited palette. I used alizarin red, ultramarine blue, yellow ocher, and titanium white. These can be mixed to make naturalistic tertiaries: orange, purple and green. You can play around with different primaries within this four-paint palette to get some warmer and brighter if you prefer. It also helps you get to know the colors and their properties.

After working with this palette I moved to an eight-color palette, with each primary including one warm and one cool variation:

> Red: cadmium red and alizarin crimson
> Blue: cobalt blue and ultramarine blue
> Yellow: cadmium yellow and lemon yellow
> Plus white (to lighten) and raw umber
> (to darken).

Once the basics of tone and chroma are understood it makes breaking the rules easier."

LUCY CHILDS, UK

# HOLDING A PORTRAIT PARTY

A portrait party can be as simple as two friends getting together to draw each other, exchanging photos to work from or drawing each other over Skype. For more of a party atmosphere, you can invite a group to get together to draw each other in your home or studio or in a café or other public place.

Each person can take a turn posing for the whole party, or if there are more than four or five people, you can break up into small groups. This allows everyone to be close enough to clearly see the face of the model.

You can warm up and get everyone used to the process by first doing a round of one minute poses, and then follow that with a round of ten minute poses. If people want to keep partying after everyone in each group has posed, the groups can reconfigure and start again.

If your portrait party is a success, you can schedule it as a regular event, such as the ongoing parties in Catalonia, Spain (http://flickr.com/groups/retratsprimerdijous).

To party with people not in your vicinity, start or join an online portrait party, such as the Portrait Revolution group (http://studiojuliakay.com/portraitRevolution). Independent of this book, there are also apps on both iPhone and Android for posting photos of yourself and drawing from posted photos.

At a portrait party, you have the freedom to interpret the subjects in limitless styles, and in turn you should be open to many different interpretations of yourself. If you choose to party, enjoy yourself, experiment, don't worry about mistakes and enjoy meeting and interacting with your portrait artist partners.

*5th Anniversary JKPP Exhibit and Portrait Party at Alley Cat Books and Gallery, San Francisco, March, 2015*

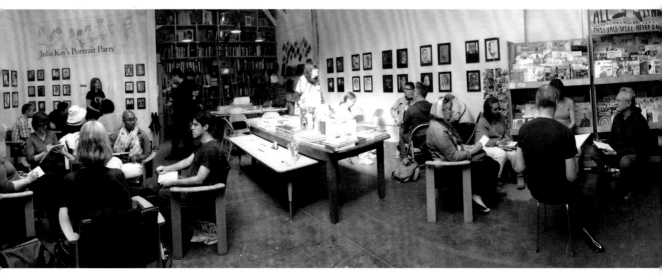

# DIRECTORY OF ARTISTS

María Luisa Aguado, Spain
http://flickr.com/photos/maguado

Leslie Akchurin, USA
http://flickr.com/photos/leslieakchurin

Olivia Aloisi, Switzerland
http://www.illustra.ch/

Samar Alzaidy, Iraq
http://flickr.com/photos/samora_watercolor

Francesca Andrews, USA
http://flickr.com/photos/frnjpn

Jane Angell, UK
http://flickr.com/photos/janedrsb2012

Marie Aschehoug-Clauteaux, France
iotamarie@gmail.com

William T. Ayton, USA
http://www.ayton.net

Kate Barber, USA
http://flickr.com/photos/101588899@N04

John Bavaro, USA
http://flickr.com/photos/john_bavaro

Valerie Beeby, UK
http://purple-owl.com

Martin Beek, UK
blakeone2004@yahoo.co.uk

Giovanni Benedettini, Italy
http://giangix70.deviantart.com/gallery

Jan Jaap Berkhout, Netherlands
http://flickr.com/photos/msouri

Frank Bingley, UK
http://frankbingley.co.uk

Anna Black, UK
http://www.annalouisablack.com

Ed Boldero, UK
http://flickr.com/photos/edboldero

Giorgio Bordin, Italy
http://flickr.com/photos/gbordin

Patricia Brasil, Brazil
http://flickr.com/photos/patricia_brasil

Anne M Bray, USA
http://flickr.com/photos/annembray

Nicolas Brossais, France
http://flickr.com/photos/croquisdenico

Geoff R. Bryan, Australia
http://flickr.com/photos/geoff_bryan

Janet Burns, USA
http://flickr.com/photos/44963371@N03

Mitt Cheevey, USA
http://flickr.com/photos/129388175@N05

Lucy Childs, UK
http://flickr.com/photos/lulipie

Tim Clary, USA
http://timclary.com

Mellanie Collins, USA
http://mellaniecollins.com

Rafael Comino Matas, Spain
http://flickr.com/photos/rafaelcominomatas

Lixandro Cordero, Canada
http://flickr.com/photos/50397680@N04

Sean Cronin, Ireland
http://flickr.com/photos/41195025@N05

Tiago Cruz, Portugal
http://avista.naocoisas.com

Dalton de Luca, Brazil
http://flickr.com/photos/daltondeluca

Bénédicte Delachanal, Canada
http://flickr.com/photos/bendelachanal

Juan Domínguez, Spain
http://flickr.com/photos/odessa80

Rodrick Dubose, USA
http://flickr.com/photos/46589619@N00

Miron Dunikowski, Poland
http://flickr.com/photos/49490738@N05

Leona Ellsworth, Liberia
http://flickr.com/photos/peachtreed

Amy Erickson, USA
http://flickr.com/photos/amyartist

Arturo Espinosa Rosique, Spain
http://www.artypaintings.com/en/

R. J. Evans, USA
http://flickr.com/photos/revansj

Barry Wayne Farmer, USA
http://flickr.com/photos/artfarm

Joan Ramon Farré Burzuri, Spain
http://flickr.com/photos/42114709@N05

Pepe Fárres, Spain
http://flickr.com/photos/pepefarresilustraciones

Nadya Fartushnaya, Russia
http://flickr.com/photos/nilla_pommy

Timothy Flanagan, USA
http://flickr.com/photos/msmakitadrill

Rita Flores, USA
http://flickr.com/photos/ritaflo

Eric Francis, USA
erictfrancis@gmail.com

David A. Friedheim, USA
davidfriedheim@yahoo.com

Patricia Gaignat, USA
http://reclinerart.wordpress.com

Isabelle Gaillardon, France
http://flickr.com/photos/127149503@N08

Isabel Galve Burillo, Spain
cruce.decaminos@live.com

Vin Ganapathy, USA
http://vinganapathy.com

Margarita Pérez García, UK
http://flickr.com/photos/margaperez

Simone Geerligs, Netherlands
http://flickr.com/photos/simosk3

Jean-Pierre Godefroy, France
http://flickr.com/photos/jipege

Helene Goldberg, USA
http://flickr.com/photos/hgberk

Ray Gross, USA
http://flickr.com/photos/49768901@N05

Manuel Grote, Germany
http://flickr.com/photos/sketchmanni

Elizabeth Gruhn-Zearley, USA
http://flickr.com/photos/71987024@N08

Joseandrés Guijarro, Spain
http://flickr.com/photos/lalegranegra

Nevada Gutierrez, USA
http://flickr.com/photos/frostylime

Roz Hall, UK
http://www.rozhall.com

Jill Harding, UK
http://flickr.com/photos/75394775@N04

Dan Harris, USA
http://www.flickr.com/photos/gringovitch

Virginia Hein, USA
http://flickr.com/photos/virginiaworksonlocation

Kristine Henshaw, USA
http://flickr.com/photos/75716799@N03

Sue Hodnett, UK
http://www.suehodnett.co.uk

Dan Hoffman, USA
http://flickr.com/photos/danhoffmanart

John Holliday, UK
http://flickr.com/photos/johnarh

Marc Taro Holmes, Canada
http://www.citizensketcher.com

Kline Howell, USA
http://flickr.com/photos/klinehowell

Steve Huison, UK
http://flickr.com/photos/13976525@N04

Hwasook Hwang, South Korea
http://flickr.com/photos/nabirani

Elizabeth Ingebretsen, USA
http://flickr.com/photos/_margauxb_

Linda Jackman, USA
http://lindajackman.weebly.com

Omar Jaramillo, Germany
http://flickr.com/photos/omarpaint

Rajesh Kumar John, India
johnrajeshk@yahoo.com

Sven Jordy, France
http://flickr.com/photos/32251171@N03

Ineke Kamps, Netherlands
http://flickr.com/photos/kattenmeisje

Barien Kanie, Netherlands
http://flickr.com/photos/Grietje

Julia L. Kay, USA
http://studiojuliakay.com

Uma Kelkar, USA
http://umakelkar.com

Grietje Keller, Netherlands
http://flickr.com/photos/Grietje

Kris Keller, Netherlands
http://flickr.com/photos/Grietje

Michael F. King, USA
http://flickr.com/photos/michaelkingartwork

Philip D. Kinzli, USA
http://flickr.com/photos/21202718@N00

Ann Kirschner, USA
http://studiojuliakay.com/ak

Nick Kobyluch, UK
https://www.facebook.com/nickkobyluchsdailydrawings

Kate Kos, Ireland
http://www.katekos.com

Diane Marie Kramer, USA
http://flickr.com/photos/25386365@N06

Jörg Krühne, Germany
http://flickr.com/photos/jkruehne

Jarrett Kupcinski, USA
http://flickr.com/photos/kpcnsk

Lynne Lamb, UK
http://flickr.com/photos/paintistworks

Tom Lambie, Australia
http://flickr.com/photos/rippleberryrazz

Nini Teves Lapuz, USA
http://flickr.com/photos/uluruminambulate

Jennifer Lawson, USA
http://flickr.com/photos/jenniferlawsonartist

Amy Lehr Miller, USA
http://flickr.com/photos/amylehr

Irit Levy, Monaco
http://flickr.com/photos/irit-levy

Nicole Little, Canada
http://flickr.com/photos/littleoutrage

Marion Lokin, Netherlands
http://flickr.com/photos/pensezels_images

Richard Long, UK
http://flickr.com/photos/130432211@N03

Elizabeth Lynch, USA
http://flickr.com/photos/23733987@N06

Elizabeth Gaye MacDonald, Canada
https://paintpleinair.ca

Valérie Mafrica, France
http://flickr.com/photos/valeriemafrica

Olivia Marcus, France
http://flickr.com/photos/mademoiselle_olivia

Theresa Martin, USA
https://theresamartindrawingsandprints.wordpress
.com/

Pedro Martin, Spain
http://flickr.com/photos/118258425@N06

Donna Campbell McMenamin, USA
http://flickr.com/photos/donnazone

J. L. Meana, Spain
http://flickr.com/photos/jlmeana

Béliza Mendes, Luxembourg
http://flickr.com/photos/beliza_mendes

Irina Miroshnikova, Russia
http://flickr.com/photos/irishishka

Anna Morales Puigcerver, Spain
http://flickr.com/photos/amorapuig

Carmen G. Moreno, Spain
http://flickr.com/photos/gonzalez_moreno1

Marina Mozhayeva, USA
http://flickr.com/photos/42011110@N08

Hans Muerkens, Germany
http://flickr.com/photos/petervanayk

Mick Mulviel, UK
http://flickr.com/photos/mickmulviel

Andres Musta, Canada
http://flickr.com/photos/andresmusta

Maureen Nathan, UK
http://www.maureennathan.com

Daniel Novotny, Slovakia
http://www.danielnovotnyart.com

Mariah O'Neill, USA
http://flickr.com/photos/mariahoneill

Pascal Paquet, Belgium
http://flickr.com/photos/blpascal

Shalini Raman Parakkat, India
http://flickr.com/photos/teshionx

Barbara Luel Pecheur, Belgium
http://flickr.com/photos/barbara_luel

Tom Pellett, USA
http://flickr.com/photos/126948036@N02

Dan Powell, USA
http://flickr.com/photos/husdant

Ujwala Prabhu, India
http://www.ujwalaprabhu.com

Ira Prussat, Germany
http://flickr.com/photos/iraprussat

Carl Purcell, USA
http://flickr.com/photos/25686844@N06

Søren Raagaard, Denmark
http://flickr.com/photos/helvildt

Rajesh V. U., India
http://flickr.com/photos/23576282@N08

Sue Ramá, USA
http://suerama.com

Jacquie Ramirez, USA
http://flickr.com/photos/artsy_jacquie

Gila Rayberg, USA
http://www.GilaMosaics.com

Cooper Renner, USA
http://cooprenner.com

Judith Repke, USA
http://flickr.com/photos/repke-art

Jutta Richter, Germany
http://www.juttarichter.com

Mia Robinson Mullen, USA
http://flickr.com/photos/34187834@N07

Toni Rodríguez, Spain
http://flickr.com/photos/tonirdgz

Bill Rogers, USA
http://flickr.com/photos/giveawayboy

Murilo Sergio Romeiro, Brazil
http://flickr.com/photos/44508342@N00

Anat Ronen, USA
http://www.anatronen.com

Mike Ryon, USA
http://flickriver.com/photos/mikeryon/
popular-interesting/

Miguel Angel Lopez Salazar, Spain
http://flickr.com/photos/salazar

Pablo Sarabia Herrero, Spain
jabb60@yahoo.es

Julia Sattout, Australia
http://flickr.com/photos/juliasattout

Carsten Schiefelbein, Germany
http://flickr.com/photos/caschie

Manfred Schloesser, Germany
http://flickr.com/photos/manfredschloesser

Rachel K. Schlueter, USA
http://flickr.com/photos/rkschlueter

Timothy Schorre, USA
http://flickr.com/photos/timothyschorre

Herman Schouwenburg, Netherlands
http://flickr.com/photos/hermanschildert

Kim Drake Schuster, USA
http://flickr.com/photos/timmielee5359

Clyde Semler, USA
http://www.clydesemler.com

Sally Sheen, UK
http://flickr.com/photos/85074368@N06

Jane Sherwood, UK
http://flickr.com/photos/vicarjane

Oksana Shiell, USA
http://flickr.com/photos/oksusha2000

Richard Shulman, USA
http://flickr.com/photos/ipadjunkie

Erica Smith, UK
http://flickr.com/photos/ericahastings

Jenny Sperry, USA
http://flickr.com/photos/jenny_sperry

Irene Stellingwerff, Italy
http://flickr.com/photos/irenesketch

Fay Stephens, UK
http://flickr.com/photos/faystephens-artwork

Leland Struebig, USA
http://flickr.com/photos/zzzwap

Paul Tabbernor, UK
http://flickr.com/photos/paul_tabby

Félix Tamayo, Spain
felixtamayo@ono.com

Charlotte Tanner, USA
caramello51@gmail.com

Gary Tausch, Canada
http://flickr.com/photos/cobol

Kim L. Thieu Domingo, France
kdcouleurs@laposte.net

John Thornton, UK
http://flickr.com/photos/foistclub

Sherry Thurner , USA
http://sherry-latebloomer.blogspot.com

Elizabeth Titus, USA
http://flickr.com/photos/sketchbookbuttons

Stella Tooth, UK
http://flickr.com/photos/stellartist

Zoraida de Torres Burgos, Spain
http://flickr.com/photos/arsaytoma-zoraida

A. J. Tudury, USA
http://flickr.com/photos/duckmarx

Tammy Valley, USA
http://flickr.com/photos/mochatribe

Ramón Carlos Válor López, Spain
http://flickr.com/photos/rcvalor

Rodney van den Beemd, Netherlands
http://rodneyvandenbeemd.com

Klaas Van der Auwera, Belgium
http://flickr.com/photos/klaasvda

André van der Kaaij, Netherlands
http://flickr.com/photos/122552013@N05

Erik Van Elven, Netherlands
3derik@gmail.com

Jim Vance, Canada
http://flickr.com/photos/thejimmer

Linda Vanysacker-Van den Mooter, Belgium
http://flickr.com/photos/aquarelinda

Elena Vataga, UK
http://flickr.com/photos/efandorin

Pieter Verbaarschott, Netherlands
http://flickr.com/photos/razornl

Patricio Villarroel Bórquez, Chile
http://flickr.com/photos/pvb2009

Pedro Villarrubia, Spain
http://flickr.com/photos/pvillarrubia

Jerry Waese, Canada
http://jerrywaese.ca/art

Janice Wahnich, UK
http://www.janicewahnich.com

Elizabeth Waltermire-Wilcox, USA
http://flickr.com/photos/storms-mom

Jean-Pierre Welch, Panama
http://flickr.com/photos/jpwelch

Cecca Whetnall, UK
http://www.francescawhetnall.co.uk

Beata Wielgos-Dunikowska, Poland
http://flickr.com/photos/ata_art

Laurie Wigham, USA
http://flickr.com/photos/lauriewigham

Barbara Jaye Wilson, USA
http://flickr.com/photos/catchthenoise

Elizabeth Wilson, USA
http://flickr.com/photos/eahwilson

Barb Wright, USA
barbartwork@gmail.com

Paul Wright, UK
http://flickr.com/photos/paulwrightdigital

Yip Suen-Fat, Hong Kong
http://flickr.com/photos/yipsss

Joan Yoshioka, USA
http://drawingonnature.blogspot.com/

Lorraine Young, Canada
http://flickr.com/photos/raineyoung

José Zalabardo, UK
http://jzalabardo.wix.com/watercolors

Angel Zhang, China
http://flickr.com/photos/angelzhang

# ACKNOWLEDGMENTS

Many people have collaborated to create *Portrait Revolution*. The words and images of two hundred artists fill this volume; I thank each contributor. I wish that I could have included portraits from every JKPP member, but it was not possible. Nevertheless, I thank every member who has joined and participated. Without all the members forming a community together, there would be no JKPP, and no book. I especially appreciate all the JKPP volunteers—from those who help new members sort out technical details to those who helped gather materials for this book, and everyone who's organized a meetup, an exhibit or a publication.

I couldn't have had a better partner on this journey than my editor at Pimpernel Press, Anna Sanderson. She conceived and pitched the idea, helped to structure the book, then guided me through the whole process, calm even in the face of tight deadlines. Her guiding hand can be seen everywhere, but most strongly in the "On Making Portraits" section, which would not have come together without her. Designer Becky Clarke made this book beautiful, working skillfully with every request I made—and I made many! And last, but never least, I thank my wife, Ann Kirschner, for her ongoing support and insights. I take my hat off to all of you.

Julia L. Kay

# INDEX

# INDEX OF SUBJECTS